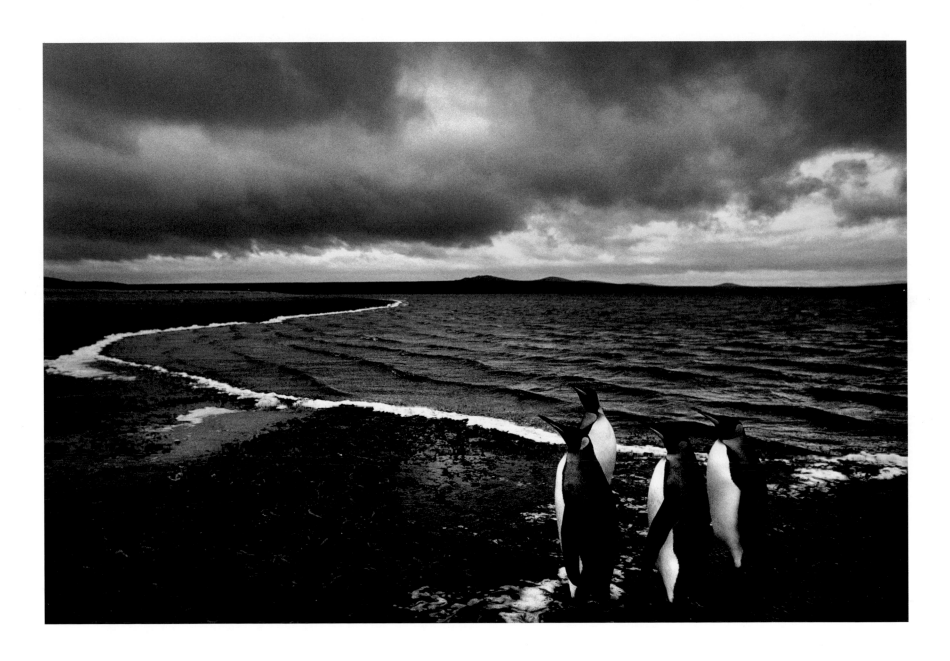

SOMEWHERE WEST OF LONELY

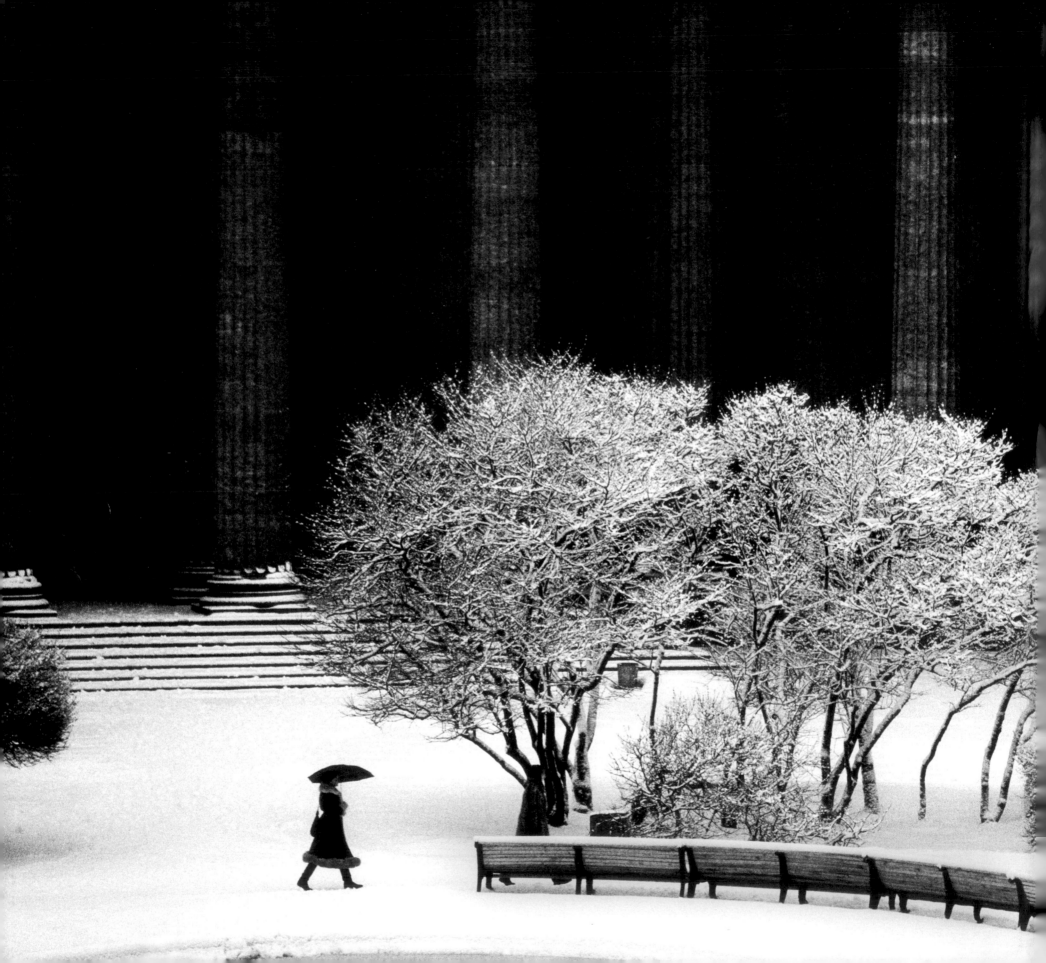

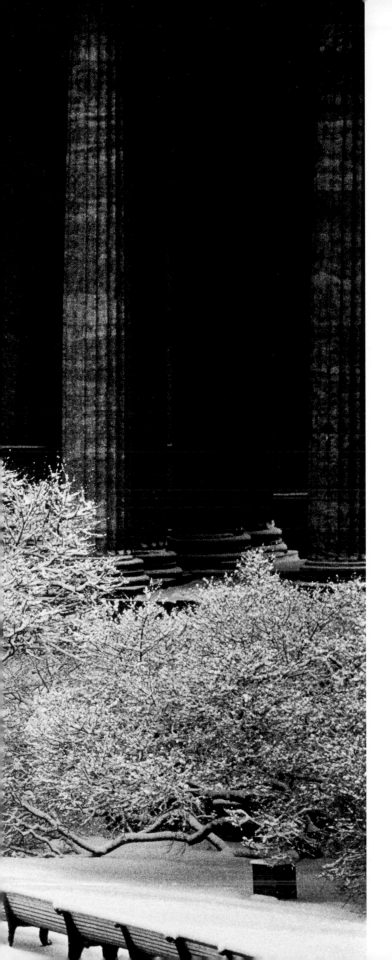

SOMEWHERE WEST OF LONELY

My Life in Pictures

STEVE RAYMER

INDIANA UNIVERSITY PRESS

Half title, A quartet of king penguins, who breed on the beaches and coastal grasslands of the Falkland Islands, a British overseas territory in the South Atlantic. In 1982, Great Britain and Argentina fought a bloody ten-week war for control of the 778-island Falkland archipelago, which today is a sanctuary for as many as a million penguins.

Frontis, Fresh from a Baltic storm, snow brightens the ninety-six neoclassical columns of the Kazan Cathedral in Saint Petersburg, capital of imperial Russia. The cathedral was completed in 1811 during the reign of Tsar Alexander I, whose ambitious construction schemes transformed Saint Petersburg into a European capital with an architectural lavishness rivaling that of Rome.

Facing, Viewed from a French colonial–era hotel, the Vietnamese Central Highlands city of Dalat is peaceful, like the country itself. Dalat is often called the "City of Eternal Spring" or "Le Petit Paris" thanks to its year-round mild temperatures and unblemished colonial architecture.

Unless otherwise noted, all images are courtesy of Steve Raymer/National Geographic Creative. The images appearing on pages ix, 30, 117, 140–41, 161, and 181 are courtesy of Getty Images. The image on page 176 is courtesy of Brian Harris. The map and the images that appear on pages 31, 33, 37, 39, 42, 49, 54–55, 132–33, 134, 136–37, and 138 are courtesy of Steve Raymer. All images used by permission.

This book is a publication of

Indiana University Press
Office of Scholarly Publishing
Herman B Wells Library 350
1320 East 10th Street
Bloomington, Indiana 47405 USA

iupress.indiana.edu

© 2018 by Steve Raymer

All rights reserved

No part of this book may be reproduced or utilized in any form or by any means, electronic or mechanical, including photocopying and recording, or by any information storage and retrieval system, without permission in writing from the publisher.

This book is printed on acid-free paper.

Manufactured in China

Cataloging information is available from the Library of Congress.

ISBN 978-0-253-03360-4 (cloth)
ISBN 978-0-253-03414-4 (ebook)

1 2 3 4 5 23 22 21 20 19 18

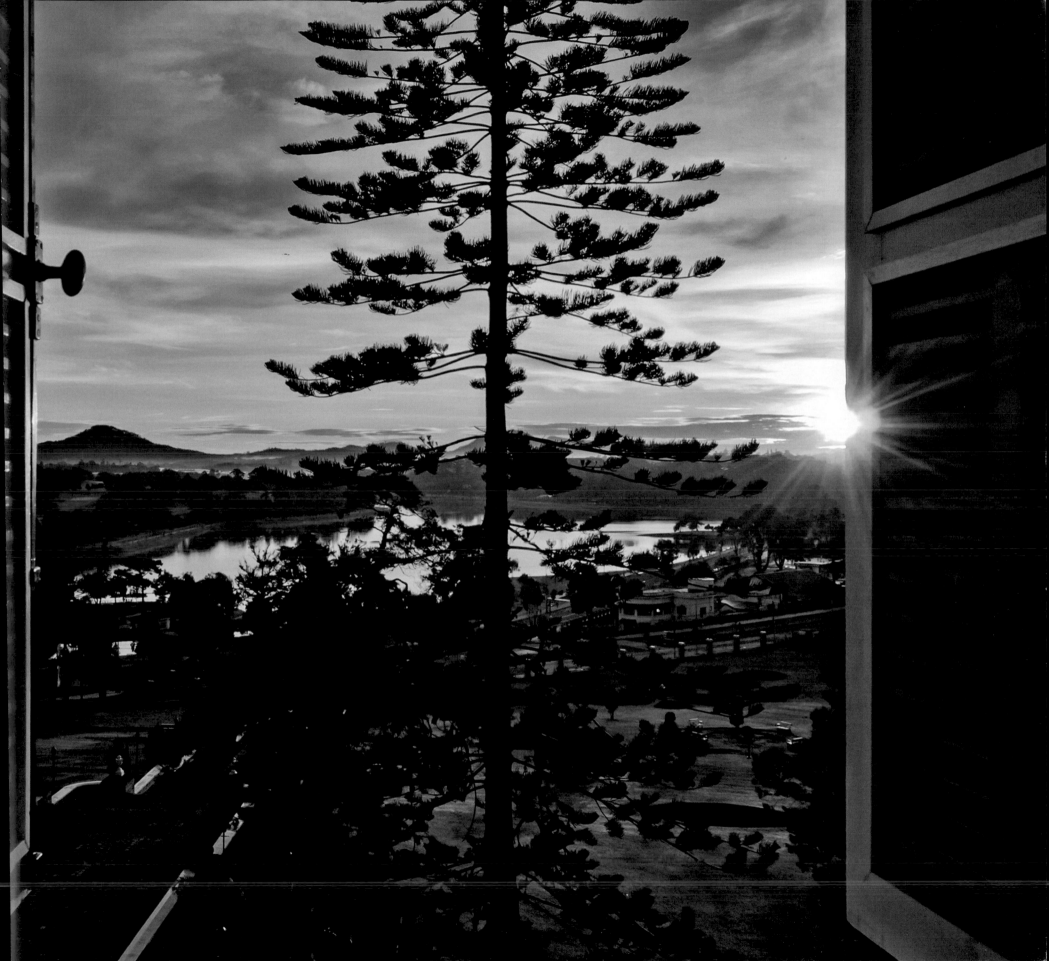

CONTENTS

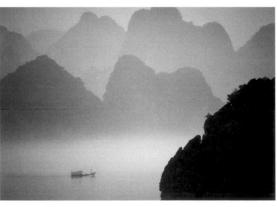

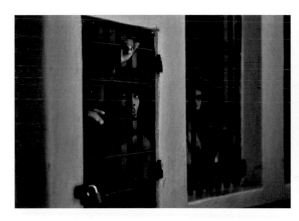 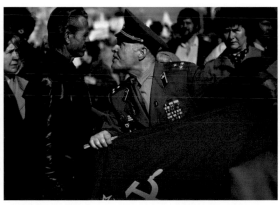 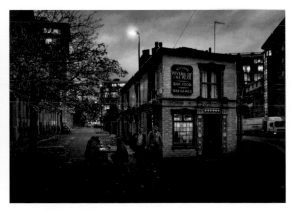

DEDICATION

AFTER I GAVE A KEYNOTE SPEECH at a creative festival in Dubai in 2017, a British reporter asked me, "Why, at the age of seventy-one, are you still running around the world shooting photographs and teaching university students?" There was a note of incredulity in her voice that demanded a serious answer. My reply came easily.

Over the last five decades, I have had too many friends and colleagues who lost their lives doing their jobs as photojournalists. I owe it to them. I feel a deep-seated obligation to continue using my skills and knowledge for as long as I can. To this end, I dedicate this book to my friends and *National Geographic* colleagues Gordon W. Gahan, Cotton Coulson, and William (Bill) Weems. We were part of a band of brothers who believed shooting pictures for *National Geographic* was our highest calling. Gordon, Cotton, and Bill died doing what they loved— telling the stories of the world. This book is also dedicated to Olivier Rebbot, a French photographer who perished after being shot by a sniper in El Salvador. Olivier had my back in several tight spots during the 1980s.

I also honor Anja Niedringhaus, a German-born Associated Press photographer who died in Afghanistan— America's longest war. She covered the Arab and Muslim world for more than twenty years, studied its culture and history, and cared deeply about what was happening to its people. And I remember Oscar-nominee Tim Hetherington and photojournalist Chris Hondros, who died together chronicling the gritty violence in war-torn Libya, and David Gilkey, a National Public Radio photojournalist and videographer who chronicled the pain and beauty of Afghanistan.

Finally, I salute the countless other photojournalists, mostly young men and women, who have lost their lives or personal freedoms taking an unblinking look at conflicts in Syria, Iraq, South Sudan, Somalia, Afghanistan, and elsewhere, as well as in political upheavals in Russia,

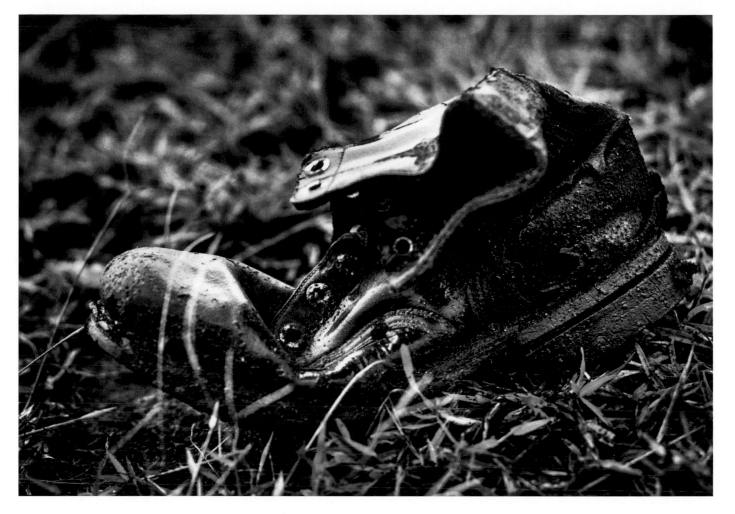

Vestige of the past, a combat boot decays in the rust-red laterite soil of the old US Marine Corps combat base at Khe Sanh near the former demilitarized zone that once separated North and South Vietnam.

Turkey, Egypt, the Philippines, and China. These countries rank among the world's most dangerous places for journalists, according to the Committee to Protect Journalists and Reporters Without Borders, which produces the annual World Press Freedom Index.

In her 2015 book *It's What I Do*, photojournalist Lynsey Addario, whose work appears in *National Geographic, Time,* and the *New York Times,* says "few of us are born into this work. It's something we discover accidentally." Indeed, photojournalism is a calling that matures with travel and exposure to a variety of people, cultures,

and governments. I have been fortunate to have a great many friends and professional colleagues who showed me how to get the picture, which is what photojournalists do. They accepted the risks not for the sake of fine art or financial reward. Instead, their motivation was to help citizens be free and self-governing. This is the role and function of journalism in a democracy, say media scholars and authors Bill Kovach and Tom Rosenstiel in their book *The Elements of Journalism.* It is a message I repeat often in the classroom and even to myself. Too many friends have died in the pursuit of these goals to do any less.

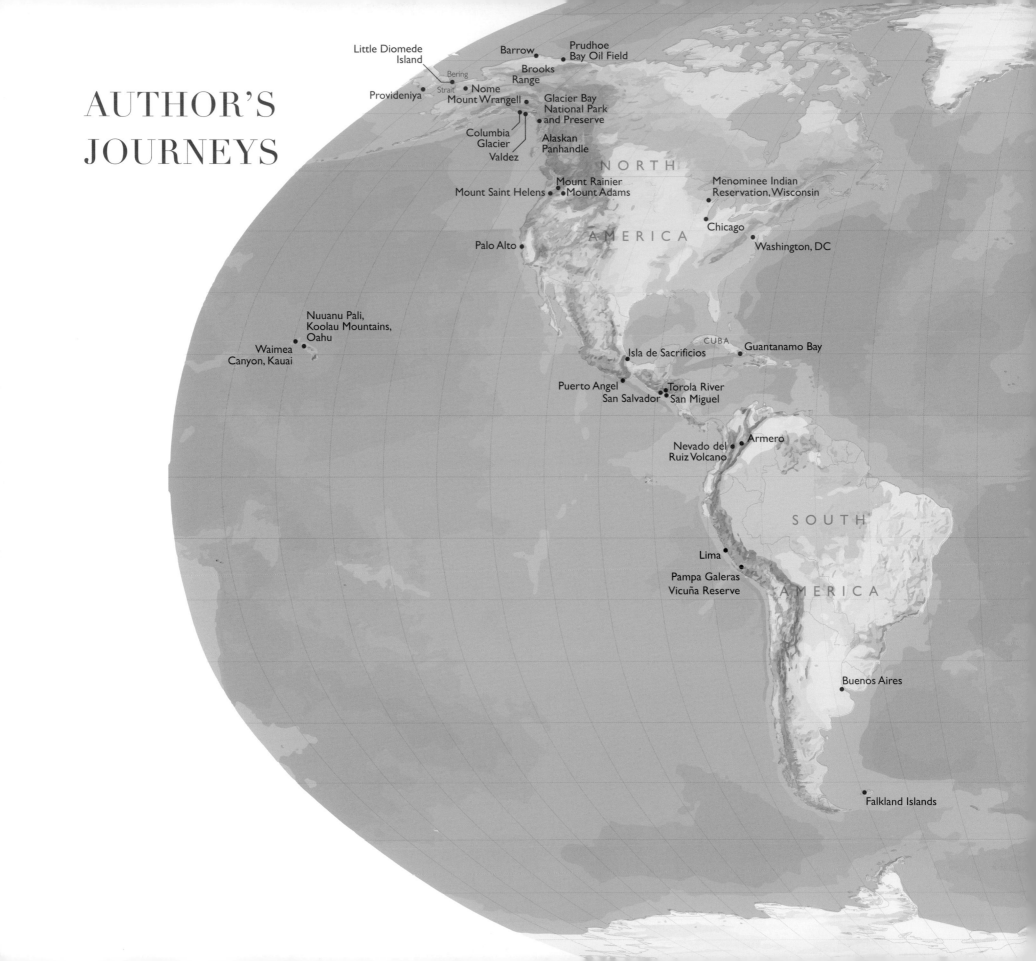

AUTHOR'S JOURNEYS

Little Diomede Island

Barrow

Prudhoe Bay Oil Field

Brooks Range

Bering Strait

Providenya

Nome

Mount Wrangell

Glacier Bay National Park and Preserve

Columbia Glacier

Alaskan Panhandle

Valdez

NORTH AMERICA

Mount Rainier

Mount Saint Helens

Mount Adams

Menominee Indian Reservation, Wisconsin

Chicago

Palo Alto

Washington, DC

Nuuanu Pali, Koolau Mountains, Oahu

Waimea Canyon, Kauai

CUBA

Isla de Sacrificios

Guantanamo Bay

Puerto Angel

San Salvador

Torola River

San Miguel

Armero

Nevado del Ruiz Volcano

SOUTH AMERICA

Lima

Pampa Galeras Vicuña Reserve

Buenos Aires

Falkland Islands

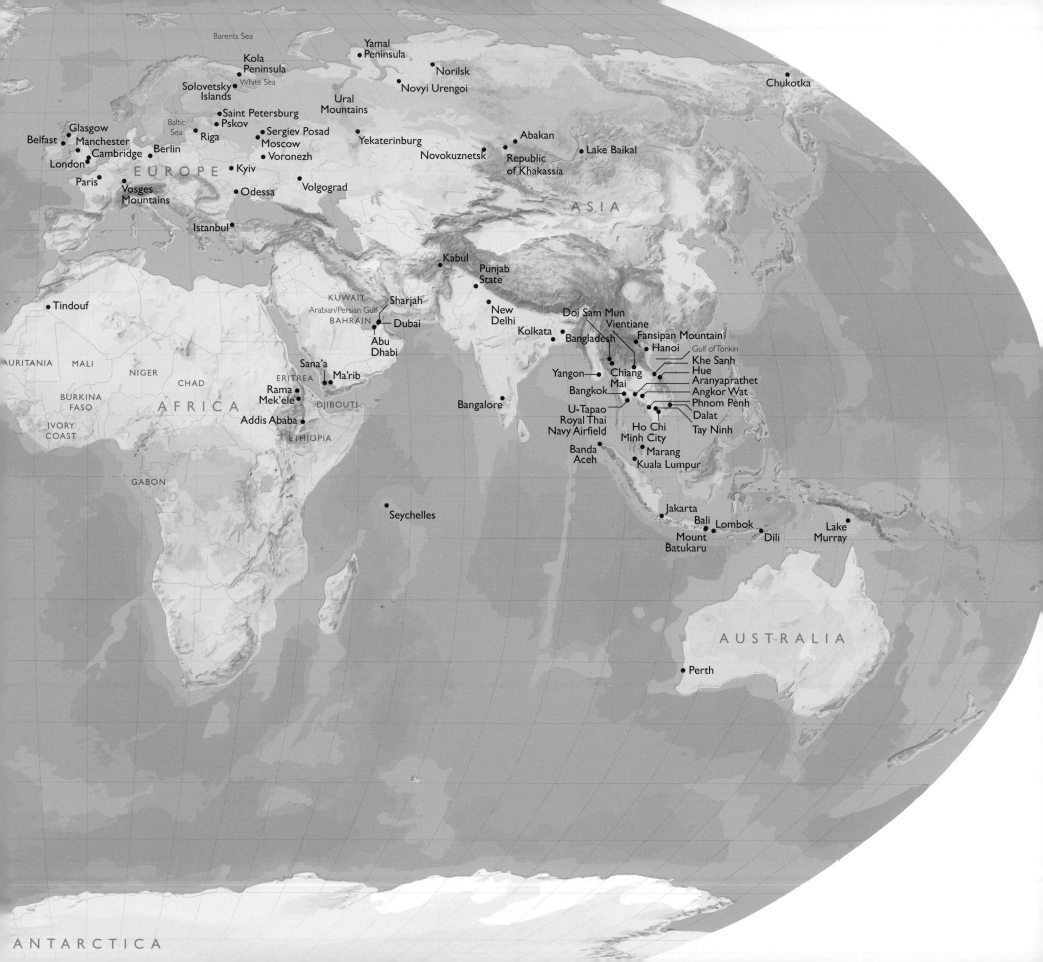

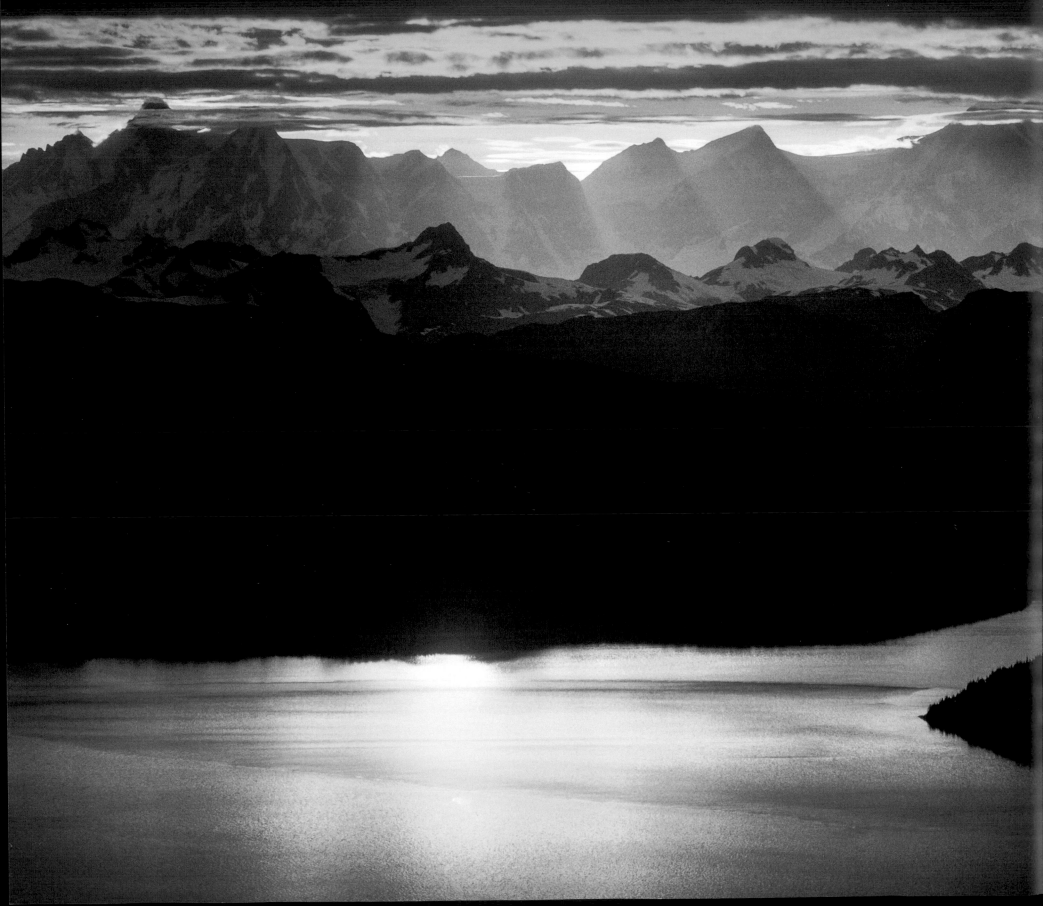

CHAPTER ONE

OLD AND NEW FRONTIERS

On a frozen February morning in 1976, our chartered helicopter lifted off from Deadhorse Airport near Prudhoe Bay, the largest oil field in North America, some 250 miles north of the Arctic Circle, and dipped its nose south. A battery temperature warning light glowed yellow amid the subdued red lighting of the cockpit. Our pilot assured us that an incoming cargo plane was reporting warmer air just five hundred feet above us. I tried to disregard the possibly of an engine flameout—flying in helicopters as a young army officer had given me a studied nonchalance in such matters—and focused instead on the pale magenta horizon and the blue Arctic plains slipping beneath us. This was the color palette of a long winter twilight.

When British explorer George Vancouver sailed the Alaska coast in 1794, Glacier Bay—set against the Saint Elias and Fairweather mountain ranges—lay beneath a sheet of ice miles wide and thousands of feet thick. Today Glacier Bay National Park and Preserve, with its receding glaciers, is a living laboratory for the study of climate change.

3

The Trans-Alaska Pipeline zigzags across the tundra, allowing the pipe to expand and contract as temperatures change. The 800-mile-long colossus was built in part as a response to the 1973 oil crisis, when the Organization of Petroleum Exporting Countries embargoed sales to the United States over its support of Israel.

Eventually the warning light went dark and our helicopter slowed to a hover so I could photograph the zigzagging Trans-Alaska Pipeline, an eight-hundred-mile-long colossus that navigates three mountain ranges and some three hundred and fifty streams and rivers on its way to the fjords of Valdez, its terminus on the Gulf of Alaska. In 1976, this was the world's largest construction project since the erection of the pyramids in ancient Egypt. With my colleague *National Geographic* magazine staff writer Bryan Hodgson, I was in the Far North to document its construction across an unforgiving wilderness riddled with earthquake-inducing faults and populated by thousands of often-brawling, well-paid construction workers who lived in camps called Happy Valley, Old Man, and Five Mile.

This photo shoot took us toward the icy cliffs of the Brooks Range, all the while paralleling the pipeline right-of-way and a gravel haul road that snaked south to the Yukon River near Fairbanks. But shooting through a small window in the helicopter passenger compartment proved nearly impossible. My cameras quickly became covered with frost and fog and our goose down parkas made the helicopter feel claustrophobic, as if we were carrying two or three extra passengers. The winter bleakness of

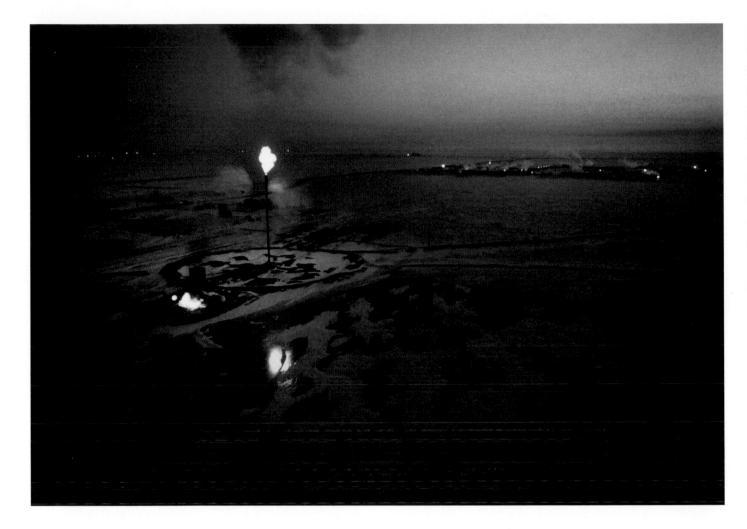

A light at the end of the earth, a gas flare illuminates forbidding Prudhoe Bay. Some twelve billion barrels of oil have been pumped from the field over the past four decades, with petroleum revenues paying for the majority of Alaska's government services. But the field has been in steady decline since the mid-1990s.

America's last frontier was nothing like my home state of Wisconsin with its snow-tipped northern forests. I felt unprepared and worried. Was I getting the picture?

"It looks like a hair on a wedding cake down there," declared Hodgson of the oil pipeline. An Englishman whose family had bundled him off to relatives in California during the Nazi Blitz of Britain during World War II, the quiet-spoken Hodgson was a former newspaper photographer and picture editor turned magazine writer in middle age, always ready with a clever turn of phrase. The image of a hair on a wedding cake was the challenge I needed. We doubled-back toward Prudhoe Bay, hugging the pipeline at five hundred feet above the tundra until I was satisfied that I had a photograph worthy of Hodgson's incisive image.

Lesson relearned—imagination is a key ingredient of the best story-telling images.

On another twenty-degree-below-zero morning, Hodgson and I flew west toward Lonely, a US Air Force early warning radar station on the Beaufort Sea coast. We packed for an overnight stay at Point Barrow, called Nuvuk by Alaska natives and the northernmost point in the United States. Barrow sat atop the former Naval Petroleum Reserve Number Four, now called the National

Working in the Arctic darkness, welders are sheltered by a "push shack" with electric heaters to shield them from cold so severe that it contributed to some of the nearly four thousand welding flaws that had to be repaired before oil flowed down the Alaska pipeline in 1977.

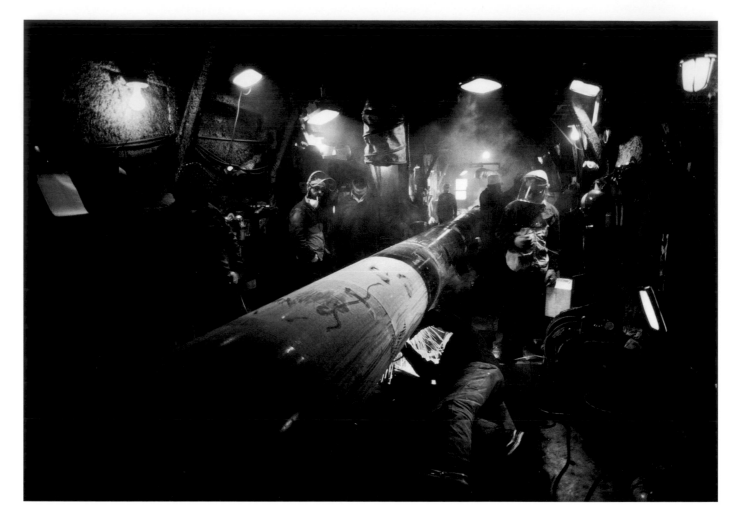

Petroleum Reserve–Alaska, which is believed today to contain nearly a billion barrels of crude oil and some 53 trillion cubic feet of natural gas. We wanted to learn how indigenous Alaskans felt about the influx of billions of dollars in Big Oil money into tribal coffers and how oil and gas exploration might change native traditions, including the hunting of whale, caribou, fox, and ptarmigan, a member of the grouse family.

But somewhere west of Lonely, a fast-moving snowstorm with voracious winds shrouded our helicopter in what Alaskans call a "whiteout," forcing us to make a quick 180-degree turn and set a course for the air force

radar station. A whiteout is dangerous at any northern latitude, but in the Alaskan Arctic it can be especially deadly. There are no shadows, no horizon or clouds, and all depth perception and visual references are lost. Our pilot radioed Lonely, but its small airstrip was closed, and, low on fuel, we set course for Deadhorse, some 120 miles distant. It was time to say a silent prayer. Mercifully we outran the storm, landing with the fuel gauge hovering on the red "empty" line. Within minutes the storm enveloped Prudhoe Bay and our prefabricated hotel, which already had five-foot snowdrifts to the roof.

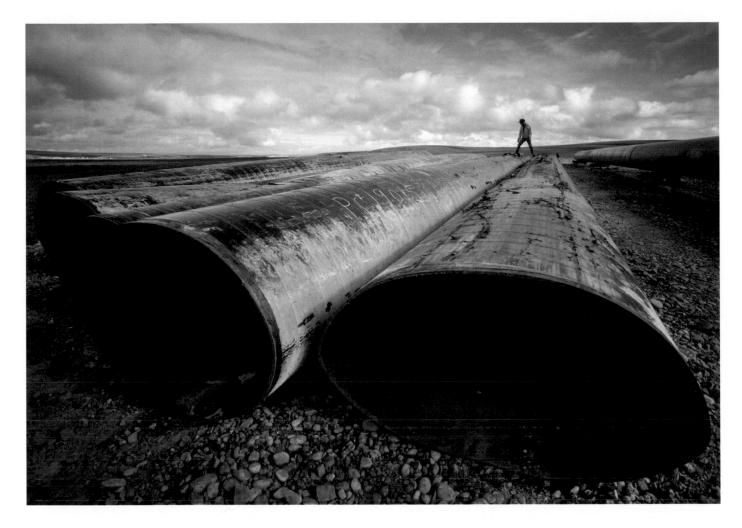

Flattened by natural forces, sections of the Alaska oil pipeline floated to the surface of the Sagavanirktok River only months after being buried beneath the riverbed. Inspectors said ice formed between the pipe and a protective concrete jacket. The jacket broke under the intense pressure of expanding ice.

Hodgson and I would have other adventures like the trip to Lonely, traversing much of Alaska in winter and summer—from Barrow and Kotzebue in the north to majestic Prince William Sound, scene of a devastating 1989 oil spill that would damage more than 1,300 miles of some of the most remote wild shoreline in the world. Our curiosity about the impact of the project on Alaska and Alaskans led us to state pipeline inspectors, who gave us legal cover to fly—unwelcome and unannounced—into the Sagavanirktok River basin. There we discovered stacks of crushed pipe that had floated to the surface after being squashed by expanding ice. Inspectors

and whistleblowers also showed us how X-rays of pipe welds were being falsified, a revelation that eventually led to 30 percent of the welds being repaired or replaced at a cost of tens of millions of dollars in cost overruns.

Pipeline security guards learned to come racing with red lights flashing on their SUVs whenever our chartered helicopter appeared overhead. But our state inspector escorts—perpetually underfunded and lacking transportation of their own to the remotest parts of Alaska—were our official cover. In one instance, as we hovered over a section of pipeline north of the Brooks Range, I photographed construction crews using steam, explosives, rock

saws, and high-pressure water to unearth pipe with defective welds—pipe on which the integrity of the pipeline depended.

The biggest loser in this drama was the tundra—a delicate Arctic plain that is home to some 200 species of birds and more than 35 kinds of land mammals, most notably polar bears, caribou, musk oxen, wolverines, arctic foxes, and wolves. Our reporting in the November 1976 issue of *National Geographic* also exposed violence between rival unions, massive thefts of equipment, and widespread fraud in hiring and overtime payments. Based on our story, other national and international media organizations, along with congressional investigators, scrambled to get to the generally inaccessible pipeline right-of-way to see the troubled $8 billion behemoth.

In the end, this was the first of a series of clashes between rival factions in the American Arctic that has continued for decades. The players are Alaskans concerned about their boom-and-bust economy, environmentalists, and Big Oil and its congressional supporters, who are eager to exploit the oil and gas potential of Alaska—and, for politicians, to top up their campaign coffers. On December 20, 2016, former president Barack Obama effectively banned oil exploration on tens of millions of acres of federal lands and the waters of the Beaufort and Chukchi Seas. Alaska now accounts for only 7 percent of the United States' oil production—a sharp drop from the 1980s, when Prudhoe Bay crude represented a quarter of US oil, according to the US Geological Survey, which estimates oil reserves in Alaska and elsewhere. But a new discovery in the area could hold as much as 1.2 billion barrels of oil and keep oil flowing in the Trans-Alaska Pipeline for years to come.

On reflection, Hodgson and I had ringside seats—albeit it often from the air, with quick forays onto the frozen tundra—to the first high-profile conflict over energy and environment in America's Far North. For me there would be other assignments in the Arctic and sub-Arctic, memorably on the violently contested Gulf of Alaska, where fishing grounds, forests, and majestic places like Glacier Bay National Park were threatened by oil exploration, foreign fishing fleets, and expanding tourism. And over the years, Hodgson and I became such close friends that he was best man at my wedding to Barbara Skinner in 1991. He penned a poem for the best-man's toast that hit just the right note for a young and beautiful Georgetown University graduate student marrying an older and somewhat world-weary photojournalist.

At an exhibition of photographs by my friend and former colleague Dick Durrance, a Colorado writer introduced him—and by extension the rest of us—this way: "Becoming a *National Geographic* photographer is a bit like being accepted into an Ivy League school. It takes luck and talent, and when you're in you have to work to keep it." So how did I get there? To my mind, I was the most unlikely of a group of staff photographers hired during a period when the magazine was trying to change its photographic style and approach the world with the unblinking look of newspaper photojournalism.

When I joined *National Geographic* Magazine in 1972, just a year out of graduate school, I confided to editors in Washington, DC, that I had never taken a color picture for publication. But director of photography Bob Gilka—a blunt and notoriously gruff legend in photojournalism—looked me in the eye and uttered words I shall never forget: "We can make the pictures any goddamned color we want. We're hiring you," he growled, "for how you think and how you see the world." These are words that I have passed on hundreds of times to university students looking for insight into how to prepare for the future.

Gilka, who would become my mentor and protector inside the *National Geographic* bureaucracy, didn't care

that I was a black-and-white newspaper photographer—in my case one who knew next to nothing about design or light, our most important story-telling tool. Durrance, a former army photojournalist, was one of the first of Gilka's new hires. In fact, all my new colleagues had news backgrounds, including David Alan Harvey, who came from the *Topeka Capital-Journal* newspaper in Kansas; Jodi Cobb, who arrived from the *Denver Post*; Nathan Benn, who shot for the *Palm Beach Post* in Florida; Jim Stanfield and Bob Madden, both fellow Wisconsinites with strong newspaper credentials; and Gordon Gahan, a United Press International news agency shooter who had won the Silver Star for heroism in Vietnam as an army photographer. This was surely going to be a new look in *National Geographic*, or so we hoped.

Gilka's faith in my potential meant that my creative life would be a constant work in progress, a process of learning and reinvention that continues to this day. Learning to read and use light effectively, internalizing the principles of design in my photographic compositions through the camera viewfinder, and understanding the color palette of artists was made more difficult because I had taken only one rudimentary photojournalism course at University of Wisconsin–Madison.

Instead, I was self-taught. I learned my craft as a precocious undergraduate covering violent anti–Vietnam War demonstrations on the Madison campus, then in the front ranks of turbulent colleges along with the University of California, Berkeley and Columbia University in New York. Assignments often came several times a week from the *New York Times, Time, Newsweek,* the Associated Press news agency, and the *Milwaukee Journal* newspaper. After covering a story, I would race back to my apartment, develop my film in the bathroom, dry the negatives with a hairdryer, quickly type up captions, and rush film and text to the Greyhound bus station in Madison for delivery

to editors in Milwaukee or Chicago. Pictures completed, I would resume my studies late into the evening. Occasionally my roommate Clyde Bachand complained about the smell of Kodak D-76 film developer in the bathroom. I also covered state government as a part-time legislative reporter for the *Milwaukee Journal*. This required mastering the art of dictating my stories from a pay telephone booth in the Wisconsin State Capitol to a rewrite person at a typewriter in Milwaukee. The payoff came in the form of summer internships at the *Milwaukee Journal*—an important connection that paved the path to *National Geographic*. At the time, the *Milwaukee Journal* was one of the nation's leading photographic newspapers, and Gilka himself was a *Journal* alumnus.

Decades later, that same work-in-progress label became my trademark when I was hired on the tenure-track ladder as a lowly assistant professor at the Indiana University School of Journalism, now the Media School. At age fifty, I was forced to relearn—this time in a theoretical way, often with healthy measures of history and philosophy—much of what I knew about visual journalism, the global news media, media ethics and values, reporting war and terrorism, and the creative process. My early years at Indiana University, as one of the oldest apprentice professors on a campus of more than 40,000 students, were a painful time. I was back in school, both as a teacher and informal student of my own profession, while former *National Geographic* colleagues continued their exciting lives. And I was in Southern Indiana, no less, without a proper bagel shop! During this unsettling time, several veteran professors showed me how to take information from books, journals, and my own personal experiences and turn it into knowledge for our students. Relearning visual journalism, from history and ethics to video and the psychology of seeing, helped me make that leap from working professional to tenured full

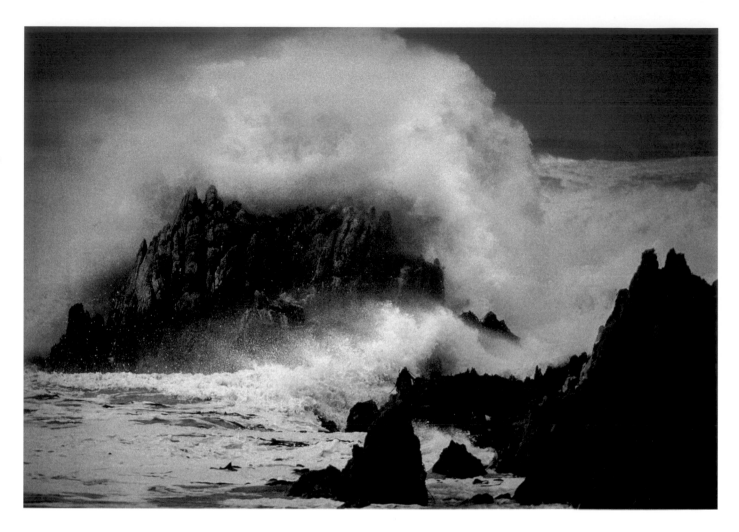

Thundering South Atlantic breakers pound Surf Bay on East Falkland Island. Located about four hundred miles off the coast of Argentina, the Falkland Islands archipelago is home to more than two hundred species of birds, herds of fur and elephant seals, hundreds of thousands of penguins, and the largest black-browed albatross colony in the world.

professor—the highest rank a university can bestow on its faculty.

Most influential was Trevor Brown, my dean at the time, who explained that to gain tenure and promotion, the clearest path was to keep doing what I had mastered as a staff photographer at *National Geographic*—long-form reporting. Brown reasoned that many extended *Geographic* assignments were the size and scope of photographic books. Brown's advice to become an author of photographic books was just the encouragement I needed from a scholar and friend—a person who remains devoted to journalism and the power of the image. And to its

credit, Indiana University has always considered creative work at an international level equivalent to academic research. When I retired in 2016, I had authored and photographed books about Saint Petersburg, Russia; the Muslim world of Southeast Asia; the global Indian diaspora; and Calcutta, the former British capital of India. I had also photographed a big picture book about rediscovering Vietnam—fellow veterans did the text—and learned a new genre of photography to do a Vietnamese cookbook with Washington, DC, chef Diana My Tran.

Like that of my former colleagues and friends in the top ranks of photojournalism, my work is about being a

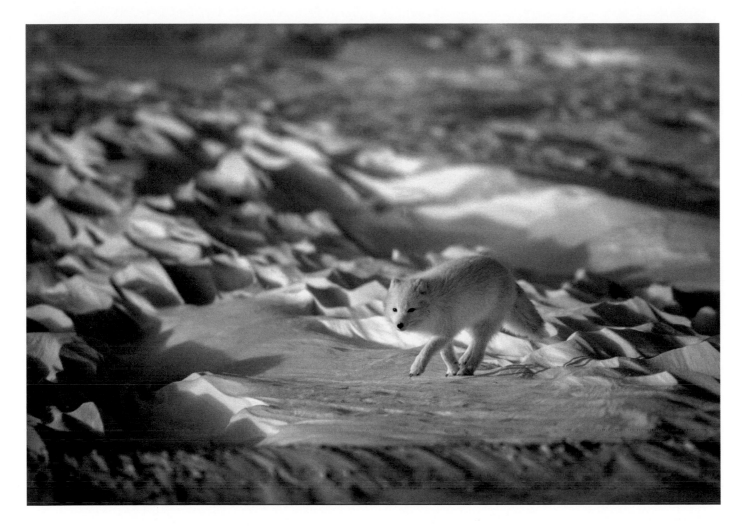

Polar bears on melting sea ice have become an icon of climate change, but the Arctic fox is also perfectly adapted to its Arctic environment—camouflaged against the snow, insulated with a heavy fur coat, and fitted with small ears to reduce heat loss. This charismatic predator is a fearful sight to the small mammals and seabirds that make up its diet.

faithful witness. Textbooks and media scholars say that photojournalism is the coming together of the verbal and the visual. This fusion of words and images doesn't occur on the printed page, television screen, or mobile device, but in the minds of readers and viewers. It's a unity of effect in which words serve as a counterpoint to pictures. In the end photojournalism strives to recreate an authentic experience. My take is slightly different, but I'm a photographer. While most people turn away, photojournalists take an unblinking look at life. We are the closest thing that an open, democratic society has to a professional eyewitness. Photojournalists chronicle achievements and

failures and just about everything in between that is part of the human condition.

Perhaps our most essential function is to bear witness to history. Importantly, photojournalists give testimony in the court of public opinion, making pictures that are accurate, verified, and full of meaning and context. For example, we can go online and find pictures of the survivors of the Nazi concentration camp at Buchenwald, near Weimar, Germany, at the end of the Second World War. We see these human skeletons gazing at their US Army liberators thanks to the tenacity and vision of *LIFE* magazine photographer Margaret Bourke-White. For any person

who would doubt the immensity or horrors of the Holocaust—and there are some—Bourke-White's pictures say, in the words of LIFE.com editor Ben Cosgrove "This is what it was like. This is what happened. . . . This is what we remember." *LIFE's* pictures in April 1945 from Buchenwald, Bergen-Belsen, and other camps were among the first to document for a largely disbelieving public, in America and around the world, the murderous nature of the camps. To this day, Bourke-White's pictures offer that essential visual testimony where words fail. If anyone is looking for a job description of what we visual journalists do, it can be distilled into this: the job of a photojournalist is to give us moments of truth—moments that we, the public, might miss or turn away from.

Photojournalists also are part of another great storytelling tradition—exposing social evils. Since the late nineteenth and early twentieth centuries, photographers and social reformers have used the power of the image to document the poverty of New York City's tenements, widespread child labor abuses, and the issues that occupy the corners of our daily lives today—conflict, drug use, and environmental degradation. Photojournalists owe a debt to Jacob Riis, a pioneering Danish American photographer and New York City newspaper reporter, who in the late nineteenth century turned his camera on joblessness, hunger, homelessness, and perhaps the most difficult of all subjects to photograph—hopelessness. Riis published his book *How the Other Half Lives* in 1890 and it is still considered a landmark in social reform.

As a *National Geographic* photographer, my work was also influenced by Lewis Hine, who documented the shame of child labor from the textile mills of New York to the mines of West Virginia during the early years of the twentieth century. From 1908 to 1924, Hine traveled widely over the eastern half of the United States, taking thousands of photos of children working long hours at

dangerous jobs: breaker boys in the mines of Pennsylvania, who risked life and limb separating impurities from coal in the mines, and children working in cotton mills in Georgia and Alabama. Hine worked undercover, since most mine owners and mill operators didn't want him, or anyone else, photographing children at work. According to historians, sometimes Hine would say he was a fire inspector or a salesman, at other times he would introduce himself as a curious photographer who merely wanted to shoot mining or textile mill machinery. In the end, Hine's work for the private National Child Labor Committee— part of the Progressive movement in American politics— was instrumental in persuading Congress to enact the Keating-Owens Child Labor Act in 1916 that regulated child labor, if not outlawing it all together. Hine's pictures also figured into congressional passage of the Fair Labor Standards Act of 1938 that said children under sixteen could not work at most jobs.

Finally, we photojournalists are part of a third great photographic tradition—showing viewers our common humanity, our relationships to one another, our connection to the family of humankind. One of the masters of this genre of photography was a wistful Frenchman named Henri Cartier-Bresson, and over the years, I became a disciple of his theory of the decisive moment. Stated briefly, Cartier-Bresson believed there are magical split-seconds in which events in the world—the result of a fortuitous interplay between people, movement, light, and form— combine in perfect visual harmony. Once these moments pass, they are gone forever. For Cartier-Bresson, whose books are piled high in my study, the photographer must be inconspicuous, nimble, and attentive. Rather than manipulating what he or she sees through the viewfinder, the photographer must work by instinct and respond instantly to reality. "The hallmark of Cartier-Bresson's genius," said *The New Yorker's* Peter Schjeldahl in an essay

titled "Picture Perfect," was "less in what he photographed than in where he placed himself to photograph it, incorporating peculiarly eloquent backgrounds and surroundings. His shutter-click climaxes an artful scurry for the perfect point of view." My wife Barbara can attest to my quest for perfection in finding that telling moment. Like a hunter, this requires a mix of intuition, anticipation, patience, and a willingness to stalk your photographic prey.

If my work has any lasting meaning, I hope it will be understood as part of these three great traditions in photojournalism.

Those early years at Indiana University also saw a digital revolution that forever changed how we take and display photographs. More important, a globalized world, made possible by the internet and aided by myriad programs and "apps," changed the very nature of journalism from mass media to individualized experience, with circulating photographs made by amateurs—bystanders to tragedy, folly, and all forms of human accomplishment and failure. In the twenty-first century, says Holland Cutter in his June 23, 2016, *New York Times* piece "Photography's Shifting Identity in an Insta-World," the world is awash "in images, infinite in number, flowing in real-time data streams and captured on [mobile phones,] webcams, video blogs, Twitter, and Instagram. This institutional shift in emphasis from hard objects (framed still photographs) to the broad field of visual culture will make old-style connoisseurs crazy."

Perhaps. As a photojournalist, I have embraced a succession of computerized and ever-more-complex Nikon digital cameras. I do not pine for the world of color slide films and cameras made of brass and precision gears. Throughout my *National Geographic* career, I embarked on each assignment with hundreds of rolls of Kodak and Fuji film, four or five Nikon camera bodies, and a dozen or more lenses. Like an astronaut embarking on a space

probe, I built multiple redundancies into my kit, anticipating two or three cameras would break down from rugged use, tropical fungi, or Arctic cold. And why so much film? One brand needed a lot of light but rendered the world in superb detail, another emulsion was biased toward red, another to magenta, while a fourth was low in contrast for photographing scenes with bright billowing clouds, blue skies, white-sand beaches, and darker-skinned people.

With a new millennium came a digital era that today allows photographers to dial these variables—sensitivity to light and color rendition—into a single highly reliable camera made of magnesium alloy and sealed against the weather to survive any situation. Within a decade, Nikon and Canon had cameras that could be thrown around at the side of a sports field, taken deep into a rain forest, or knocked about in a war zone—or perhaps even used to stop the odd bullet. The newest digital cameras also tame the shadows, whether I am shooting a portrait of a Hindu holy man in a candlelit Calcutta temple or a high school football game on a cold moonlit October night. With the latest generation of cameras, we photojournalists now have near–night vision capability that goes well beyond the range of the human eye.

The digital world has also taken many of us back to the magic of the darkroom, albeit now at our Apple computers. Tools like Adobe Photoshop and Lightroom allow photographers to create, or "image," digital picture files of ones and zeroes into pictures on the screen—or to print pictures on the finest of photo papers as we once did in the darkroom. This technology has allowed photographers to adjust the range and intensity of tones from white to black and all the grays in between, as well as increase the fidelity of color to more accurately reflect what we see through the viewfinder. Moreover, in this new digital darkroom, we can assiduously work on the smallest part

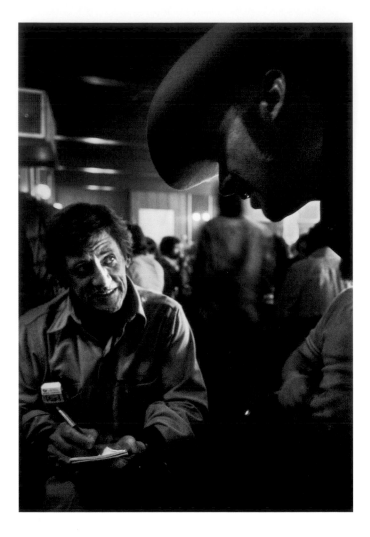

Friend, fellow traveler, and *National Geographic* writer Bryan Hodgson interviews an oil worker in Valdez, Alaska— scene of a massive 1989 oil spill. Together Hodgson and the author documented the troubled construction of the Alaska oil pipeline, as well as stories in the Falkland Islands, India, Thailand, and Great Britain.

of a picture—the eyes in a face or the intensity of a spot of color—to make an aesthetically pleasing image and a picture that is clear and easy to read or understand for the viewer.

This quest for some artistic refinement would become a hallmark of my images, though not without controversy. Over the years, I have been criticized for beautifying what many readers and viewers find obscene—war, famine, and poverty. For example, I photographed the 1974 famine in Bangladesh, in which some 1.5 million people died, in color instead of in high-impact black and white. I heard

a tape recording of contest judges at the National Press Photographers Association Pictures of the Year competition where some wrestled with what they saw as my inappropriate "beautification" of a humanitarian disaster. Several internationally known editors believed that tragedy could, or should, be rendered only in black and white, not the eye-popping color associated with *National Geographic*. Still, I won. In 1975, I was named Magazine Photographer of the Year for my reporting—in color—of global hunger.

Today I continue to look for aesthetic elements in emotionally charged or hostile situations. Why? Because I want to make even the most difficult pictures accessible, approachable, and amenable to readers and viewers—people who are bombarded with thousands of images daily. Images that draw readers into a story rather than repulse them have a better chance of catching their attention—of getting them to stop, look, and say, "I understand." And the research seems to support me. Media scholars say that images that cause emotions of fear and anger, or show us things we are not supposed to see, are more likely to cause us to tune-out. This is part of a modern-day phenomenon called "compassion fatigue," a result of the media bombarding us with decontextualized images of war, famine, disease, and violence in ever-smaller bites that chisel away at our capacity to understand, to care, and to empathize with our fellow human beings.

Brazilian-born documentary photographer Sebastião Salgado's work has also been criticized for emphasizing aesthetics in his arresting images of difficult subjects. In "Good Intentions," a 1991 review of Salgado's work for the *New Yorker*, art columnist Ingrid Sischy argues that "finding the 'grace' and 'beauty' in the twisted forms of [Salgado's] anguished subjects . . . results in pictures that ultimately reinforce our passivity toward the [horrific] experience they reveal. To aestheticize is the fastest way

to anesthetize the feelings of those who are witnessing it. Beauty is a call to admiration, not to action." The late writer and public intellectual Susan Sontag explored and acknowledged the dual powers of photojournalism—to both generate a document and create visual art—in her book *Regarding the Pain of Others*. Today, says Sontag, the puritans seem to have won, insisting that "a beautiful photograph drains attention from the sobering subject [matter]" of journalism and compromises a "picture's status as a document."

As the pictures in this book will attest, I try to find what is redeeming in my photography. I side with humanity over gore and starkness that simply shock the reader. Often it is a simple human gesture—like the hand of a nurse caring for a so-called Agent Orange baby in Vietnam—that can be understood across cultures and languages and draw readers into the harshest situation. At other times, it may be the sharp interplay of shadow and light on political prisoners in a Salvadoran jail that can help readers understand the desperation of the moment. Or it may be the juxtaposition of lines, shapes, forms, and patterns that helps readers see a familiar subject in a new way.

I take solace in the fact we still have editors whose job is to mediate what writers, photographers, designers, and webmasters produce. Editors are required to simultaneously consider the social good, the truthfulness, and, yes, the beauty of an image under deadline pressure. I tell students that rational human beings will differ on the aesthetic merits of any image. The mushroom cloud of the nuclear bomb is a good example—much of humanity finds it revolting or threatening, but a picture of a post–World War II atomic test on a Pacific atoll sold at Christie's in New York for $13,750 some years ago. One of the ethics textbooks I use in class states that agreeing on beauty is one of the most difficult issues in all of philosophy. In

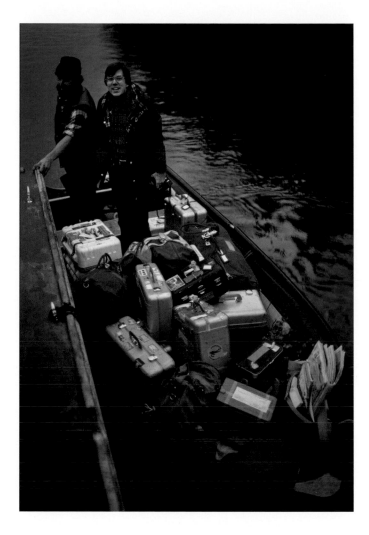

With wilderness guide Mike McBride (*left*), the author sets off for Kachemak Bay on Cook Inlet near Homer, Alaska. In this predigital era, *National Geographic* photographers routinely carried hundreds of rolls of color slide film, multiple camera bodies and lenses, and, in this instance, scuba diving gear for Raymer and colleague David Doubilet.

the end, philosophers and media critics seem to be more successful in defining standards for truth and social good than in deciding if an aesthetically appealing image can be effective journalism. I think it can. Art, meanwhile, remains in the province of the art critics and the eye of the beholder, not the photographer.

Our leap into digital technology has brought a new array of ethical challenges, especially surrounding the ability for photographers to seamlessly manipulate their pictures in undetectable ways. For me, there is a great deal of wisdom in an aphorism credited to my former *National*

Geographic colleague Sam Abell: "Photography is truth; Photoshop is perfection."

Photojournalism has always had its liars: photographers who staged their pictures or added and subtracted content after a picture was taken. Setting up picture situations—in effect creating moments that never happened—is easy to understand as dishonesty. In photojournalism, this would be analogous to reporters inventing facts or quotations. And today this is generally a firing offense at major newspapers, magazines, and international news agencies.

Moreover, before there were computers and Adobe Photoshop, there were newspaper and magazine art departments that airbrushed away unwanted content, something I witnessed as a young intern at the *Milwaukee Journal* newspaper. Historically, Soviet leader Joseph Stalin and his propagandists were masters of the airbrush technique, famously erasing Leon Trotsky from all official photographs after he ran afoul of the Communist Party leadership. In recent years, Russian president Vladimir Putin's government has mastered more sophisticated photographic techniques to influence world opinion. On July 15, 2016, Andrew E. Kramer of the *New York Times* reported that arms control researchers had confirmed that satellite images released by the Kremlin after Malaysia Airlines Flight 17 was shot down over embattled Eastern Ukraine were digitally altered. These findings were compatible with a propaganda campaign to absolve Russian-backed separatists from the July 17, 2014, downing of the jumbo jet in which all 298 people on board were killed—the worst atrocity of the ongoing war in Ukraine.

Some years ago, *National Geographic* squeezed the Great Pyramids of Giza together to better fit the magazine's vertical format. *Time* magazine digitally altered a police mug shot of O. J. Simpson that appeared on its June 1994 cover after Simpson's arrest on murder charges.

Patrons of newsstands were quick to spot the fakery after *Time*'s competitor *Newsweek* published an unaltered mugshot on its cover. *Time* editors said they wanted to make Simpson appear "darker" and more "menacing," words I have challenged some white students to define when they have carelessly tossed them around in front of African-American classmates. Someone on trial for his life should have enough impact for any reader, viewer, or internet clicker without introducing a racial slur into the mix.

Following an egregious incident some years ago, the National Press Photographers Association asked me to address the issue of altering images, this time by a former colleague with a worldwide reputation. I have been on the NPPA ethics committee and have taught media ethics and values for some two decades at Indiana University. During that time, digital technology has increasingly propelled photojournalists to cross the line between journalistic images that are spontaneous, honest, and visually truthful and fine art photography. In photojournalism, we generally allow manipulations to adjust tonality and the intensity of colors—something we call saturation—and to make certain vital areas of a picture, usually the shadows, more readable to the viewer. Since the time of the darkroom, photojournalists and editors have agreed on these visual editorial standards. But as I discuss in my NPPA column, problems arise when photographers fail to make clear to the public—book buyers or gallery audiences—that their work has moved into a world where aesthetic considerations take precedence over accuracy of representation. In some cases, this would involve the photographer disclosing that their journalistic work has been altered and is no longer a literal rendering of reality. In other cases, the journalist might emphasize that they are exploring an entirely new photographic genre, with different cameras, formats, or

ways of seeing the world. Transparency is the key to avoiding deception.

But putting theory into practice is not always clear-cut. I have struggled with creating images for sale as exhibition prints and how to ensure that gallery-goers understand my aesthetic motivation for an alteration—to create a work of beauty that goes beyond the strict limitations of journalism. Some years ago, for a retrospective exhibition, I OK'd a *National Geographic* darkroom technician removing a prominent telephone wire from a winter scene of Saint Petersburg, Russia, in a picture that had been published double-page in the *Geographic* with the wire clearly visible. The image appears on the title page of this book with the wire removed. I wrote in the exhibition catalogue that several images were digitally altered to enhance their aesthetic appeal. Yet by today's standards this seems insufficient. Altering a work of photojournalism intended to portray a universally understood moment, or to inform some segment of society, or to expose a social evil, or to document something for history, now seems difficult to justify without greater transparency. Perhaps the answer lies in creating a new context for a photographer's work that emphatically calls digitally altered images "The Art of . . ." Whatever else the digital revolution has brought our profession, I have found myself spending increasing hours thinking, teaching, and writing about photojournalism ethics, sometimes to the chagrin of respected professionals whom I have had to take to task.

During those dark days and nights at Prudhoe Bay, and at camps and lodges up and down the Trans-Alaska Pipeline, I had many opportunities to reflect on another dilemma: What does it mean to be a creative person behind the head-turning moniker "*National Geographic* photographer"? It turns out that it is difficult for creative people to completely know themselves. As creativity researcher Scott Barry Kaufman told the Huffington Post's

Carolyn Gregoire, "Our creative self is more complex than the non-creative self. Imaginative people have messier minds." At our core, we photographers who roam the globe are professional outsiders, entering and exiting the lives of others for long hours, or days, or sometime weeks on end. And then we are gone—off to another assignment, another set of strangers with whom we seek to empathize, understand, and find some level of intimacy that will take readers and viewers to places they cannot go for themselves. This is an unsettling job description at best.

But to be open to our potential and listen to our thoughts, creative people need time alone. Or, in the case of our ill-fated trip to Lonely, Alaska, and back, the enforced solitude of being snowed in on the Arctic Ocean coast in the middle of winter. Over the years, I have spent days alone in a five-star hotel in Bali, awaiting a visa to travel to embattled East Timor—then occupied at gunpoint by the Indonesian Army. I have also waited in the former Manama Hilton Hotel and the souks of Bahrain for a delayed commercial flight to isolated Yemen, and paced the corridors and coffee shops of the international press center in Dhahran, Saudi Arabia, waiting for permission to join US forces in the Persian Gulf War of 1990–91.

Quiet and solitude allow the creative mind to focus. We can take time to think, to take stock, and, importantly, to reflect on the meaning of what we are seeing and learning in the moment—one of the greatest challenges for journalists in our 24-7 news environment. Moreover, today journalists must turn mountains of information that is available on the internet, in libraries, and in government and private sector databanks into knowledge that the public can understand and use to make good decisions. Or at least that is the theory in what is today a deeply divided world.

Gone are the days when we could report a story at the deliberate, leisurely pace that characterized magazine

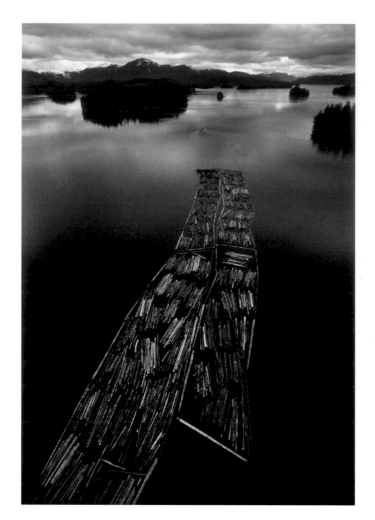

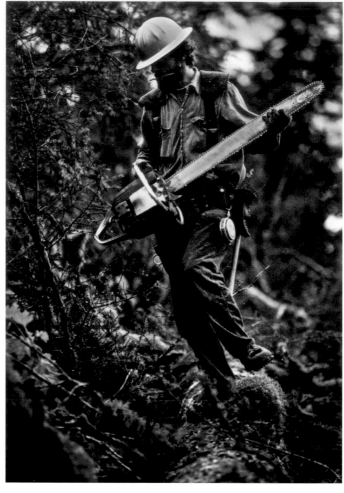

Timber harvested in Alaska's Tongass National Forest—which includes the largest intact temperate rainforest in the world—is towed to a saw mill. Mining Alaska's green gold, a timber cutter trims a freshly fallen spruce on Afognak Island, westernmost of the Gulf of Alaska's timber stands.

journalists, documentary film producers, and others who specialized in long-form narrative journalism. There was a time when we journalists could talk over a story at Duke Zeibert's or the Bombay Club near the White House, or in the bar of the American Colony Hotel in Jerusalem, the Europa in Belfast, the Hotel Intercontinental in Kabul, or—my all-time favorite—the Continental in Saigon, capital of the former South Vietnam. The Continental's terrace was known as "the Continental shelf" and was the center of news and gossip for several generations of diplomats, spies, and journalists, including Graham Greene and Walter Cronkite. Today we can read and see in real

time what our competition and others are reporting and broadcasting. All we need is a smartphone connected to the internet or, perhaps, in the most remote parts of the world, a satellite telephone tethered to our laptop computer.

One of the great job satisfactions at *National Geographic* was to get lost in a story, to go "off the grid," to ferret out words and images for days on end without editors knowing our whereabouts. With *Time* magazine photographer Roland Neveu, I once tramped through the Golden Triangle, where Thailand, Laos, and Burma (now called Myanmar) meet along the Mekong River. For

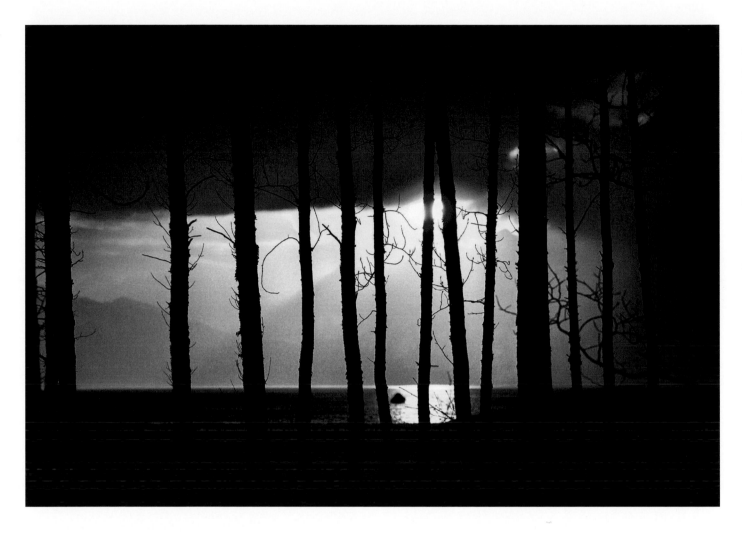

In the salmon-rich Copper River Valley, the sun rises behind 14,000-foot-high Mount Wrangell in the Wrangell-Saint Elias National Park and Preserve, a vast wilderness the same size as Yellowstone National Park, Yosemite National Park, and the country of Switzerland—combined.

a week or more, we saw the Yao, Hmong, Akha, Lahu, and Lisu ethnic hill tribes growing rice to eat and opium for medicine and money to buy jewelry, silver bars, rifles, radios, and pigs. In Burma, we met the Wa, a group of former headhunters, who now control some of the major opium growing areas in Myanmar. In the former Soviet Union, being out of touch was enforced by the communist government as well as a lack of infrastructure, especially in Siberia, where there simply was no telephone or telegraph service to the United States. But today the marriage of computers and satellites means that we are always at the beck and call of editors for near-instant pictures, videos,

and social media postings—and with less and less time to make sense of what it all means.

For introverts like my friend Hodgson, who died in 2015, solitude was never a problem. Happy loners like him are said to do better in silence, running over ideas in their heads, working things out on paper, and thinking through stories. Psychologists say introverts are better planners; they can see the ups and downs of ideas, and, being detail-oriented, often spot mistakes before they ever happen.

But for a competitive extrovert like me, one who hauled a succession of Sony shortwave radios around the

world for more than thirty years to be better in touch with the news, loneliness can be a demon. Some days all I have wanted was news of family, American politics, or office gossip. Psychologists who study creativity say that coming up with imaginative ideas requires both solitude and collaboration with our colleagues and friends. Yes, some exceptional creativity may require solitude bordering on isolation to find a new way of looking at a problem. But breakthrough ideas are more often the result of exchanging information and interacting with others. Why? Because innovation frequently emerges from different mindsets and personalities looking at the same problem or idea.

On the surface, Hodgson and I were an unlikely team. More than one *National Geographic* colleague asked where the chemistry was that would allow a thoughtful loner like Hodgson and an audacious extrovert like me to work together so well. Yet over the years, we took on assignments together in India, England, and the Falkland Islands in the far South Atlantic, where Great Britain and Argentina fought a war in 1982. Over drinks in the Donovan Bar, an elegant, wood-paneled watering hole in Brown's Hotel off Piccadilly, or in the company of *Dalits* (formerly called untouchables) breaking rocks in a quarry outside Delhi, Hodgson and I clicked. We fed off each other's insights, experiences, and shared passion for telling untold stories through the voices of people who do not normally make the news. Or, as I am constantly urging students to do, giving voice to the voiceless. In the end, Hodgson and I, despite our personality differences, both believed in stories that no other magazine had or cared about.

In trying to understand my own creative urges—I have often wondered how original or profound they really are—I came across the work of British psychologist Lorenzo Stafford of the University of Portsmouth. He has discovered that extroverts in a good mood can be some of the world's most creative thinkers because they have

more of the "happiness chemical" dopamine. And having more dopamine in your system helps you stay alert and remain focused, doing the heavy lifting and grunt work that goes along with fantastic, or at least original, ideas. Yet the reality is sometimes different.

On assignments in more than one hundred countries, I have discovered that feeling lonely can sometimes turn to isolation—a bad thing. There is a growing body of evidence that being socially isolated is associated with greater risk of health issues, from mood disorders like depression to stress-related chronic conditions like heart disease. Unlike traditional foreign correspondents for, say, the *New York Times* or CBS News—journalists who would live in one city or region for three or four years—I would often "parachute" into a country or hotspot for a few weeks or months and then be gone. Making friends quickly became a key to staying healthy and on an even keel. My exhaustive research usually dealt with the story—the issues, ideas, and people that I was trying to convey with my photographs—and not the unfamiliar cultures with perplexing languages and customs that I was about to encounter.

For example, I walked off the first-class section of an Air France Boeing 747 one evening in Djibouti in the Horn of Africa to be greeted by a French Army colonel of the Foreign Legion. He wore a peculiar round hat with a flat top, called a kepi, and a flap of fabric protecting his neck and sported an unnerving black eye patch—the result of a combat wound elsewhere in Africa, the colonel said. Introductions were made in rapid-fire French and we were off to an Ethiopian restaurant, where the Foreign Legion officers were regulars or *habitués*. We ate with our hands, drank liters of Kronenbourg beer, and exchanged war stories—all before I had checked into my hotel, unpacked, and called home. The following morning, I was given the standard *tunic du combat* in desert-sand camouflage and

we were off in a flotilla of helicopters for a week in the arid borderlands where Ethiopia, Somalia, and Djibouti meet. In twenty-four hours, I had gone from the rain-soaked streets of Paris, perhaps my favorite city, to being part of a combat unit looking for terrorists and migrants in one of the most unforgiving parts of Africa. And not a word of English was spoken. It was lucky for me that *National Geographic* had subsidized French classes for me over the years and that I understand the culture of the military.

Still, creative people observe—everything. Writers, photographers, and painters all keep notebooks, sketchbooks, and snapshots—today perhaps on an Apple iPhone. And they see acutely. We photographers often see what others do not see. Creative people have the ability, as Gestalt psychologists would say, to break up the whole and see its parts, though we human beings are hardwired to see the whole and skip the components. But it is that ability to pinpoint something telling or meaningful amid the larger panorama of life—to find those evocative details—that gives authority to our work, be it newspaper stories, works of fiction and nonfiction, or photographs.

"The facts we have in abundance," said Joe Judge, the late *National Geographic* senior assistant editor in charge of the editorial staff, as I struggled to write my first story for the magazine about the 1974 famine in Bangladesh in which more than a 1.5 million people died. And by this, of course, he meant we have databases, experts, talking heads, libraries, universities, and statistics from every imaginable organization from the World Bank to the CIA and its authoritative *World Fact Book*. "But what only you can do," he continued, "is tell the reader what it smelled like. How people looked in their tattered tunics. Were famine victims stoic or anguished? What did

the relief food taste like? And was there enough?" That's called seeing.

Moreover, we photojournalists must constantly turn life's obstacles to our advantage. We are resilient. We must adapt to adversity, trauma, tragedy, threats, and stress—and still get the job done. Resilience is a prerequisite for any creative success.

In late summer of 1984, I found myself at the epicenter of a terrorist bombing in the airport in Kabul, Afghanistan. One minute I was waiting for my luggage on the baggage-claim conveyor belt, the next second I was flat on my back from the concussive effect of the blast, splattered with the blood of a fellow passenger whose arm was severed by flying glass. I used my belt as a tourniquet for the man with the severed arm, and those of us who were uninjured helped get the wounded outside the terminal. At the end of the day I checked into my hotel with only my camera bag, briefcase, and ten rolls of film, wearing bloody khakis and a bloodier blue blazer.

But as I learned in the army, you continue the mission. *National Geographic* writer Mike Edwards helped me buy clothes in the Kabul market—he had earlier served in the Peace Corps in Afghanistan—and a trip to the American embassy yielded an offer to send me film from the US embassy store in neighboring New Delhi via the diplomatic pouch. I was back in business in a day or two, which isn't to say the bombing was wiped from my consciousness or subconsciousness. I needed help for a year with insomnia, intrusive thoughts of the bombing, and hypervigilance—all symptoms of post-traumatic stress disorder or PTSD. But I got the pictures in Kabul, then a central Asian crossroads under Soviet military occupation.

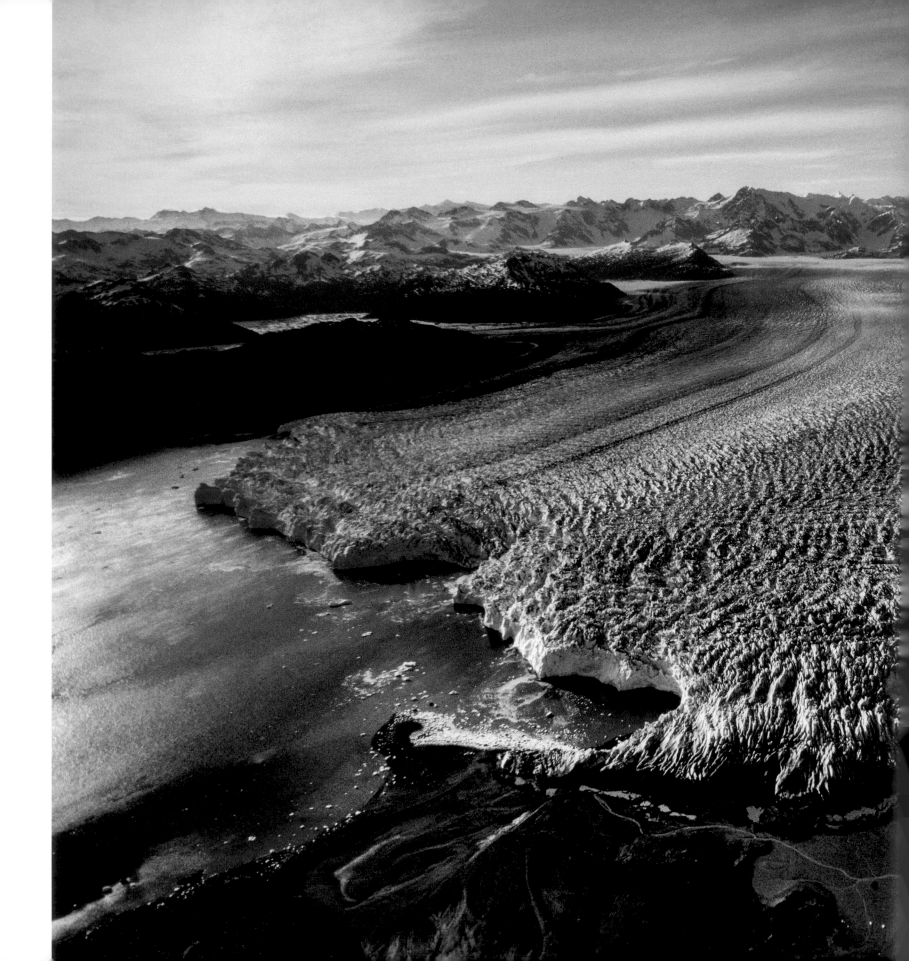

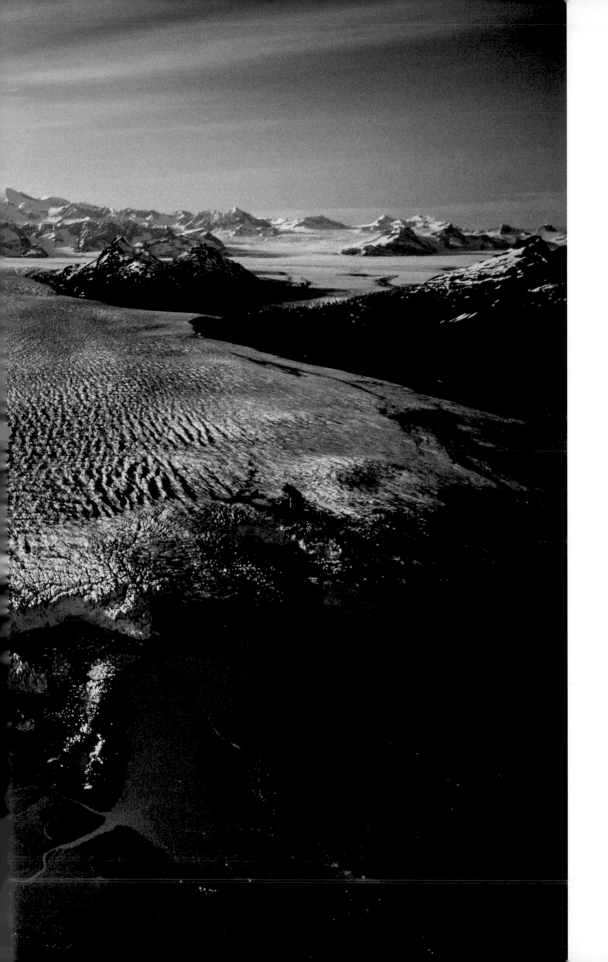

One of the fastest moving glaciers in the world,
the Columbia Glacier on the Gulf of Alaska has
retreated to its lowest point in nine hundred years as
a consequence of global warming. Calving icebergs
from the glacier's 300-foot-high cliffs continue to
threaten oil tankers navigating Prince William Sound.

Steller sea lions pursue a school of herring in Prince
William Sound near the rapidly receding Columbia Glacier.
Scientists studying the sea lion population across the Gulf
of Alaska and Bering Sea suggest that global warming
has dramatically reduced the numbers of small oily fish
that are a staple of the sea lions' diet, in turn reducing
the sea lion population across western Alaska.

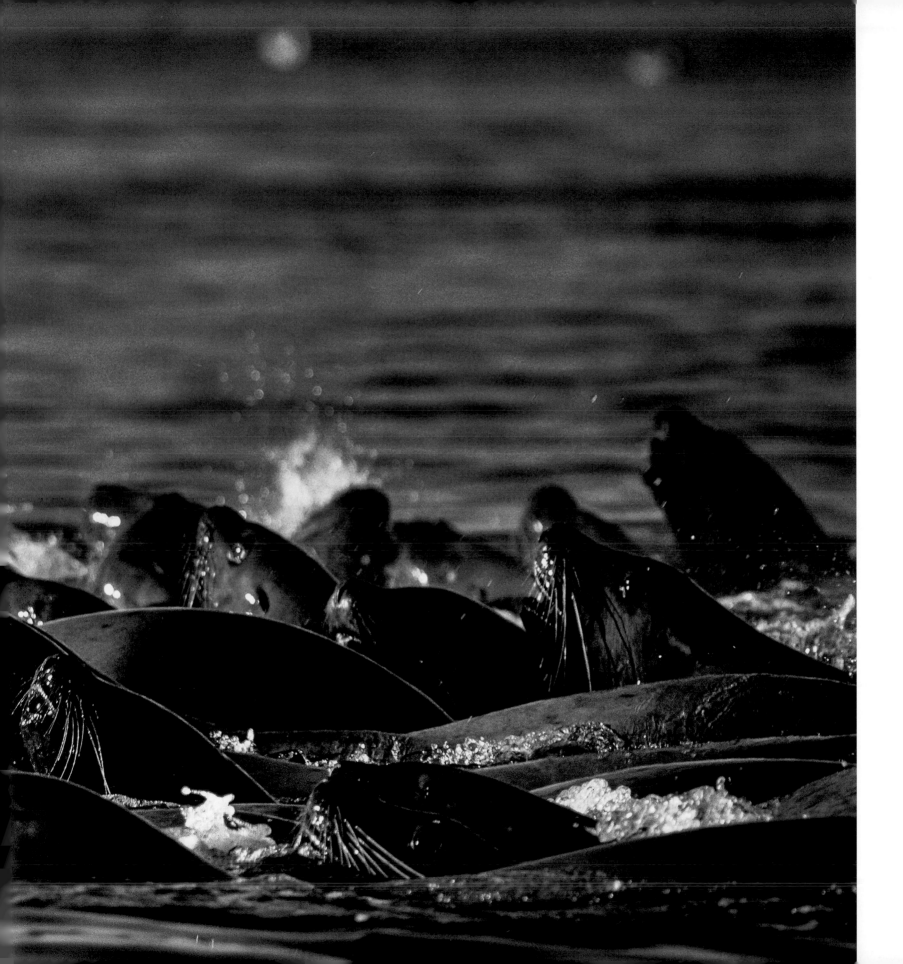

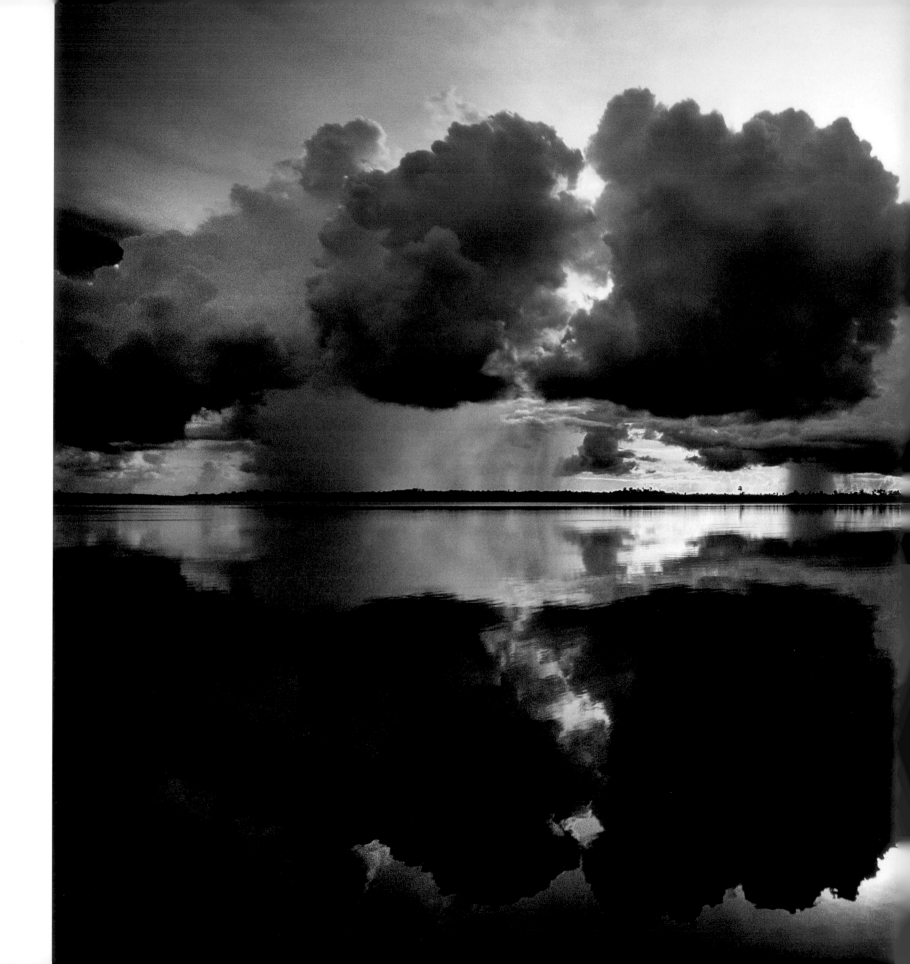

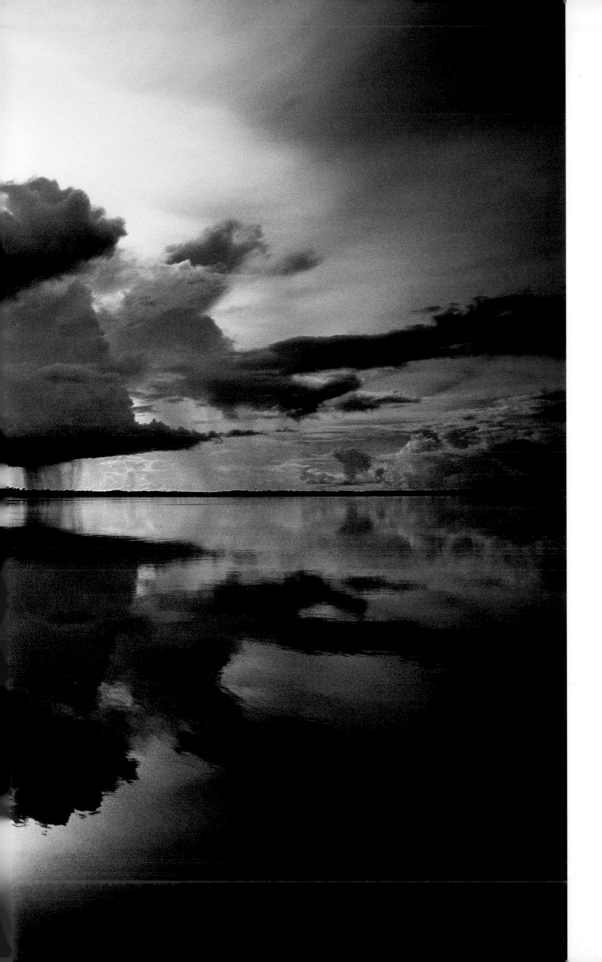

Menacing cumulus clouds are mirrored in the placid
waters of Lake Murray, the largest lake in Papua New
Guinea, covering an area of some seven hundred
square miles. About five thousand indigenous
communites inhabit this lake region. In 1923, the
New York Times reported on an Australian expedition
that used amphibious airplanes to chart Lake Murray
and the explorers' close encounters with indigenous
people called, at the time, "head-hunters."

21

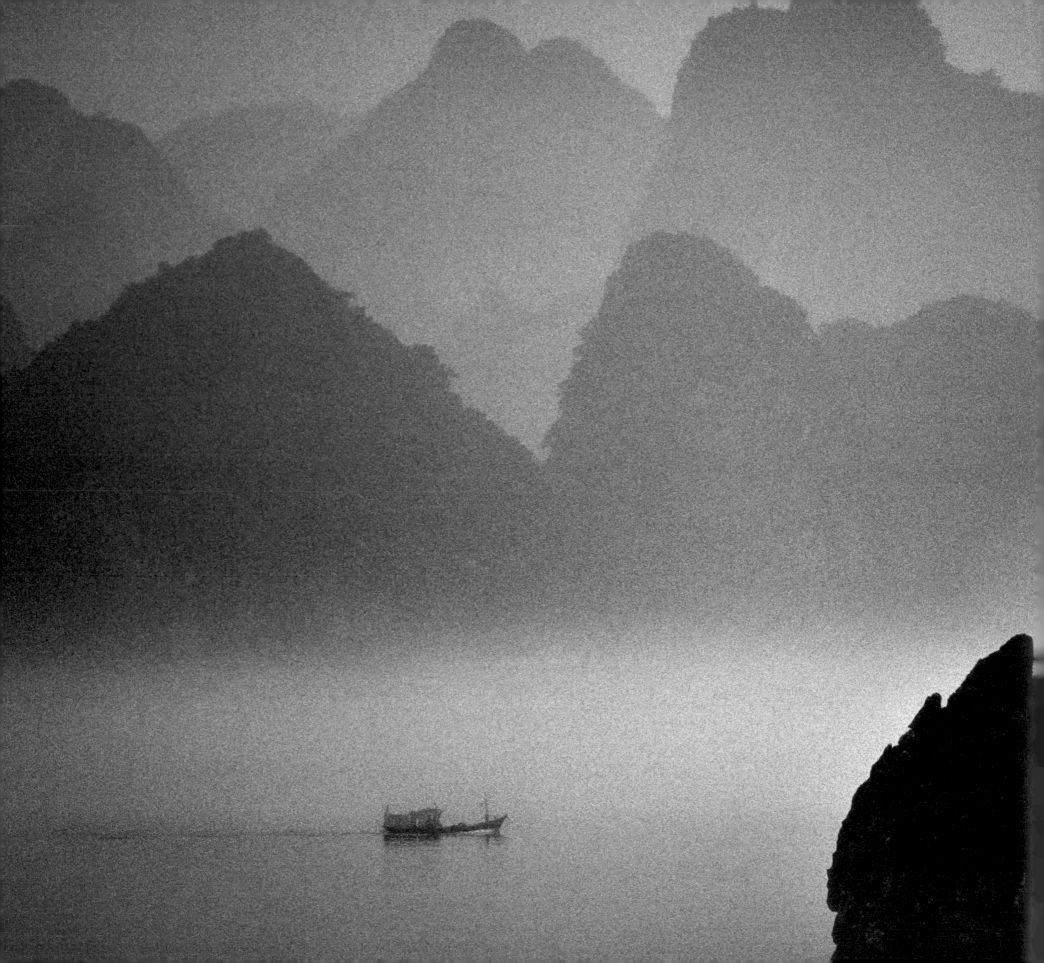

CHAPTER TWO

THE TUG OF ASIA

First I was a soldier, then a journalist, finally a professor. But always my heart seems to have been in Southeast Asia. I tell students that often our first post-collegiate experiences shape our adult lives, and they have mine. As a twenty-two-year-old army lieutenant and public affairs officer, I saw what we called "The Big Green Machine" pulverize South Vietnam and neighboring Cambodia but still not win a war against an army of determined peasants. After graduate school I was sent to Thailand, Cambodia, and Vietnam as a *National Geographic* staff photographer to witness the sad unraveling of what was, at the time, America's longest war. As a professor, I have returned to Southeast Asia many times to document a region transformed by

On the tranquil waters of Vietnam's Gulf of Tonkin, a sampan glides through Halong Bay, where limestone cliffs and rocky outcroppings covered in tropical hardwoods disappear into the fog. A UNESCO World Heritage site, Halong Bay today is overwhelmed with tourists arriving in buses, sailboats, and cruise ships.

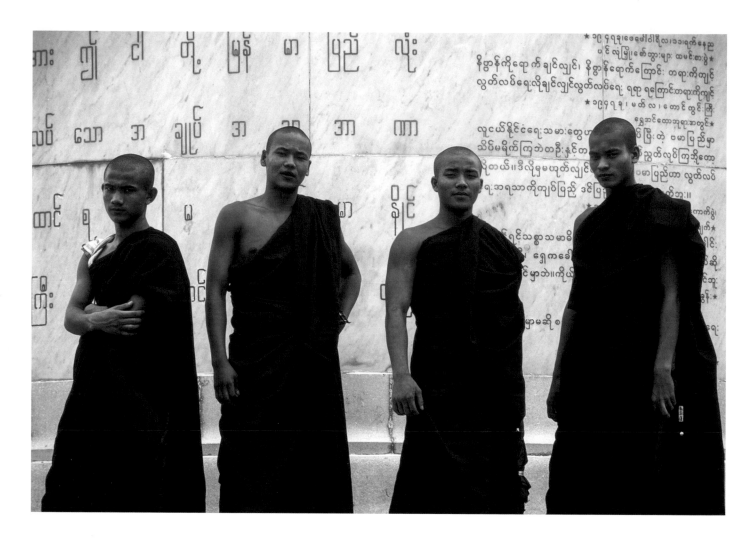

Becoming a monk is a rite of passage in Myanmar, where there are a half million Buddhist monks, novices, and nuns in a nation of 53 million people. About 90 percent of Myanmar's population is Theravada Buddhist, the rest being Christians, Hindus, or Muslims, many of whom have been persecuted in recent years.

globalization, climate change, habitat destruction, and an explosion in trade and tourism. I also have had the privilege of teaching a new generation of Vietnamese, born after the last American soldiers and airmen left the war zone in 1975.

On August 9, 1974, the day Richard M. Nixon resigned the US presidency in disgrace, I was accompanying an American relief shipment to a refugee camp in Kampong Speu—about thirty miles southwest of the Cambodian capital of Phnom Penh—when the communist Khmer Rouge rocketed the Buddhist temple where the goods were being distributed. I was there to take photographs as

California-grown rice, red and white sarongs, and bars of soap were being handed out to refugees. They were innocents—peasants caught in the middle of fighting between the US-backed government of General Lon Nol and the Khmer Rouge. Among correspondents in Phnom Penh and diplomats in Washington, DC, the Cambodian conflict was cynically described as a "sideshow" to Vietnam, although the Strategic Air Command bombers dropped 2.7 million tons of explosives on Cambodia between 1965 and 1973—more than the Allies dropped in all of World War II. But on this day, the conflicts in Southeast Asia became personal. When the shelling died down, I found

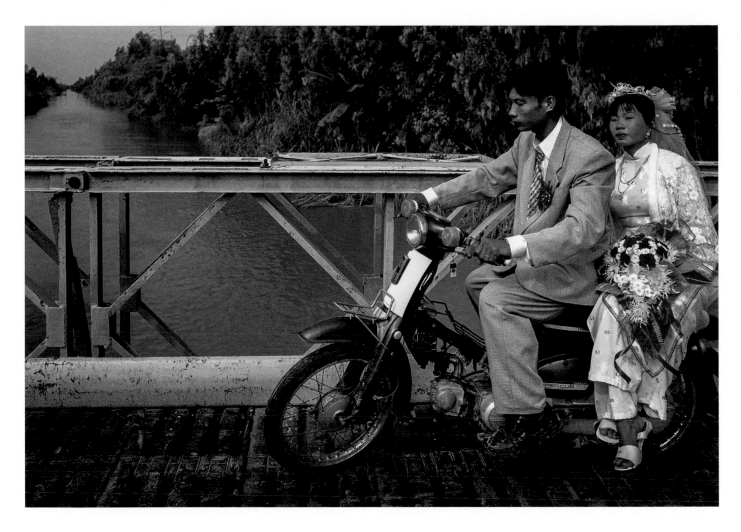

A newly married couple rumbles over one of the hundreds of canals that crisscross the Mekong Delta of Vietnam. Called the "rice bowl of Asia," the delta usually produces some 15 percent of the world's rice, but shifting rainfall patterns and rising salinity threaten not only rice crops, but fruit, fish, and shrimp harvests.

myself curled in a ball on the ground with a piece of blistering hot shrapnel in my lower back and blood oozing through my jeans.

Luckily for me, I was the "f—king new guy," or FNG in military slang, in Phnom Penh to document how the Khmer Rouge guerrillas were starving a Southeast Asian capital to death. That morning I had accompanied other journalists to the United States embassy press office to learn more details about Nixon's pending resignation. In passing, a diplomat warned me that I was taking a risk accompanying the delivery of American food by an NGO. He called my destination "Indian country"—derogatory

slang for a dangerous Southeast Asian locale. But at least the Americans knew my whereabouts.

Afraid to move me, aid workers reported my injuries to the embassy and several US military attachés arrived in Jeeps bristling with antennae to assess my injuries. I could hear one of the blue jean–clad men calling for a helicopter to take me to a Cambodian army hospital, where doctors stopped the bleeding. Eventually I was taken to Phnom Penh International Airport and put on a plane to the 11th US Air Force hospital at U-Tapao Royal Thai Navy Airfield, where the Americans had a base. In a matter of hours, I was stitched up and safe.

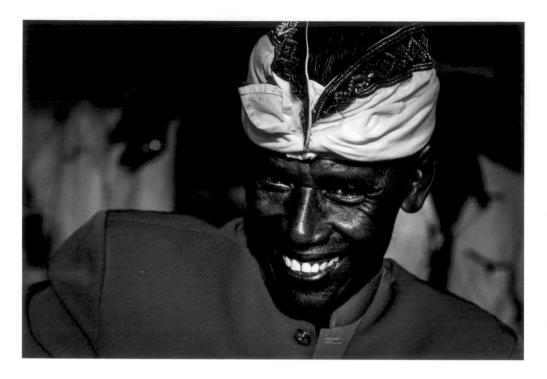

Clad in a traditional white Balinese headband called the *udheng* to symbolize purity, a Balinese elder celebrates the anniversary of the Batuan Temple near Ubud. The eleventh-century Hindu temple is a landmark in its namesake village of Batuan and in the region, best known for traditional Balinese arts and paintings.

the day I was hit and evacuated from Kampong Speu. But in gratitude to those anonymous foreign service officers and military attachés, I have made a point throughout my career of checking in with local American embassies or consulates and offering to do a press club talk or university lecture. It is a small way of making payments on a debt that can never be settled.

That bombing was the first time I was seriously hurt on assignment for *National Geographic*, but it would not be the last. Over the years I developed something of a reputation for misadventures that garnered chuckles at *Geographic*'s headquarters on Seventeenth Street NW in Washington, DC—broken bones, parasitic infections, animal bites, a diagnosis of trichinosis from eating wild black bear meat with Native Americans, Legionnaire's Disease at the Mount Saint Helens volcano site in Washington State, a life-threatening bout with typhoid fever contracted in Africa, and a severe allergic reaction in Vietnam that triggered the onset of the asthma that I live with to this day.

I never did check out of the Hotel Le Phnom, now the five-star Raffles Hotel Le Royal in Phnom Penh. In 1974, the hotel was a fading French colonial landmark and the unofficial headquarters of the international media. Every day journalists and their drivers—mine were two ethnic Chinese guys with an aging white Mercedes Benz—left the Hotel Le Phnom for the field to report on Cambodia's downward spiral from a peaceful oasis in Indochina to the homicidal takeover by the Khmer Rouge in 1975. In the evening, journalists, spies, and aid workers would dine by the pool at Le Phnom to the sound of distant artillery explosions. One night while I was drinking with several journalists, Khmer Rouge rockets struck a nearby hospital. I recall sending a telegram to *National Geographic* that the situation in Phnom Penh was "dicey," but the "hotel was well sandbagged."

I have no idea whom to thank for saving my life and my exposed film with pictures of the food distribution

The day of the bombing in 1974, after I was moved from the recovery room to a hospital ward, I asked an air force nurse to help me telephone Bob Gilka, the director of photography at the *Geographic*. I was half expecting to be fired for my misfortune on a high-profile overseas assignment. Instead, this bear of a man was all compassion and ordered me to Japan to rest before continuing the story on the world hunger crisis. Several days later I checked into the luxurious Hotel Okura Tokyo and headed straight to the newsstand to buy the last copy of the August 9, 1974, *New York Times*, with its historic front page headline: "Nixon Resigns." It remains a treasured possession—a memory of Cambodia and of the beginning of a less trusting era in American politics.

The collapse of the US-backed governments in Cambodia, Laos, and Vietnam in the spring of 1975 remains a

shameful memory for many of us who lived through the "Vietnam experience." Right up until April 30, the day the North Vietnamese rolled into Saigon and raised the Viet Cong's flag atop the presidential palace, I was trying to persuade *National Geographic* editors to send me back to document the unfolding catastrophe. But it was not to be.

Whatever the reasons for our intervention in Southeast Asia—to honor our commitments to a non-communist government of South Vietnam that turned out to be corrupt, tyrannical, and loyal to a Roman Catholic minority or to halt what we Americans saw as Soviet and Chinese communist expansionism—the war was probably lost before it ever began. The memoirs of American military and civil officials reveal a pessimism about its outcome even before president John F. Kennedy was assassinated and Lyndon Johnson made the Vietnam War his own. The United States could not prop up a brutal, unpopular regime in Saigon. The infiltration of South Vietnam by ever-growing numbers of North Vietnamese troops was relentless. Every American escalation to prevent South Vietnam from collapsing—our stated goal—was matched by the North Vietnamese, and it would never end.

Years later, I had an opportunity to interview the North Vietnamese supreme commander, General Vo Nguyen Giap, who told me he was prepared to "sacrifice as many soldiers as necessary to defeat the Americans." This was no idle boast. Giap lost between ten thousand and fifteen thousand troops during the siege of the US Marine Corps combat base at Khe Sanh in 1968—a battlefield still littered with unexploded shells when my wife Barbara and I walked it in 1993. American generals thought Giap was focused on tying down US forces at Khe Sanh, but the general told me that his larger goal was to promote a communist uprising throughout South Vietnam. He suffered another forty thousand North Vietnamese and Vietcong

to be killed or missing in action during the disastrous 1972 Easter Offensive. But the ruthlessness that I saw in Giap's eyes during our interview eventually prevailed.

Back home in the United States, by the summer of 1970 one in every two American families had direct, personal experience with the war, leading to a dramatic shift in public opinion. Most Americans came to believe that our causalities were unsustainable, as were draft calls, and that there was no clear path to victory. The public wanted to wash its hands of the Vietnam War.

Importantly, research shows that comparatively few Western journalists initially saw the folly of the intervention in Vietnam. Early in the war, say many scholars, American correspondents generally supported US military goals, even while they disagreed with the tactics being used to combat the Vietcong and North Vietnamese. Only after the 1968 Tet Offensive and, later, the My Lai Massacre of as many as five hundred South Vietnamese

A Buddhist monk walks through the streets of Yangon, capital of Myanmar. In line with Buddhist teachings, monks take to the streets every morning to collect alms—a key barometer of the economy, since ordinary Myanmaris will struggle to give monks enough to eat even in lean times.

Tamarind blossoms frame the bridge to the Tortoise Tower at the Lake of the Restored Sword in Hanoi. The tower dates to the late nineteenth century, when a Vietnamese bureaucrat working for the French colonial government built a shrine to Emperor Le Loi, who led the Vietnamese to victory against China's Ming dynasty in the fifteenth century.

civilians by US troops, did journalists change their frame of reference—often because their government sources in Saigon and Washington were in disarray. In effect, the US government lost control of its own story. As historian Phillip Knightley documents in *The First Casualty*, after 1968 increasing numbers of journalists and photographers stepped forward with stories and photographs of brutality and potential war crimes against Vietnamese civilians. And as the war dragged on, it became more and more acceptable to write about a negotiated end to the stalemate instead of a victory in Vietnam.

One of my journalistic heroes in Vietnam was the late Gloria Emerson of the *New York Times*, who perceived the war as a "misery that inflicted physical suffering and psychic damage on civilians, children, and soldiers on both sides," according to her fellow *Times* correspondent Craig Whitney. Emerson eschewed the "Five O'Clock Follies" military press briefings and the officers who prepared them, reporting instead on the plight of ordinary soldiers and civilians. To show how easy it was to buy heroin—a menace ravaging the US military in the early 1970s—Emerson bought the narcotic outside the gate of

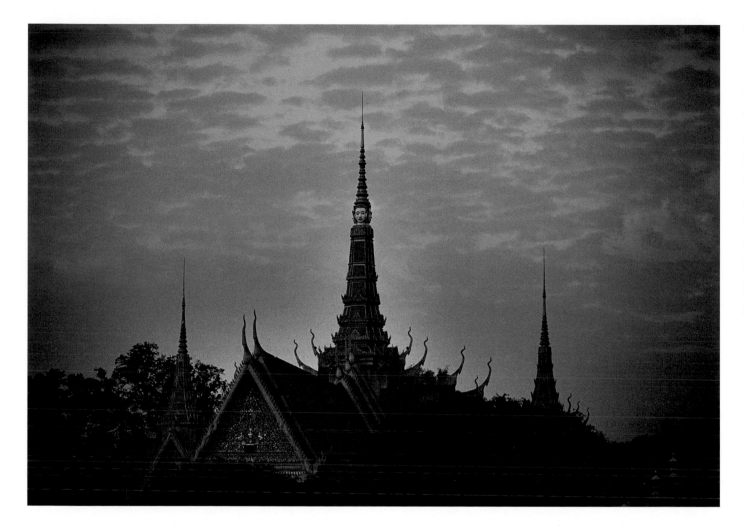

With its classic golden Khmer gables framed by forested grounds at sunrise, Cambodia's Royal Palace in the capital Phnom Penh is situated at the confluence of three great rivers— the Mekong, Tonle Sap, and Bassac. The palace, built in 1866, is the royal residence of King Norodom Sihamoni, who succeeded his father, King Norodom Sihanouk, in 2004.

a large army base. And she reported on a US Army general who ordered soldiers to write him up for a medal he didn't deserve in a battle that never happened. A decade later, reporting on the opium poppy for *National Geographic*, I walked the back streets of Bangkok to see how easy it was to buy heroin. Five US dollars bought me five small soda straws filled with "Chinese White," which I held in my hand to photograph before throwing them away. From Emerson I learned to be direct in the pursuit of truth.

A second journalistic hero from the war was Frances "Frankie" FitzGerald, a brainy freelancer and daughter of the deputy director of the CIA, who concluded, through dogged reporting and research in three languages on several continents, that there was no US military solution to what amounted to a civil war in Vietnam. FitzGerald's reporting for the *Atlantic* and the *New Republic* and her Pulitzer Prize–winning book *Fire in the Lake* stand the test of time more than four decades after the last US combat troops left Vietnam. FitzGerald's work showed the importance of talking to peasants and scholars alike as she applied her remarkable intellect to making sense of the conflict.

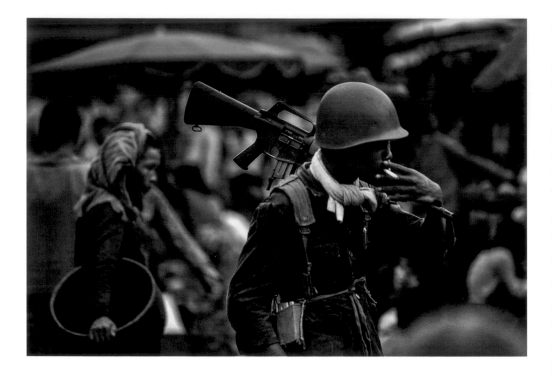

Minutes before the author was wounded in 1974 reporting on relief delivery to a starving Cambodian nation, a soldier of the American-backed government slogged through a market in Kampong Speu Province. In 1969, the United States began secretly bombing North Vietnamese forces in Cambodia, fueling a civil war that ended in victory for the genocidal Khmer Rouge.

I tell students that a good foreign correspondent must have a low threshold for injustice. Emerson seemingly had none, seething at the lies; the metric of the daily "body count" of dead enemy soldiers, as if that was any measure of success against an unwavering enemy; and the loss of so many innocents—Vietnamese and American. After the war, Emerson wrote in *Esquire* and her best-selling book *Winners and Losers* of holding so many dying American soldiers in her arms, most of them just kids, that it broke her heart. Emerson left Vietnam a haunted woman, Fitz-Gerald a celebrated writer who won the Pulitzer Prize and National Book Award. Both women taught me an important lesson: never accept the government's version of the truth without seeing it for yourself.

Hundreds of other journalists—adventurers, war junkies, old warhorses retreaded from Korea and World War II, and thoughtful policy wonks—covered the war in Southeast Asia's vast canvas. They reported on jungle

firefights for television, couriering film to Tokyo and New York for the nightly news, and held military and civilian officials accountable for lies and failed policies. The late Michael Herr, writing for *Esquire*, added the authenticity of the New Journalism movement, using the profanity and slang of the GIs or "grunts." "Your task was not to make it more popular or less popular," Ward Just of the *Washington Post* famously said on writing about Vietnam, "but to report what you saw and heard faithfully and completely. But from the beginning irony was the voice of choice, and irony is the enemy of faith. 'We had to destroy the village in order to save it.'" The life of soldiers in the field was inexplicable. Beer, ice cream, mail from home, and ammunition were delivered by helicopters to GIs in the middle of the jungle. The same helicopters carried out the dead and wounded. And even if you were one of the REMFs, or Rear Echelon Mother F—kers who ate decent food and had a Jeep to check out the Nikon cameras and scotch whiskeys in the well-stocked post exchanges, you would still find yourself at an airstrip hitching a ride. And there would be a helicopter crew chief washing out the inside of his chopper, the dark residue of blood and water spilling on the tarmac, after the wounded were off-loaded.

The war turned out to be a fool's errand, paid for with the lives of more than fifty-eight thousand Americans and perhaps as many as two million or more Vietnamese. But few of us saw how badly Vietnam would end until it was too late. As a student in the Army ROTC program at the University of Wisconsin–Madison, I could recite from memory these fateful lines from President Kennedy's January 20, 1961, inaugural address—lines that foreshadowed a hot war in the middle of a larger conflict called the Cold War. "Let every nation know, whether it wishes us well or ill," said Kennedy on a bitterly cold afternoon on the steps of the US Capitol, "that we shall pay

any price, bear any burden, meet any hardship, support any friend, oppose any foe to assure the survival and the success of liberty." This was the rationale for the life-and-death dramas, in uniform and out, that motivated many of my generation who saw the world through the lens of Kennedy's call to service—kids from small towns and West Point, young foreign service officers from the Ivy League, and Red Cross aid workers like Sally Deale, a high school classmate and daughter of a college professor. Two fraternity brothers died in Vietnam, as did numerous high school acquaintances, and a buddy from the heavily Polish south side of Milwaukee by the name of John Rydlewicz, an Air Force Academy graduate and hotshot pilot who would sit down at the piano and play Mozart. In the end, there is cold comfort in knowing that friends in Asia still believe that in fighting the Vietnam War, the United States gave neighboring Thailand, Malaysia, and Singapore some "breathing room" to defeat their own communist insurgencies and to develop their own economies.

The Asia of my youth, a continent that was once so intoxicating, is all but impossible to find today. Yes, there is still the beauty of the green-hued limestone karsts that reach into the clouds in Laos and Vietnam, as well as the mystery of the Hindu temples at Angkor Wat in Cambodia and My Son in Vietnam. And young women in northern Vietnam still wear the graceful *áo dài* silk tunic with white trousers that was once so ubiquitous throughout the country—an outfit first worn in the court of the Nguyen Lords at Hue in the eighteenth century. Occasionally a visitor might go off the beaten path in Southeast Asia and find a working elephant herd. But in Myanmar, Thailand, Cambodia, and Vietnam, those elephants will likely now be involved in the illegal logging of teak and other precious hardwoods or performing for tourists.

In Southeast Asia, the modern world with all its ills has replaced the life-and-death drama of my generation.

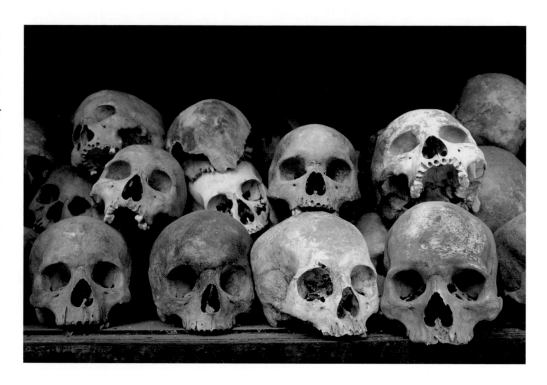

The canals or klongs of Bangkok have long been paved over for freeways and a "skytrain" elevated railroad, and the city's floating markets have given way to shopping malls. Moreover, the Kingdom of Thailand has stepped up enforcement of tortuous lèse-majesté laws that are among the strictest in the world—laws that have been used against the news media, bloggers, authors, and ordinary Thais to squelch any questioning of the ultra-royalist military junta that rules the country.

Further south in Peninsular Malaysia, rainforests have been turned into gigantic palm oil plantations, factories, cities, suburbs, and airports. Singapore, a city-state where I first stayed in the Somerset Maugham Suite at the old Raffles Hotel for $45 a night, has been transformed beyond all recognition. Once the malaria-infested port and garrison in Maugham's exotic tales of the British Empire, it has become the most prosperous state in Southeast Asia, and, by many measures, the most open and transparent place

Monument to massacre, some eight thousand human skulls lie stacked at the Tuol Sleng Genocide Museum outside Phnom Penh, capital of Cambodia. Tuol Sleng was one of several torture centers and factories of mass execution run by Khmer Rouge soldiers who murdered an estimated 1.7 million people, or some 21 percent of the Cambodian population, between 1975 and 1979.

Epicenter of Buddhist upheaval in the 1960s, the Xa Loi Pagoda in Ho Chi Minh City is a place of interest for its past. In June 1963, a Buddhist monk travelled from the pagoda to a nearby intersection, was doused with gasoline, and burned himself to death in front of AP journalist Malcolm Browne, whose iconic image of the self-immolating monk encapsulated the dilemma the United State faced with a despotic South Vietnamese government.

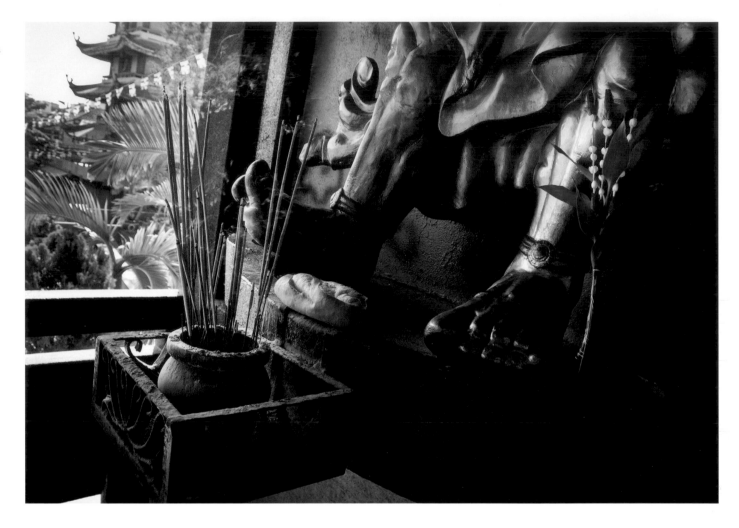

to do business in the world. In Vietnam, the battlefields of the French and American wars have been reclaimed by the jungle or erased on orders of the government in Hanoi. Even the infamous Hoa Lo Prison, nicknamed the "Hanoi Hilton" by US pilots held prisoners of war there, has been turned into a museum, though not before my frequent traveling companion, retired US Air Force Colonel Joe Breen, and I dashed inside the jail as it was being dismantled to interview the guards. We each took home a red brick from the prison, bittersweet souvenirs of another time in our lives and those of our countrymen and countrywomen.

When I first came to Bangkok in 1973 for *National Geographic*, American warplanes were still flying against communist forces in Laos and South Vietnam from seven US air bases across the kingdom. Container loads of war materiel flowed into the port at Sattahip, and a friend at the American embassy confided that he was involved in more than one hundred top-secret operations across the region. Meanwhile, soldiers and airmen crowded places like Soi Cowboy, a Bangkok street of brothels and bars playing country and western music. Foreign correspondents and photographers would gather for a lunch of Chinese dim sum at a nameless joint on Patpong Road,

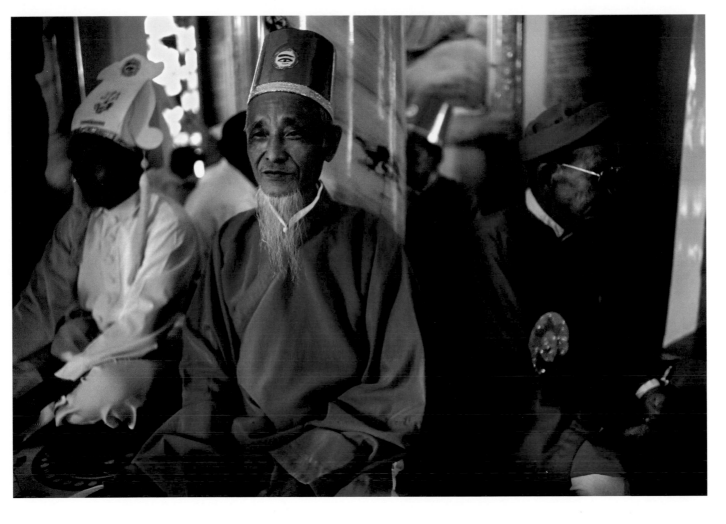

Quietly seated in blue robes signifying Taoism, elders of the Cao Dai faith meditate inside their elaborate, dragon-adorned temple in the Vietnamese city of Tay Ninh. For more than seventy years, the Cao Dai temple, about sixty miles northwest of Ho Chi Minh City near the Cambodian border, has been the center of a homegrown faith that combines elements of several religious traditions for some five million adherents in Vietnam.

swapping war stories and digesting the latest news from Vientiane or Saigon. I had a tailor in Bangkok—a shop called Sonny's—where twin brothers would routinely stitch up something called a "journalist's suit" for correspondents and photographers. These were modified safari suits with military epaulets and plenty of pockets for pens, notebooks, and film. If we journalists were going to war, it would be in style.

Over the years, I would go on to report on the kingdom's porous and troubled borders. In the mid-1980s, I walked among the poppy fields along the border between Thailand and Myanmar with United Nations drug enforcement officials asking villagers if they could direct us to an opium warlord or smuggler. A Thai trader in the village of Ban Huai Nam Rim in Chiang Rai Province agreed to an interview and eventually to having his photograph taken with a strongbox full of foul-smelling, golf ball–sized spheres of raw opium. He showed me how he packed these into 1.65 kilogram packages called *jois*. While media ethicists today say that we do not pay for the news, I was grateful for the lesson in the economics of opium production and smuggling and left him with some Thai bahts as payment for his time. Perhaps foolishly, I also gave the smuggler my *National Geographic* business

card. Images from Thailand's troubled periphery figured prominently in my *National Geographic* story titled "The Poppy."

But my most wrenching memories of Thailand are of the forlorn refugee camps of Khao-I-Dang and Sa Kaeo—thousands of thatched shacks turned into cities in the karst-studded jungle. Here I reported on the work of the International Committee of the Red Cross, the World Food Programme, and other humanitarian organizations caring for Cambodians fleeing war and famine. For nearly a decade after the end of the Vietnam War, I traveled regularly to the Thai-Cambodian border to document this forgotten chapter of America's war in Southeast Asia. Before the Khmer Rouge genocide abated in Cambodia and the Vietnamese withdrew their army in 1989, an estimated two hundred thousand refugees passed through Khao-I-Dang camp—some of them returning to Cambodia when the situation improved, others resettling to third countries including Australia, France, and the United States. Parts of Khao-I-Dang camp were informally administered by steely-eyed Khmer Rouge cadres, who would rape Cambodian women and children. Even Thai military officers were afraid to approach their domain. The weekly food distribution ritual amounted to a miles-long parade of the hungry and destitute carrying bags of rice on their heads back to their dwellings. Officially only women and children were fed, lest food fall into the hands of combatants, but this never seemed to stop Khmer Rouge sympathizers and unscrupulous Thais from syphoning rice from the defenseless refugees to feed an array of ragtag armies.

On one occasion, US Army Colonel Michael Eiland, an easygoing West Pointer and military attaché, guided me through a minefield to cross into Cambodia. I photographed the forces of the non-communist Cambodian opposition, called the Khmer People's National Liberation Front (KPNLF), and its leader, Son Sann, who received political and military support from the American government. China backed another Cambodian faction and Vietnam propped up its own puppet government in Phnom Penh, adding to the uncertainty and violence. KPNLF troops fired old recoilless rifles at their Khmer Rouge foes while I fretted over the harsh midday sun that cast ink-black shadows on the warriors' faces. In the moment, the problems of light were greater than the threat of being shot. A former Army Special Forces officer, Eiland gently suggested we return to the relative safety of Thailand before I got us both killed—standing in the open and unprotected—as I fixated on getting the picture.

In Bangkok I also became friends with a dashing Frenchman and *Time* magazine photojournalist named Roland Neveu, who helped me uncover unscrupulous wildlife traders on the city's back streets and gem miners on the Cambodian border—all in the pursuit of *National Geographic* stories. On April 17, 1975, Neveu, along with British journalist Jon Swain and the late Sydney Schanberg of the *New York Times,* stayed behind as the revolutionary Pol Pot and the Khmer Rouge emptied Phnom Penh of more than two million residents. The Khmer Rouge's reign of terror led to the deaths of nearly a quarter of Cambodia's seven million people through execution, torture, starvation, and disease—a genocide by any measure. The courage of Neveu, Swain, and Schanberg, and a handful of others, remains a high-water mark in the annals of conflict journalism. These brave few held their ground to bear witness to what my friend Seth Mydans of the *New York Times* called "one of the twentieth century's most brutal and radical regimes of anti-Western peasants." Eventually the Khmer Rouge expelled all foreigners and Year Zero began for the Cambodian people.

Years later I walked the killing fields of the Choeung Ek extermination camp outside Phnom Penh, where some seventeen thousand men, women, children, and infants

were tortured and murdered at a camp then called S-21. Human skulls were stacked to the ceiling. My driver that day called himself "Mr. X X" because he was orphaned during the Khmer Rouge genocide and had no knowledge of his parents or extended family—a standard story told by many soft-spoken, gentle survivors. I also searched for remnants of the Cham Muslim minority that was decimated by the Khmer Rouge and discovered a small community of several thousand observant Muslims along the Mekong River. Over the years, some courageous journalists like Elizabeth "Beth" Becker of the Washington Post and several of my *National Geographic* colleagues risked their lives to report from inside Cambodia. Sadly, the world paid scant attention to Cambodia, then or now, as the last of the Khmer Rouge leaders were tried, imprisoned, or died of disease or old age. In the end, Cambodia—once the seat of a great civilization—seems destined to be remembered as a sideshow to the American war in Vietnam.

By a coincidence, I was in Paris on January 28, 1973, when the United States, South Vietnam, the communist Vietcong, and North Vietnam formally signed an "Agreement Ending the War and Restoring Peace in Vietnam" at the Hotel Majestic. My pictures on that cold Saturday of US secretary of state William P. Rogers and the North Vietnamese delegation waving to the crowd were images without meaning. As most of us suspected, the treaty was merely a fig leaf for the United States as it washed its hands of Vietnam. The agreement allowed more than one hundred thousand North Vietnamese troops to stay in place in South Vietnam, and it certainly did not extinguish the North's determination to merge the country under its flag.

On the day following the Paris Peace Accords, battles continued across Vietnam—one reported on by my friend Arnold R. (Skip) Isaacs of the *Baltimore Sun* under the headline "After the Cease Fire, January 1973: War

Lingers in Hamlets as Cease-Fire Hour Passes." A year later in Saigon, before my ill-fated trip to Cambodia, I saw this contempt for the Paris accords with my own eyes as the fighting between South Vietnamese forces and those of the Vietcong and North Vietnam continued unabated but without the once massive US aid for the South. The Watergate scandal, Nixon's resignation, and eventually a vote of the US Congress stopped most of the military and economic support. At Tan Son Nhat Airport in Saigon, planes and helicopters sat idle for lack of spare parts, and the remaining foreign journalists left in the country talked of plans to evacuate their Vietnamese staffs. With no prospect of renewed American bombing—something Nixon had secretly promised—the South Vietnamese Army simply collapsed in the spring of 1975 and the North Vietnamese won their final victory in a lightning advance on the capital.

Some years later, Skip would write a passionate indictment of the collapse of Indochina titled *Without Honor*, a history that the investigative journalist Seymour Hersh called a "courageous and honest book about a period of American history which most would rather forget." Skip and I would become friends for a lifetime, working together during a famine in neighboring Bangladesh and later becoming professors of journalism. And, like Skip, I would forever feel a sense of shame at the way we Americans fought a long, wildly expensive, and ultimately futile war, only to abandon as many as a million or more Vietnamese, Cambodians, and Laotians who had trusted their fate to the United States government. It would be a long time before the war in Southeast Asia could be put to rest for either of us.

For my part, I have continued to report on Vietnam and to strive to improve relations between our two countries. During more than twenty trips to Vietnam, working as a photojournalist or teaching as a university professor, I

A Vietnamese child with hydrocephalus is cared for at Tu Du Hospital, a research center in Ho Chi Minh City studying the effects of the defoliant Agent Orange. The United States sprayed twenty million gallons of Agent Orange on the jungles of Vietnam over a decade of war, causing thousands of birth defects in two generations of Vietnamese children, according to Vietnamese doctors.

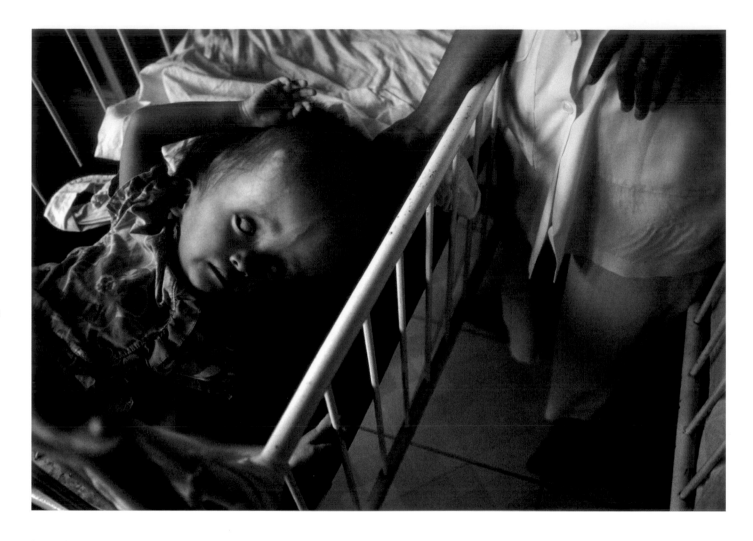

have found a land transformed. Though still under Communist Party rule, the S-shaped country some 1,025 miles in length has cast aside Marxist economic theory and an alliance with Soviet Russia in favor of trade, tourism, and a new openness with the West, including the United States.

The world has turned over many times since the fall of Saigon, wrote one of my early heroes, the late David Halberstam, who won a Pulitzer for his work as a *New York Times* correspondent in Vietnam. "The Americans, then newly departed, having been chased off the roof of the US Embassy, are now the most welcome of returnees, back as tourists and potential investors." According to the

Economist, Western businessmen and women appreciate Vietnam's "cheap labor, long coastline, numerous ports and pro-business policies—all assets that will grow increasingly important as Chinese labor costs rise." Today Vietnam is a land of humming cities with hundreds of foreign-run factories filled with workers who are overwhelmingly pro-American—something I have seen on assembly lines making Nike athletic shoes and Ford SUVs and vans. Moreover, Vietnam is a land of improbable beauty, considering how hard both sides fought to destroy it during what today is called the "American War." For Europeans, Australians, New Zealanders, and a few

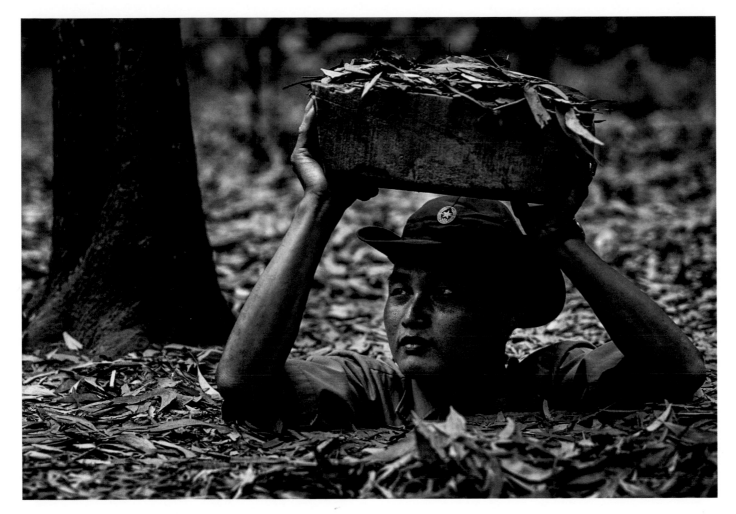

A Vietnamese soldier shows tourists a "spider hole," part of a network of fighting positions and underground tunnels—some deep enough to contain hospitals—that supported the Vietcong insurgents near the American base at Chu Chi. American and Australian troops and massive B-52 bomber strikes tried for years to rout out the tunnels, killing as many as forty-five thousand Vietnamese.

adventurous Americans it is an indispensable tourist stop with breathtaking scenery, great food, and just enough exoticism to make travelers feel they have been somewhere exceptional. And for the Asian business elite, Vietnam's beach resorts, thousands of South China Sea coast condominiums, and golf courses are a new and affordable weekend getaway.

Moreover, America is now the largest customer for garments made in Vietnam and seafood from its waters. The Vietnamese have one of the largest foreign student communities in the United States with some twenty thousand young people studying in America. Yet, the

two countries remain far apart on the issues of human and political rights, especially given Vietnam's continued government crackdowns on journalists, bloggers, Buddhist clergy, and evangelical Christians, dozens of whom are imprisoned each year. Yet in one of the ironies of early twenty-first-century geopolitics, the United States is now seen as Vietnam's protector against China, its giant neighbor to the north. The United States is providing military hardware, friendly show-the-flag visits by US warships, and diplomatic backing to Vietnam because of China's growing assertiveness over much of the South China Sea. Perhaps the greatest irony is that many Vietnamese, young

and old alike, see the "American War" as only a blip in a long history of fighting foreign invaders.

For more than two decades, joint US and Vietnamese teams of soldiers and archeologists have been searching for the remains of Americans missing in action. And today there are new forms of cooperation on old issues. Vietnamese and American doctors and cleanup teams are at last addressing the issue of Agent Orange, the chemical defoliant sprayed from the air more than four decades ago to deny communist troops their jungle sanctuaries. Tragically, there are thousands of Vietnamese children born each year with missing limbs and other birth defects attributed to dioxin—the active ingredient in Agent Orange. Many end up in hospitals in Saigon and Hanoi, abandoned by families too poor to care for these so-called Agent Orange babies. It appears that dioxin lingers in old dumps and near air bases throughout what was South Vietnam and has damaged the genes of both American war veterans and their Vietnamese counterparts. Indeed, the last battle of the Vietnam War may be to stop the genetic mutations caused by Agent Orange—mutations that now reach into a second generation of Vietnamese born since 1975.

Over the years, I would also report on the plight of Vietnamese who served in the South Vietnamese armed forces or worked for the United States during the war. Thousands were sent to brutal reeducation camps, a euphemism for prison camps deep in the jungle. Some years ago, a fifty-year-old servant at the Majestic Hotel in Saigon took me aside one day to show me a picture of himself as a South Vietnamese army helicopter pilot standing in front of the White House in Washington, DC. The small man in the starched white waistcoat said in whispered tones that after the fall of Saigon, he was imprisoned and tortured for more than a decade—one of thousands who cast their fate with the United States, and who, with the arrival of

the communists from the north, were imprisoned and then limited to menial jobs for the rest of their lives.

Another three million so-called boat people—Vietnamese, Chinese citizens of Vietnam, Cambodians, Laotians, and Indochinese minorities—risked their lives on the high seas between 1975 and 1980 to flee communist rule. About thirty-two thousand of those refugees were brought to Fort Indiantown Gap, Pennsylvania—one of four military posts in the United States that were temporarily used as refugee resettlement centers in the aftermath of the war. *National Geographic* sent me to Pennsylvania, where I focused on several Vietnamese families to personalize the arrival of this immense wave of immigrants from the other side of the world. Friends from Wisconsin—Doris Meissner, former commissioner of the US Immigration and Naturalization Service and her family in Bethesda, Maryland—"adopted" or sponsored a family from Indiantown Gap, and many of us helped support them until the parents could find work in the Washington, DC, area. Such was the warmth of the welcome in the 1970s—America's arms were still wide open.

When Americans were finally able to regularly travel to Vietnam in the early 1990s, I also reported on some forty thousand mixed-race children of American servicemen—children known as known as "Amerasians." Viewed as an unsightly legacy of an invading army, Amerasian children and their mothers were left by the Vietnamese to live in wretched poverty or as prisoners in communist reeducation camps. Other children were abandoned by their families to live in bands of roving "street children" in Ho Chi Minh City, formerly Saigon, while a lucky few were shipped off to orphanages. Shamed by these unsettling conditions, the United States Congress enacted legislation giving Amerasian children special immigration status. Since the late 1980s, more than twenty-one thousand Amerasian children, accompanied by more than

fifty-five thousand relatives, have moved to the United States. But according to the *New York Times*, only a tiny fraction—perhaps fewer than 5 percent—have ever found their fathers. If there was any silver lining in this sad tale, one of my photographs of an Amerasian orphan became the public face of the United Nations campaign for world literacy thanks to the sponsorship of Mont Blanc, the German manufacturer of luxury writing instruments.

The culmination of decades of work in the region led to a book about Vietnam—a self-assigned project of journalistic curiosity and emotional reconnection that began in 1993 before the United States and Vietnam had trade or diplomatic relations. With fellow veterans Paul Martin of *National Geographic* and the late Jack Smith of ABC News, we had a straightforward thesis for the project that became *Land of the Ascending Dragon: Rediscovering Vietnam*. Vietnam today is a land at peace, both with itself and its neighbors, though we recognized the ongoing persecution of minorities and pro-democracy activists, as well trouble with China at its borders in the new millennium. Through the four years I spent taking photographs for the book, I met scores of returning American veterans doing charitable work for and with the Vietnamese—everything from mapping old minefields and stocking rural medical clinics to caring for the Amerasian street children of Saigon, now called Ho Chi Minh City.

One of those returning veterans was my late father-in-law Albert Skinner. Accompanied by two "minders" from the foreign ministry, Al and I drove from Saigon to Hanoi in a cramped Peugeot 406 sedan jammed with my camera equipment and our luggage. Our route took us from the Central Highlands and the old battlefields and bases at

Da Lat, An Khe, and the Mang Yang Pass; to My Lai, an out of the way hamlet where officers ordered US troops to murder hundreds of unarmed South Vietnamese civilians in 1968; the port city of Da Nang and the white sands of China Beach; the ancient imperial city of Hue with its magical sunsets on the Song Huong (Perfume River); and the old combat base at Khe Sanh, where US Maines were besieged for 77 days under a day-and-night barrage of mortars and rockets from the North Vietnamese. Two accidents with motorcyclists and four flat tires later, Al and I arrived in the capital of Hanoi in time for the Tet Lunar New Year celebration, a festival with flowers and gift-giving that at the time was also celebrated with days and nights of fireworks, now banned. In 1994, with no diplomatic or trade relations between our two countries, Al and I were two of just a handful of Americans allowed to stay in Hanoi during this most important celebration of the Vietnamese calendar.

Al was a retired US Army lieutenant colonel, a Protestant chaplain, and a "soldier's soldier" who earned two Bronze Stars for valor in Vietnam and a Purple Heart for his wounds while caring for troops under fire. On the blazing hot tarmac of Hanoi's No Bai International Airport, a US State Department official asked Al to say an invocation—an ecumenical prayer—over the coffins of thirteen missing-in-action American soldiers before their remains were flown to Hawaii for identification. With tears in his eyes, Al told me the repatriation ceremony, and his central role in it, brought him a closure with the war that few other Americans would experience. He left Vietnam a man at peace—and with a mission to encourage fellow veterans to see Vietnam as a country, not a war.

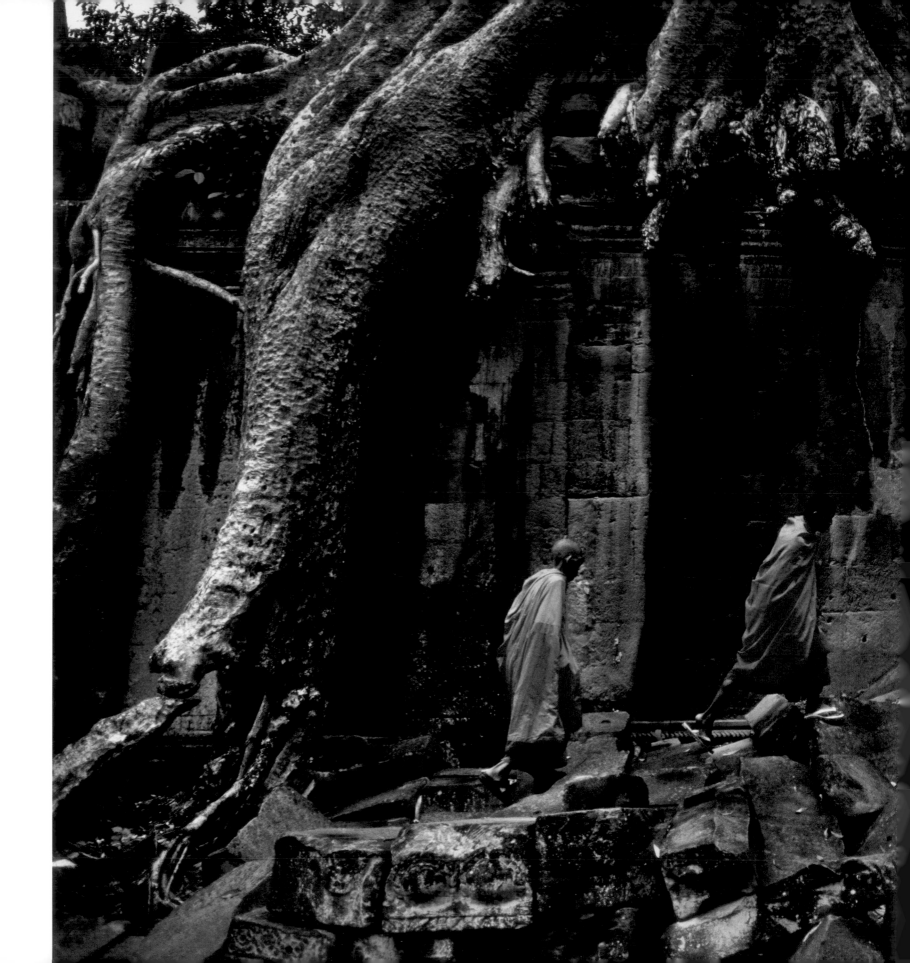

Buddhist monks climb among the ruins of the ancient
Ta Prohm temple, now strangled by the jungle, near
Siem Reap in Cambodia. Built in 1186 during the golden
age of the Khmer Empire and forgotten for centuries,
Ta Prohm has been left as it was rediscovered,
swathed by giant strangler fig and silk-cotton trees
that extract water from the porous sandstone. An
inscription at Ta Prohm says some eighty thousand
workers constructed the temple, which lies in close
proximity to the better-known Angkor Wat settlement.

47

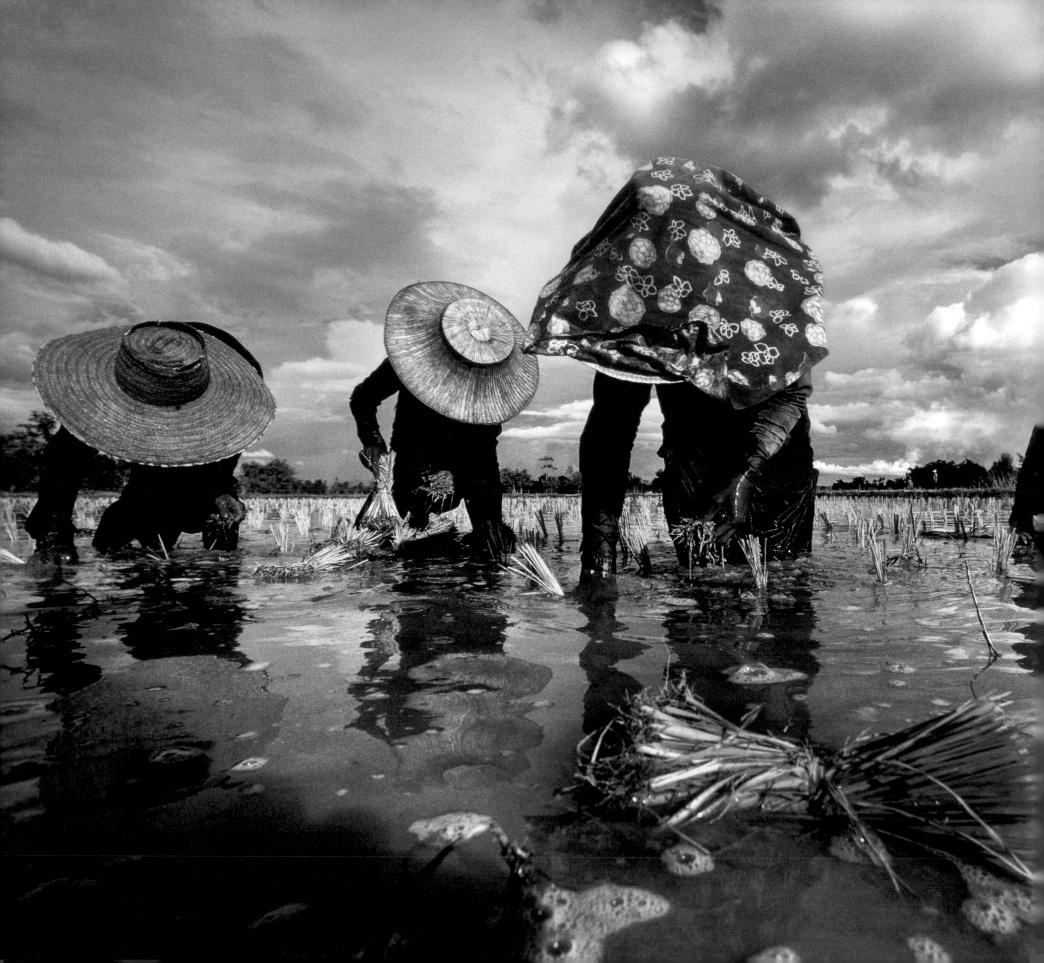

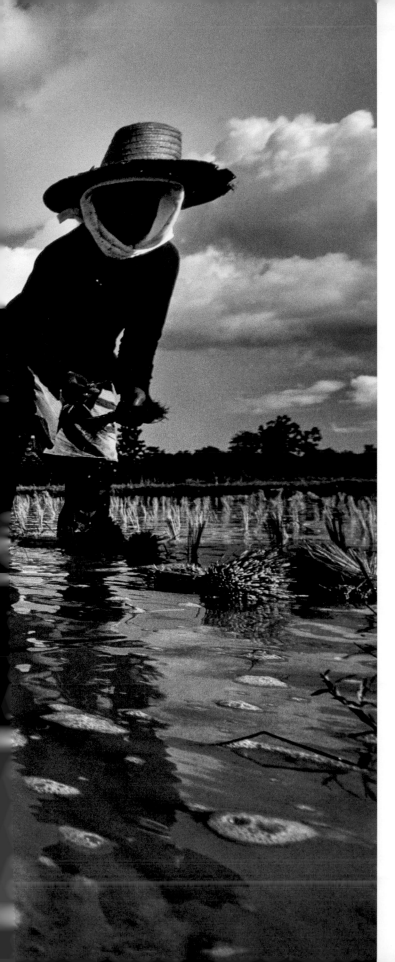

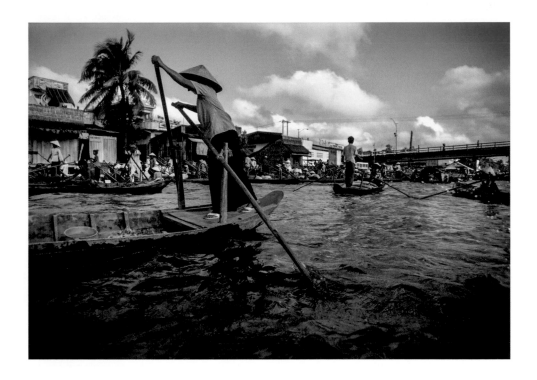

Transplanting rice seedlings is backbreaking work for
Thai farmers, who in 2016–17 produced an estimated
eighteen million metric tons of long-grain Jasmine rice.
The world's largest producer of rice, Thailand harvests
two crops a year in the wet and dry seasons. Near Can
Tho, Vietnamese traders in dugout boats ply one of
the Mekong Delta's endless waterways. But the fabled
Mekong is both shrinking and sinking because of
multiple dams under construction further upstream.

A misty dawn reveals one of the three hundred Buddhist wats or temples inside the Old City of Chiang Mai, Thailand, with its vestiges of ancient moats and walls, some dating to the thirteenth and fourteenth centuries. A conservative cultural and religious center, Chiang Mai is the jumping-off point for tourists exploring the Golden Triangle—an area inhabited by about one million ethnic tribal people.

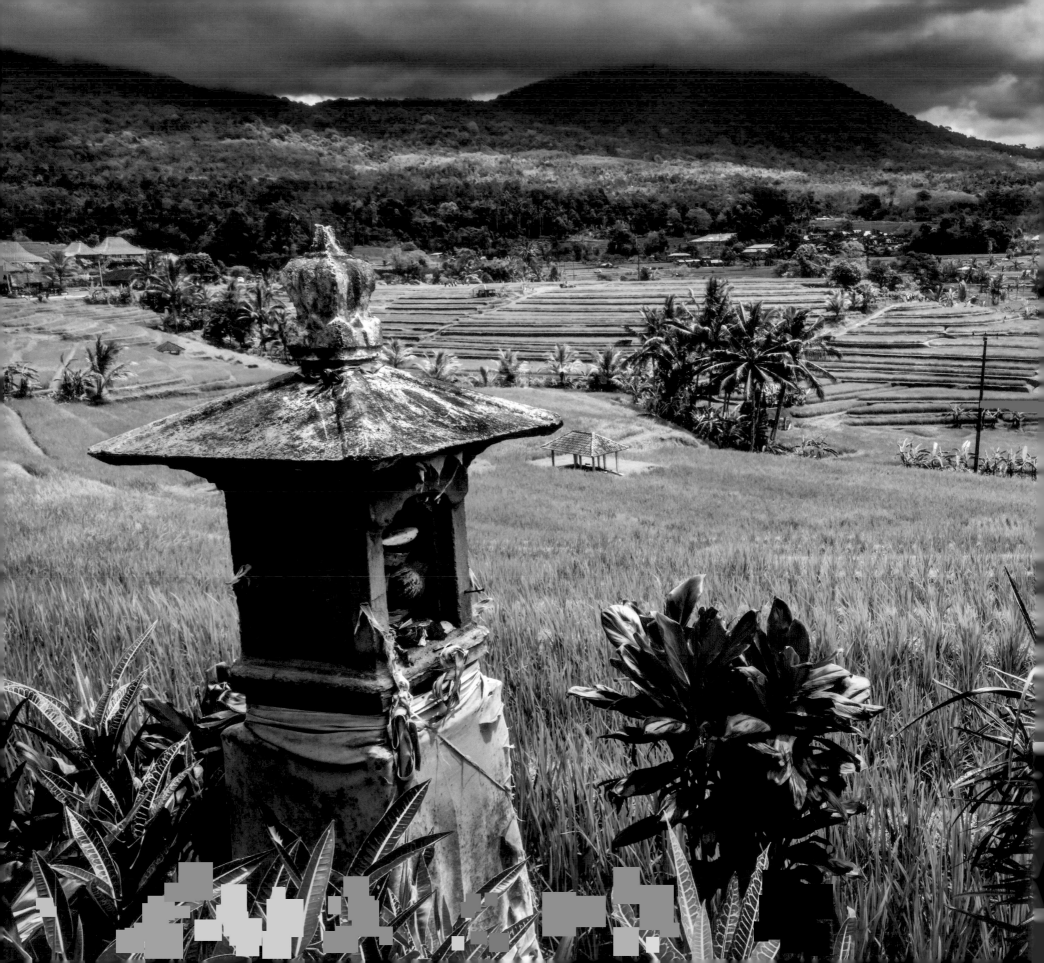

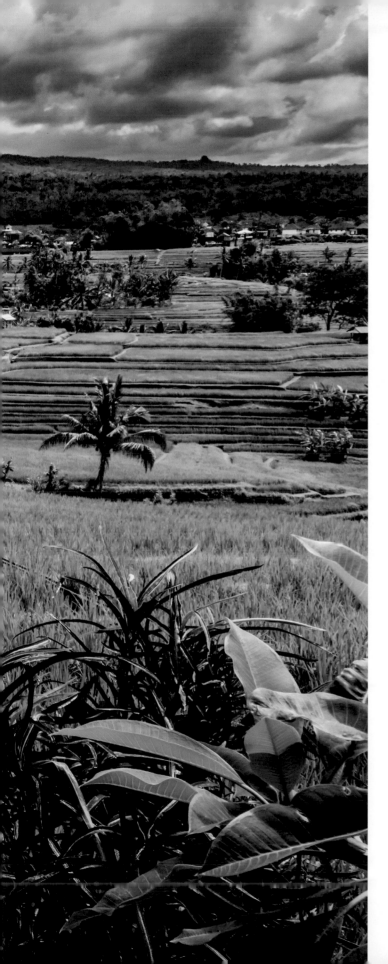

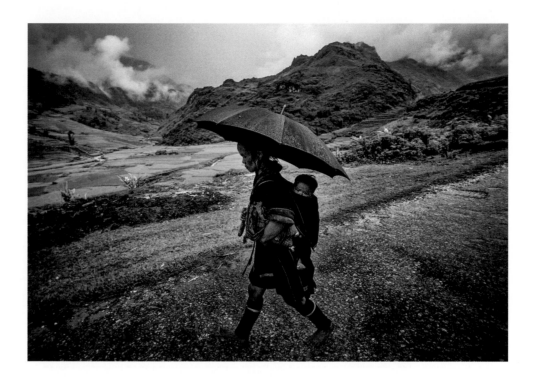

Lime-green rice paddies carpet Southeast Asia,
from the China–Vietnam border to the Indonesian
archipelago. In the shadow of Indonesia's Mount
Batukaru the terraced Jatiluwih rice fields on the island
of Bali are a UNESCO World Heritage site. Dotted
with small Hindu temples (*left*), the ancient terraces
are tied together by a system of canals and weirs that
dates to the ninth century. In northern Vietnam, a
mother and child of the Hmong tribe trek through the
mountains near the old French hill station of Sapa.

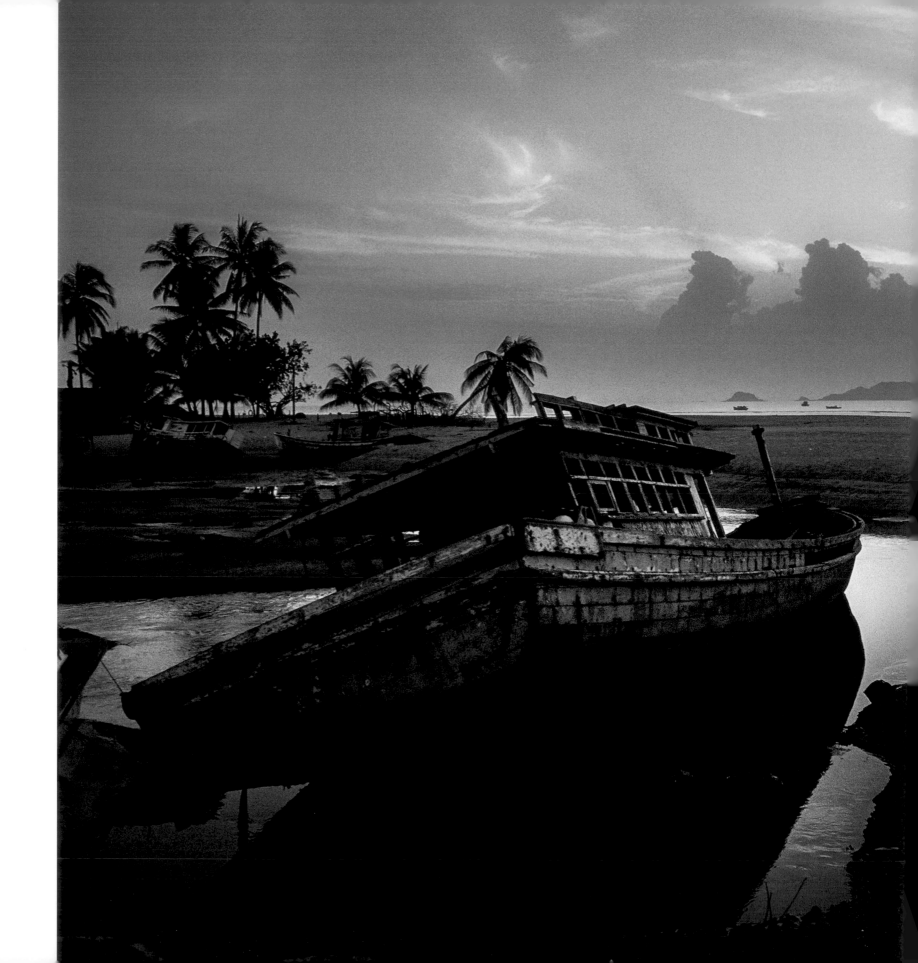

The Malaysian fishing village of Marang slumbers as dawn breaks over the South China Sea. Few coastal vistas can compare to the view across the Marang River estuary, where fishing boats come and go with the tide. Scholars generally agree traders brought Islam to the Malay Peninsula and elsewhere in Southeast Asia—a generally peaceful conversion that followed the path of commerce with South Asia, China, and the Middle East.

Despite living through years of hardship under the French, the Americans and their Vietnamese allies, and, more recently, conflicts with China, a vendor in a market in the coastal city of Hoi An has a ready smile for customers. She wears the *nón lá*—a conical hat made of palm leaf and worn by Vietnamese of all ages and both genders.

56

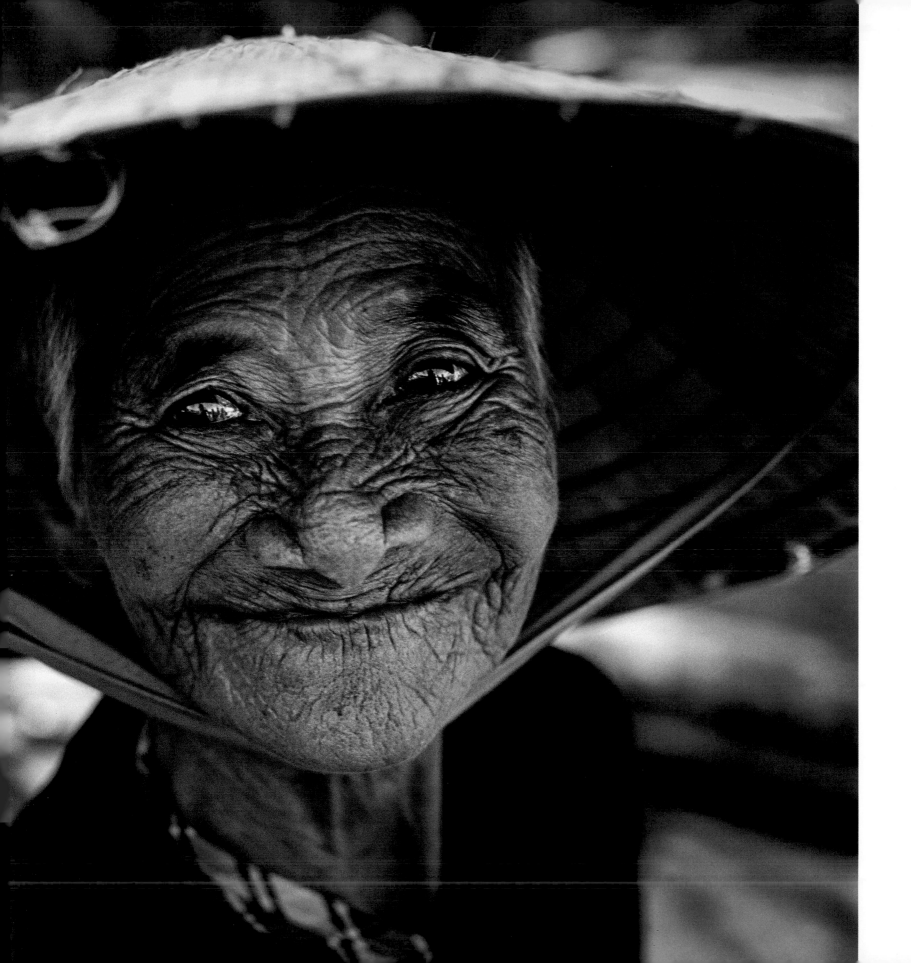

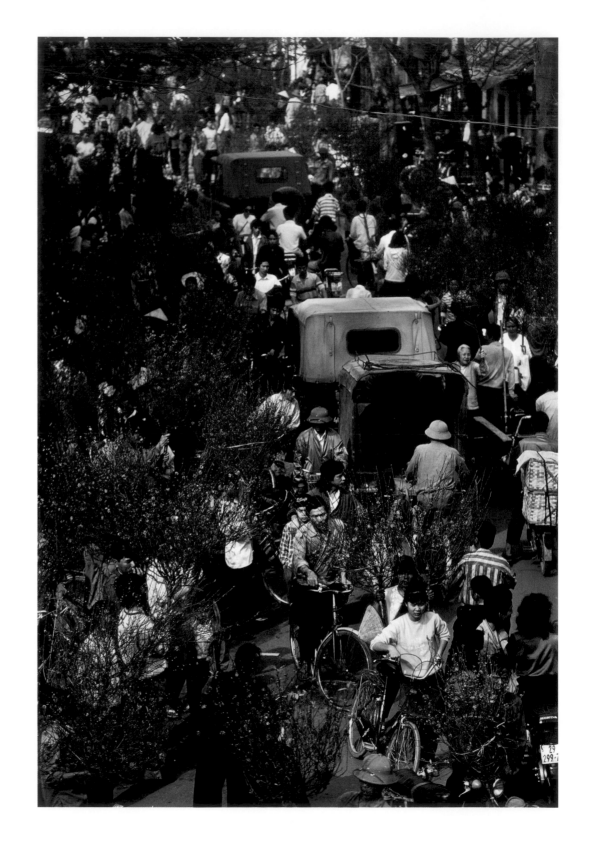

Flower markets like the one on Hang Luoc or "comb
street" in Hanoi's Old Quarter burst into bloom during Tet
Nguyen Dan, better known in the Western world as Tet, the
Chinese or Lunar New Year, and Vietnam's biggest holiday.
Every house is filled with flowers during the festivities,
especially sprigs of eye-popping peach blossoms.

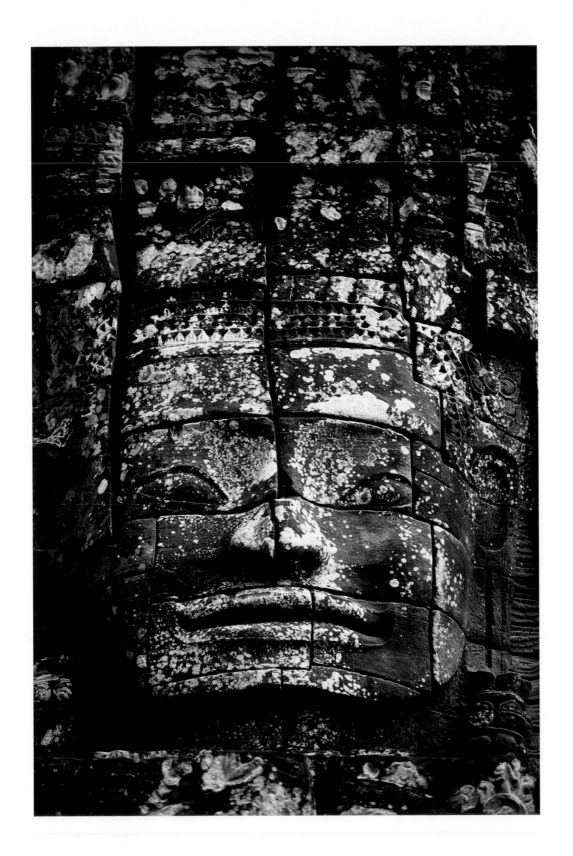

A giant Buddha smiles over Ta Prohm, one of the most visited temples in Cambodia. When temples near Angkor Wat were rediscovered in the early twentieth century, all were overgrown, but none so spectacularly as Ta Prohm, which was built as a monastery dedicated to Queen Sri Jayarajacudamani, mother of the Khmer ruler.

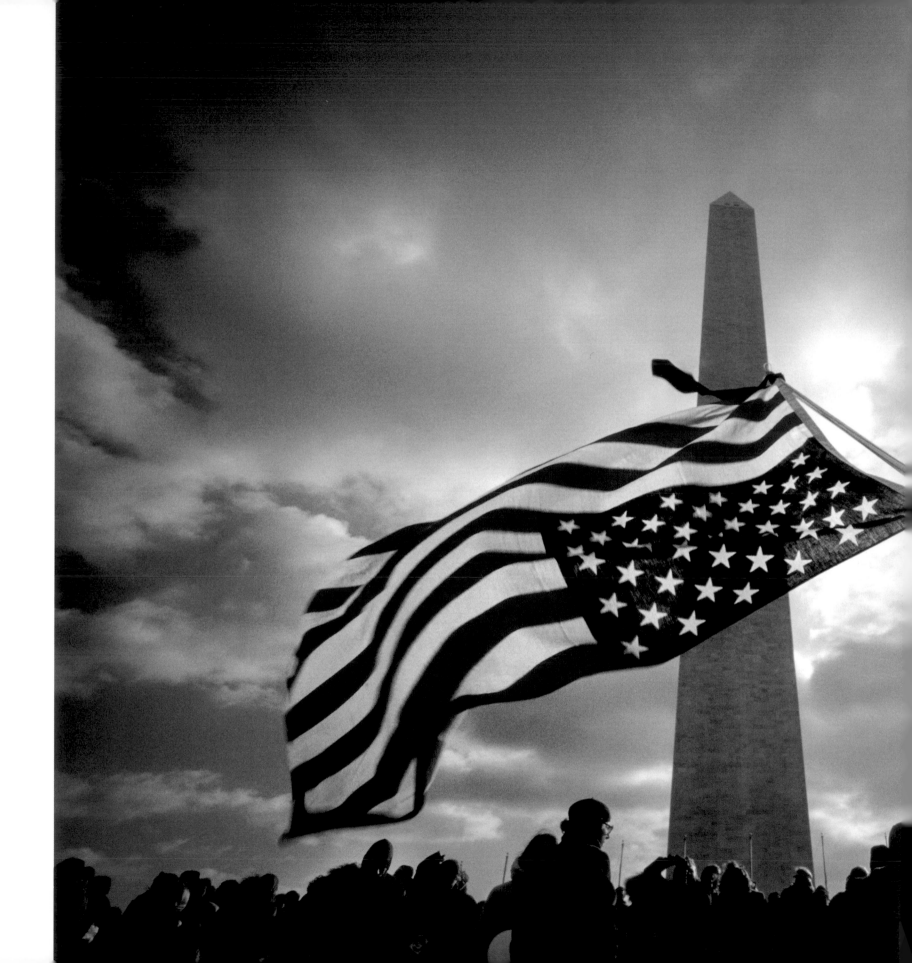

Eight years into the Vietnam War, an elderly antiwar protestor carries his American flag upside down—the international distress symbol—at a demonstration of more than one hundred thousand persons at the inauguration of President Richard M. Nixon on January 20, 1973. Protestors sang anti-war songs, chanted slogans, and threw stones at the president's limousine. Seven days later, the government announced that it would stop drafting young men for service in Vietnam.

61

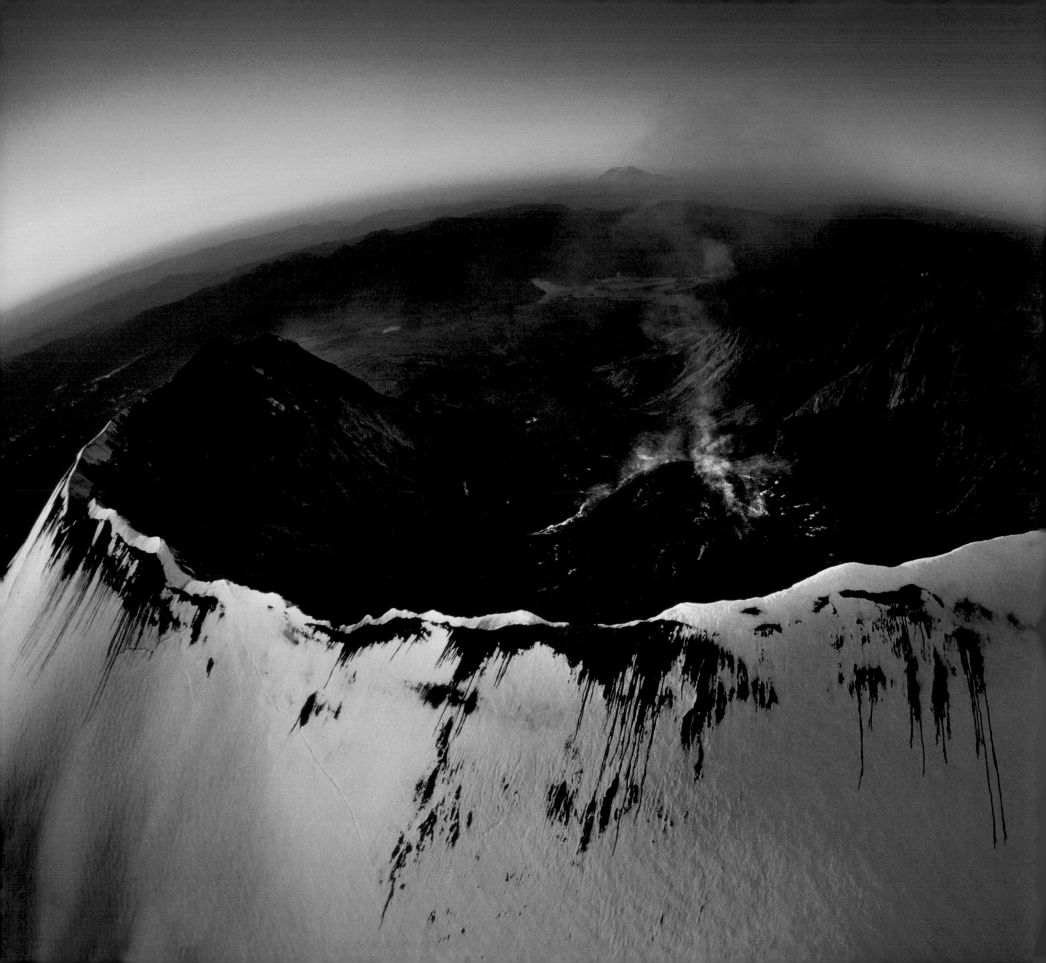

CHAPTER THREE

ADVENTURE AND MISADVENTURE

Many of us who call ourselves creative constantly seek out new experiences. Psychologists say part of being creative is some combination of intellectual curiosity, thrill seeking, openness to our emotions, and susceptibility to our fantasies. I have often thought that being a *National Geographic* photographer allowed me to live out many of my dreams, including spending hours flying in American, British, and French fighter jets—being a jet pilot was my first career choice that, because of poor eyesight, I was never able to pursue. Profiling the French Air Force for a story about France's outsized military role in the world, I flew a simulated low-level nuclear attack in a two-ship formation of Mirage 2000Ns, which

A year after Mount Saint Helens erupted in the most ruinous volcanic explosion in US history, a lava dome more than 600 feet high steams inside the massive crater. When the volcano exploded in 1980, it leveled a forest, sent an ash column eighty thousand feet into the air, and buried two hundred and thirty square miles with hot mud and pulverized soil.

63

are designed to fire a 300-kiloton nuclear-tipped cruise missile. Our flight carried dummy missiles as we tore through the Vosges Mountains of Eastern France, skimming beneath power lines, maneuvering around farmers' barns, and roaring over the autumn forest canopy at 575 miles per hour. Pulling off target near Mount Blanc, my pilot made a 5-G climbing turn, and despite my narrowing field of vision, I struggled to take a "selfie"—a souvenir of soaring close to the edge.

Hand in hand with this willingness to experience the new and the unknown is a willingness to take risks—both physical and creative. "Creativity is, in fact, the act of making something from nothing. It requires making public those bets first placed by imagination," says Steven Kotler for *Forbes*. Like other creative endeavors, being a photojournalist is rarely "a job for the timid. Time wasted, reputation tarnished, money not well spent—these are all by-products of creativity gone awry."

In the mid-1980s I flew to Hollywood to have a special camera mount made for a helicopter so I could photograph Mexican authorities spraying illegal opium poppy fields run by the Sinaloa Cartel, an international drug-trafficking and money-laundering syndicate. My idea was to trigger the camera with an infrared link while sitting in the copilot's seat, hopefully wearing body armor and a protective helmet. No one at *National Geographic* ever asked why I was in California or why the camera mount cost several thousand dollars. (After having it made, I needed it test-flown and certified by a Federal Aviation Administration inspector.) But I knew I had better take a double-page image with it or my autonomy and reputation would suffer. I did, although I hadn't bargained for Mexican authorities also arming me with a 9mm pistol in case our helicopter was shot down by the opium poppy farmers and their guards.

Another time I embarked on a long assignment to explore the history of Hawaii and the Hawaiian people with then *National Geographic* colleague and now best-selling author Louise Levathes. Once again, I found myself taking creative risks with my reputation and financial risks with *National Geographic's* money. This storyline was about the life and times of King Kamehameha the Great and required taking to the air at dawn to show the sheer Nuuanu Pali Cliffs on Oahu just a few minutes from downtown Honolulu. On these jagged outcroppings and dense forests in 1795, King Kamehameha fought a climactic battle that united Oahu under his rule. A semi-fisheye lens with a 180-degree angle of view was the answer—and the dramatic interplay of shadow and light at dawn. To illustrate the revival of the ancient Hawaiian hula, I flew a helicopter-load of dancers to Waimea Canyon on Kauai, a spectacular landmark some ten miles long and three thousand feet deep known as the Grand Canyon of the Pacific. The breathtaking setting for my pictures was the canyon rim. But there was no place to land, so the pilot had to hover on the canyon's slippery, rain-soaked edge. The photo shoot being my idea and responsibility, I hopped out first, helping each dancer stand on the helicopter's skids and jump several feet to the slick ground. When we finished, we repeated the tricky maneuver and, as in the army, I was the last person to climb on board after the hula dancers were safely buckled up. On the same project, I also negotiated a few hours in the helicopter used to film the popular television series *Magnum P.I.* with actor Tom Selleck. Why? Because the helicopter was rigged with something called a Tyler mount—a giant gyroscopic stabilizer for cameras—fitted in the door. Hovering over Ala Moana shopping center and Waikiki Beach at twilight, I was certain the adventure was all for naught. There was just too much vibration, even with the gyroscopic mount. But mercifully

there was one sharp frame amid several rolls of film and it appeared double-page in *National Geographic*.

Yet there was a price for all of this flying we *National Geographic* photographers were asked to do. In the mid-1980s, two *National Geographic* colleagues were killed in helicopter crashes, including my best friend Gordon Gahan. Another *National Geographic* photographer was seriously injured in a hard landing at the Great Salt Lake in Utah. My friend Gordon had survived the Battle of Hill 875 at Dak To in Vietnam, in which some 155 paratroopers of the 173rd Airborne Brigade were killed, only to die of head injuries plunging into the harbor at Saint Thomas in the US Virgin Islands in front of the tourists on several cruise ships. Engine failure was cited as the cause of the crash. I gave one of the eulogies at Gordon's funeral at Riverside Church in Morningside Heights in Upper Manhattan on the eve of his fortieth birthday.

"Gordon was the quintessential photojournalist," I began, my leg quivering with stage fright. "He was the diplomat patiently waiting and with good humor negotiating with the Soviets or with a Third World embassy official. He loved good food and fine wine. And always he was a professional trying to show us what was important with exciting, finely crafted, beautiful pictures." What more to say except that I think of Gordon most every day?

Meanwhile, Bill Weems died when the helicopter from which he was photographing the Washington, DC, waterfront crashed into the Potomac River near Reagan National Airport. Bill had worked on Capitol Hill as a legislative assistant after serving as a naval intelligence officer and earning a master's degree at Johns Hopkins University. But Bill traded a secure, well-paying job for his passion to become a photojournalist and *National Geographic* photographer. Bill left behind his Hungarian-born wife Prisca, a son, and a daughter.

We journalists, like the military, used helicopters much like rental cars to get to and from inaccessible places, to photograph the unapproachable, and to see the world from a new perspective. Drones with miniaturized cameras are replacing photographers taking to the air, in good weather and bad, with veteran pilots and beginners who have just earned their wings. Gone are the times when photojournalists strapped in, inhaled the odor of jet fuel, donned earphones that blocked the deafening whine of the engine, and lifted off for places unseen. Not because it was fun, though flying nap-of-the-earth at high speed often was, but because we needed to see and bear witness. Aerial photographs, whether they are taken by a photojournalist, a drone operator, or both, help readers, viewers, and internet clickers see the world in all of its shapes, forms, patterns, and imperfections.

The helicopter crash in which Gordon Gahan was killed weighed on me as I marked my own fortieth birthday in Colombia covering the eruption of a volcano called Nevado del Ruiz in the Andes. The explosion of lava and hot gases on the snow-capped mountain triggered a mudslide mixed with ice and rocks that caught most of the residents of the town of Armero sleeping in their beds. More than twenty thousand Colombians were buried alive or killed outright. The only way I could get to Armero was hitchhiking on one of the giant US Army CH-47 Chinook helicopters that were leading the search for survivors and hauling relief supplies. (Before leaving for Colombia, I had called in a favor with a Pentagon press officer to ensure that I would be at the head of the line when US rescue operations began.)

On one of these rescue missions, we were about halfway up the 17,457-foot Nevado del Ruiz when the lumbering Chinook in which I was a passenger came within two or three seconds of colliding with electric power

A Thai Ranger surveys a farmer's opium poppies in a remote village of ethnic Hmong in the Golden Triangle, where Thailand, Laos, and Myanmar meet. Today, farmers on the Thai side of the border grow coffee, macadamia nuts, corn, and green vegetables. After traveling to thirty countries to report on the opium poppy, the author photographed heroin use only blocks from the White House in Washington, DC.

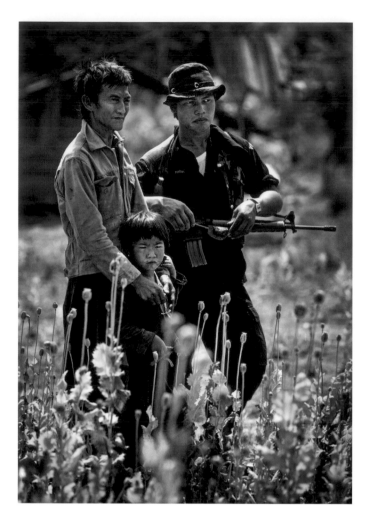

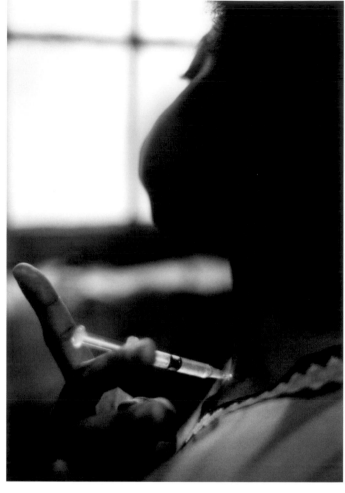

lines. Moments before we escaped this fatal collision, I had been standing in the door, photographing farmers with their arms outstretched, begging for help, when pilots firewalled the twin-engine behemoth of a helicopter, lifting us straight up like an express elevator and sending me tumbling to the deck. This wasn't the first time that I would cheat death in a helicopter. I had survived a crash in Vietnam and a hard landing in another helicopter while reporting on legal opium poppy cultivation on the Australian island of Tasmania. But the recent death of my best friend in a helicopter crash, coupled with this close call in Colombia, brought my own mortality into focus.

Approaching middle age, I asked myself many times, often after my children were asleep, if I was taking too many risks. There were my daughters, Katelynn and Susanna, to consider—today both successful career women and mothers.

Several months before the trip to Colombia, I was in Ethiopia's embattled Tigray and Eritrea provinces—Eritrea is now a separate country—to report on a famine that by the end of 1985 would claim more than one million lives. I was hitchhiking with the British Royal Air Force while working on a story with my colleague Peter White about the International Committee of the Red

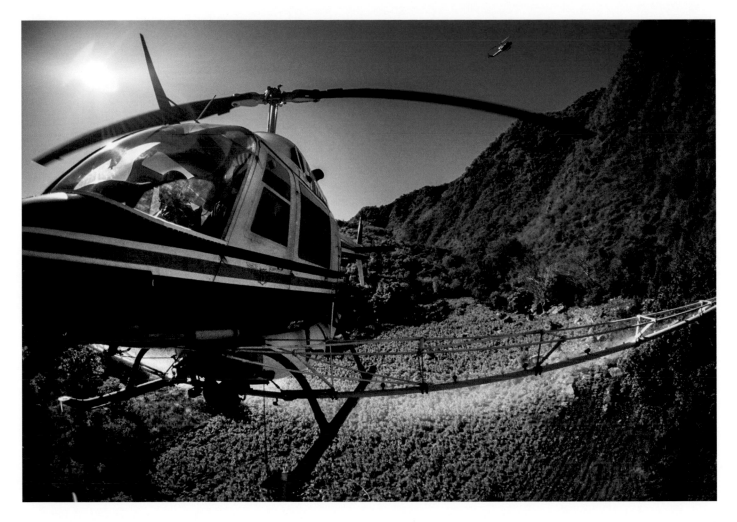

Using a powerful herbicide that kills everything in its path, Mexican police spray red and purple opium poppies and latex-filled seedpods in a remote quarter of the Sierra Madre Occidental. Authorities say Mexican cartels produce about half the heroin found in the United States, despite a robust campaign to eradicate poppy plantations that are protected by heavily armed militants.

Cross, which was flying humanitarian aid through rugged mountains, craggy canyons, and low clouds like Alaskan bush pilots, to land on gravel runways in what amounted to a war zone.

The cause of the famine was officially ascribed to drought, but the root causes were civil conflict and human rights abuses by a communist junta that ruled Ethiopia from 1974 to 1987 during a period called the "Red Terror." The powerful four-engine RAF C-130 Hercules would deliver us to makeshift camps on the inaccessible high Ethiopian Plateau, where we would find what one BBC News correspondent called the "closest thing

to hell on Earth," with the dead and dying overflowing small hospitals. Small arms fire, mortar barrages, and distant artillery exchanges frequently interrupted aid deliveries and food convoys. One day I rode with a food relief convoy of the International Committee of the Red Cross through Tigray Province to a camp that had been bombed by Ethiopian MiG jets just days before. I marveled at the fearlessness of the young ICRC delegates—their official title—but reminded myself that I, too, had felt somewhat invincible at their age. They wore no helmets or body armor as I did, just a badge with the Red Cross and Red Crescent symbols, which

seemed to me foolhardy considering that their relief convoys were sometimes targeted by the Ethiopian Air Force.

Meanwhile, there was "tension, if not enmity, between . . . the communist government of Chairman Mengistu Haile Mariam, Moscow's closest ally in Africa, and the Reagan administration, now the principal donor of emergency relief supplies to Ethiopia," as veteran British journalist William Shawcross said in his "Report from Ethiopia" for *Rolling Stone*. "The Ethiopian government almost never publicly acknowledged US aid." In fact, the hostility toward Americans was palpable, and my *National Geographic* colleague Peter White and I were forced to take government minders with us every time we left the capital of Addis Ababa. Our minders would greet fellow government workers as "comrade," which grew tiresome after a day and unbearable after two weeks. Occasionally their numbers were reinforced by East German security agents, another reminder of the Cold War rivalry that infected this wretched part of Africa.

Once upon a time, *National Geographic* photographers would have six weeks to six months for an assignment. I took a year to do the story about the opium poppy and eight months to document the humanitarian work of the International Red Cross in fourteen war zones, seeing doctors, nurses, and all-purpose "delegates" tend to the wounded, the sick, the dying, and prisoners of war. *National Geographic* photographers—there once was a mix of staff people like myself and contract, or freelance, photographers—had sufficient time to learn about the place and its people, and discover, focus, and conceptualize the story they wanted to tell. Understanding your subject well enough to have something to say with your pictures is perhaps the most difficult part of photojournalism. Actually taking the pictures, and being that eyewitness to history, is the payoff—the icing on the cake. Or so I tell students.

In a sense, we *National Geographic* photographers were photo-anthropologists, as former IU dean Trevor Brown described us at my retirement lecture—we spent a good part of our time getting to know the subject, the storyline, and the people. Like social scientists we would learn the sweep and complexity of cultures, including their history and sometimes the biological and physical sciences of the region. Photographing roughnecks ramming drill pipe into an oil well or talking to petroleum geologists on at least four continents, I have been grateful for the rigorous course I took in geology, now called earth sciences, at the University of Wisconsin–Madison. I can say the same for a long-remembered course in comparative politics, which helped me understand parliamentary democracies, the numerous incarnations of French republics, and, for what was to come later in my career, communism and communist governments.

Among my friends and former colleagues, examples abound of *National Geographic* photographers whose award-winning work has benefitted from long assignments and in-depth knowledge of their subjects. David Doubilet, whose honeymoon I interrupted in Israel in the early 1970s to ask for help with a picture of aquaculture in the Negev Desert, is probably the world's most accomplished underwater photographer. David's knowledge of the world's oceans, from the Southwest Pacific to the North Atlantic, and of freshwater ecosystems such as Botswana's Okavango Delta and Canada's Saint Lawrence River, has earned him a fellowship in the Royal Photographic Society in London, as well as the prestigious Lowell Thomas Award and the Lennart Nilsson Award in Photography. Wildlife photographer Frans Lanting's work has literally taken him to the far corners of the earth. As a photographer and conservationist, Frans has won the Sierra Club's Ansel Adams Award and the title of BBC Wildlife Photographer of the Year, and was made Knight in the

Royal Order of the Golden Ark by Prince Bernhard of the Netherlands. Another friend and former colleague, Jim Richardson, from the plains of Kansas, has focused on the challenges of feeding humankind, whose population will likely reach 9.6 billion by 2050—if not more. Drawing on twenty years of *National Geographic* reporting about agricultural subjects, Richardson has traced the story of food from the beginning of settled agriculture some ten thousand years ago to the critical research and development taking place today in laboratories around the world.

But sadly, the support for in-depth photojournalism, in which words serve as a counterpoint to images that strike an emotional cord, has withered. Today, *National Geographic* assignments are shorter and laser focused on specific issues, be it the global food supply or threats to African wildlife, and all of the photography is done by freelancers—some young and on their first assignment, others veterans with international reputations as journalists and artists. All of this comes as the magazine's subscription base is shrinking: few readers now bother to collect and stack old issues in their basements, and kids increasingly turn to their iPads for maps. *National Geographic's* domestic circulation totals about 4 million (international editions bring this up to 6.8 million), down from 10.8 million at its peak in 1989. But it is still the eighth-largest magazine in the United States, according to the Alliance for Audited Media. *National Geographic's* web traffic is escalating, and several apps target students and nature enthusiasts.

But by 2015, it became clear that the refocusing and cutbacks at *National Geographic* would not be enough to save the iconic yellow-bordered magazine. Financial problems and declining circulation forced the nonprofit National Geographic Society to sell the beloved magazine and its media assets to for-profit 21st Century Fox, whose principal shareholder is media tycoon Rupert Murdoch.

Hundreds of staffers took buyouts on the eve of the Fox takeover, gutting the magazine of talent and corporate memory. The sale of *National Geographic* to Fox, which already had a majority share in National Geographic's TV channels, came amid broad declines in the magazine industry, according to the Pew Research Center's Project for Excellence in Journalism, which reports that news magazines, including *Time* and *Newsweek*, as well as four smaller niche publications—*The Economist, The Atlantic, The Week* and *The New Yorker*—are among the hardest hit. In an interview about the National Geographic Society's upheavals, CEO Gary Knell said that "the digital 'disruption' in the media business has made the old ways of doing business unsustainable," according to Paul Farhi of the *Washington Post*.

These changes at *National Geographic* come as photojournalism itself has changed. Increasingly, editors are no longer looking for what French documentary photographer Henri Cartier-Bresson termed the "decisive moment," in which the journalistic message and the aesthetic elements come together in one eye-catching moment. Instead, pictures are more layered, with out-of-focus foregrounds leading readers into a mix of messages in middle distance and beyond. Editors speak openly of how women photographers seem more capable of capturing the subtle "moment between the moments" in pictures that evoke a more nuanced recreation of reality.

Social media has also played its part in changing the profession. Today a photojournalist must be able to navigate the terrain of Facebook, Twitter, Instagram, and other platforms, posting images from the field as a story unfolds with meaningful captions that tell the reader what to think about the pictures. And photojournalists must now at least be competent in shooting and editing video, which today is viewed as an essential component of all digital media websites. I am perhaps unusual as a photojournalist

A giant Sioux Indian painted on its tail, a French Air Force Mirage 2000N nuclear attack jet streaks across the countryside. The fighter-bomber is assigned to the *Escadrille de Lafayette*, or Lafayette Squadron, which during World War I was composed of American volunteer pilots who adopted the Sioux insignia.

in that I often write the stories that accompany my photographs. But all visual storytellers must be able to craft compelling captions that describe what is happening in the photograph, clear up questions or ambiguities, and tell the reader or viewer what to think about a picture.

Writing about "Photojournalism in the Age of New Media" for the *Atlantic,* Jared Keller says a whole universe of photojournalists, "both amateur and professional, is now available to [editors and] the public through social networks, allowing news organizations to ferret out important stories using tools beyond their existing technical capabilities." "When there's a breaking story," says Santiago Lyon, long-time director of photography for the Associated Press, in the same article, "whether it's an ongoing crisis or a spot development—like a plane down in the Hudson—we're very actively trolling social media sites for imagery: performing searches, scraping Twitter and

Facebook, soliciting information." Verification of images posted on social media remains a problem, but there is no turning back for *National Geographic* or any other major newspaper and magazine. Editors today can select from an almost infinite number of pictures made by a mix of tourists, voyeurs, and drive-by journalists. And scholars rightly ask if the acceleration of delivery and consumption of images in a 24-7 world has diminished the impact of the single image. Probably not. So long as we still have editors making decisions about what pictures tell a story with the greatest clarity, emotional impact, and compelling visual organization, or composition, the best images have a good chance of being seen by the public.

Moreover, this isn't to say major magazines and newspapers such as the *New York Times* and the *Washington Post* have abandoned their in-depth coverage of major social, environmental, and scientific issues. They haven't. For example, author and photojournalist Lynsey Addario has reported from Afghanistan, Libya, Iraq, Lebanon, Darfur, and the Congo on issues ranging from the women of Afghanistan to Baghdad on the eve of the US withdrawal in 2011. Other photojournalists are partnering with nonprofit organizations such as the Pulitzer Center for Crisis Reporting, an independent organization that sponsors reporting on global affairs, and ProPublica, another nonprofit that produces investigative journalism in the public interest. Human rights groups and nongovernmental organizations, from Doctors Without Borders to the Nature Conservancy, also offer photographers opportunities. In return for access, some photojournalists will donate their work or heavily discount their fees.

But gone are the large magazine staffs of talented generalists with a certain self-assured flamboyance—generally white men, though Margaret Bourke-White of *LIFE*, Jodi Cobb of *National Geographic*, and Annie Leibovitz of

Rolling Stone set a high bar years before women became commonplace in the profession. And big agencies such as Magnum Photos and VII, based in New York and Paris, are finding they must diversify their stable of contributors or close their doors. Today, editors are looking for freelancers with some years of photojournalism experience, but sadly little else beyond how much a photographer will cost them. Veteran editor and mentor of a generation of photojournalists Don Winslow says there used to be a personality with a name, reputation, and special way of seeing the world assigned to photography. But no more. Most photojournalism is anonymous. Few editors or publishers today care about "the vision thing." With the advent of smart phones, tablets, and point-and-shoot digital cameras, everyone is a photographer. Which is a bit like saying I own a copy of Microsoft Word, therefore I'm going to write like Earnest Hemingway.

There still are photographers with a driving need to tell stories, as well as specializations in portraiture; aviation and drones; and wildlife, underwater, nature, still life, or scientific photography. But their ranks are thinning as it becomes harder and harder to earn a living taking still photographs. Today, much of the best work in photojournalism is driven by the passion of young people. I think of the work of freelancer James Foley of Evanston, Illinois, the American photojournalist beheaded by Islamic State militants in 2014 after repeated trips inside Syria to document a brutal civil war—an all-consuming story Foley gave his life to tell. "No matter what kind of story you're trying to tell, you have to get in there and be very intimately involved with your subjects," says Addario, whose best-selling book *It's What I Do* is a must-read for any aspiring photojournalist. "You have to care."

Until the early 1970s, few *National Geographic* readers associated the magazine with reporting about conflicts.

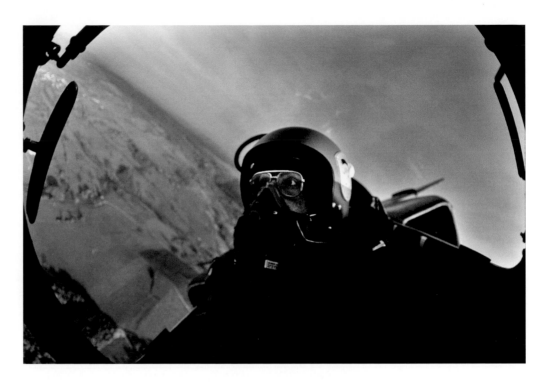

But by the time I joined the *Geographic* in May of 1972, Wilbur E. "Bill" Garrett was sharpening the look and focus of the magazine as he steadily climbed the career ladder to become editor in 1980. And with Garrett's rise came an increased focus on the world's hot spots. A restless photojournalist who never seemed comfortable behind a desk, Garrett had already won photographic honors for his *National Geographic* coverage of the Vietnam War. When he died in 2016, Garrett was eulogized by former *Geographic* staff writer Cathy Newman as a person who "loved smart, compelling ideas and people who could execute them, and pushed to extend the range of hard-charging subjects covered by the magazine." The secret to Garrett's success in making *National Geographic* the world's most talked-about picture magazine during the golden age of photojournalism in the 1970s, 1980s, and 1990s was no secret, said former staff photographer James L. Stanfield

Flying with the *Escadrille de Lafayette* of the French Air Force, the author snaps what can only be described as the "ultimate selfie," as his pilot makes a steep, high-G turn approaching the foothills of the Alps. The Lafayette Squadron's Mirage 2000Ns form the core of the French air-based nuclear deterrence.

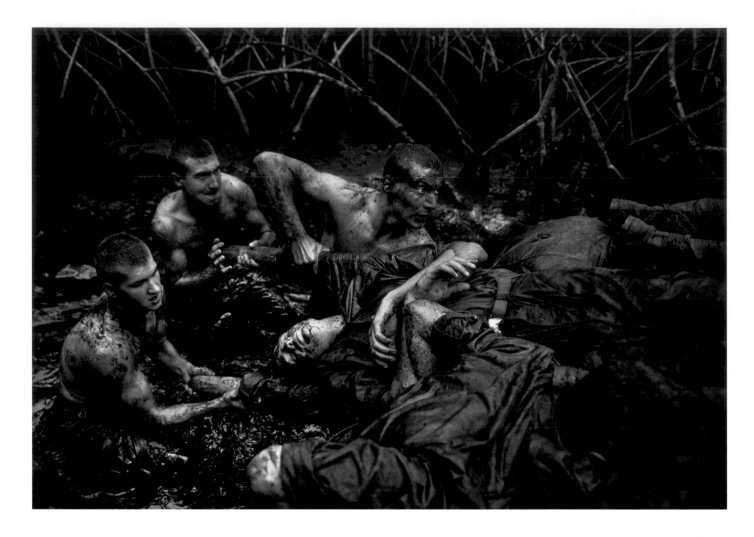

Deep in a West African swamp, French Marines in Gabon carry an injured comrade to safety. With Al-Qaeda and the Islamic State looming as threats in Africa, France retains considerable influence in its former colonies, and is fighting militants in Mali, Mauritania, Burkina Faso, Niger, and Chad. French troops are also stationed in Ivory Coast and Gabon—rich markets for French businesses.

at Garrett's memorial service: He "surrounded himself with those made of a different fiber—men and women who were committed, courageous, and charismatic . . . an assortment of gifted individuals who were curious, stubborn, and perfectionistic!"

My career prospered under Garrett and in many ways reflected his focus on conflicts and global issues. I had been wounded in Cambodia in 1974, after all, had barely survived a terrorist bombing in Afghanistan in 1984, and, over the years, had photographed fighting in Northern Ireland, Vietnam, El Salvador, and the Horn of Africa, on Thailand's porous borders, and between the Polisario

Front guerrillas and the Moroccan Army. In 1986, I was embedded for a month over Christmas and New Year's with the US Navy during the so-called "Tanker War" in the Persian Gulf. This anti-shipping campaign was part of the larger Iran-Iraq War of 1980–88, with Iran attacking ships belonging to Iraq's trading partners and to countries that loaned Iraq money to support its war effort. My friend Dick Swanson, a former *LIFE* magazine staff photographer of Vietnam fame, says that you remember the sound of every bullet fired at you. And he is right. To this I would add every red-colored Iranian tracer bullet fired at the helicopter I shared with ABC News as we flew

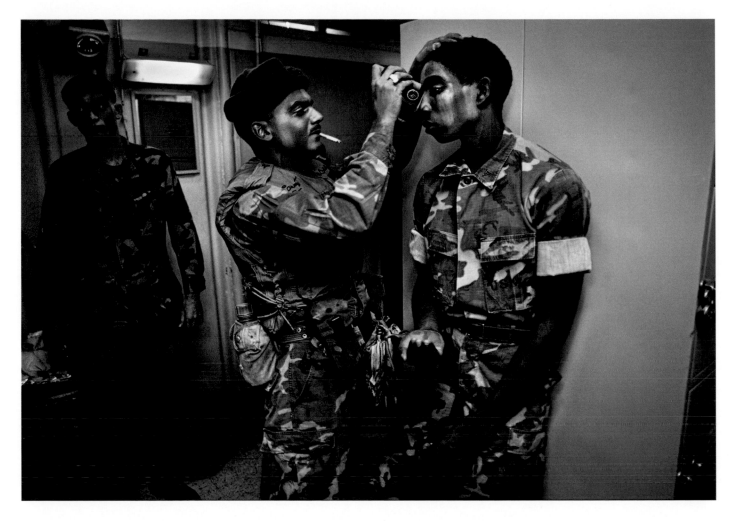

US Marines apply camouflage war paint on board a navy amphibious assault ship before storming ashore in an exercise near Perth, Australia. In recent years, quick-reaction marine units based at sea have fought in Afghanistan, provided artillery fire for forces fighting Islamic State militants in Syria, and, with their helicopters, brought hurricane relief supplies to the Caribbean.

several times from Dubai into the Strait of Hormuz to see oil tankers attacked and set ablaze by gunboats of the Iranian Revolutionary Guards.

By the summer of 1984 I was frankly happy to put that part of my career on hold and go west to Stanford University in Palo Alto, California, to study Russia and the Soviet Union as a John S. Knight Journalism Fellow. This was a globally competitive sabbatical for midcareer journalists, much like the Neiman Foundation for Journalism program at Harvard University, where I was also accepted. The late Howard Simons of the *Washington Post*, who ran the Neiman fellowships at the time, advised me to take the

Stanford option, saying, as I recall, that Harvard would be a culture much like that at *National Geographic*, with tweedy sport jackets, neckties, and a lot of lunches and seminars with experts from think tanks and universities along the Boston–New York–Washington corridor. Stanford, indeed, provided a new and liberating way of seeing the world, a place detached by time and distance from the mayhem on the front pages of the *Washington Post* and *New York Times*. In Palo Alto, I had the luxury to reflect on my life and career, to learn about the history of modern Japan, to examine colonialism in Southeast Asia, or to go to the Green or Lathrop libraries and pick up a

book simply because it satisfied some inner curiosity. On reflection, my family and I agree that it was one of the best years of our lives.

Former secretary of state Condoleezza Rice, then a young assistant professor with a host of teaching awards to her credit, was my favorite instructor. I took three graduate classes from her on the role of the military in foreign affairs, the Soviet perspective on the Cold War, and Soviet policy in the developing world. Whatever hard-right conservative worldview she later showed working for former president George W. Bush, Rice introduced me to a circle I had only read about in the newspapers. As a political science professor, she served as a special assistant to the director of the Joint Chiefs of Staff at the Pentagon and was a fellow at the Council on Foreign Relations. She knew influential people and generously shared her ideas and theirs over lunch or dinner. Condi once told me she preferred to travel to the former Soviet Union and Eastern Europe only occasionally, instead examining our adversaries from afar, and in several languages, through the speeches and writings of academics, politicians, and intelligence officials. While this was surely not the way I approached the world, Rice helped me to understand, once again, that without knowing the languages, history, and context of the Soviet Union in the world—my next "permanent" assignment at *National Geographic*—I was apt to fail before I began.

Rice also took a shine to our daughters, Katelynn and Susanna. Years later, when she was national security adviser to president George W. Bush, she would be a career mentor to Susanna, then a White House intern. Interestingly, their relationship was not one based on foreign policy, but on music. Rice was a brilliant classical pianist and Susanna, though she held a top-secret security clearance and strolled the executive mansion delivering documents and briefing books to the powerful at will, wanted a career

as an opera singer. Rice had given up a promising career as a concert pianist because she feared she would never make it to the very top. But she advised Susanna to follow her dreams and her talents, which is what she did.

Despite my hard-earned five-year assignment in the Soviet Union, I volunteered to go to Saudi Arabia in 1990 after Iraqi leader Saddam Hussein invaded and occupied neighboring Kuwait. My job was to establish a *National Geographic* presence for a war that began the following January. By the time the air war against Iraq started on January 17, 1991, a thirty-four-nation coalition stood arrayed against Saddam Hussein. I joined the US Army's First Cavalry Division as it took up positions on the Saudi-Iraq border. And I landed by helicopter on the teak-covered decks of the battleship USS *Wisconsin*, a dreadnought whose keel was laid in 1941, to see the opening rounds of the conflict. But a post-Vietnam policy of keeping the news media at arm's length from the fighting meant most journalists saw very little of either the five-week air war against Iraq or the hundred-hour ground offensive to rid Kuwait of occupying Iraqi soldiers. So effective was the Pentagon's censorship that in the history of modern warfare there are no images of the greatest tank battle to ever take place in the western Iraqi desert and few published pictures of the dead and the dying on either side.

My experience and interest in conflict reporting would allow me to create, some years later, a course at Indiana University on reporting war, terrorism, and humanitarian intervention. This was not a how-to class, but an academic look at subjects from the history of war correspondence and its modern inception in the Crimean War of 1853–56, to the age-old tension between professionalism and patriotism, the way women correspondents changed how war is reported, the power of images, and the struggle inside the global news media to define who is a terrorist and what defines an act of terrorism. The course

pulls no punches, looking at brutality and inhumanity in all its darkness during World War II—the Holocaust, Japan's "Rape of Nanjing" and its treatment of prisoners of war, the mass rapes by Soviet soldiers of German women in the dying days of the war, the British firebombing of Dresden, the American firebombing of Tokyo, and culminating in the United States' use of the atomic bomb against Hiroshima and Nagasaki. Why? Because I wanted students to put a human face on mass extermination, enslavement, torture, deportation, and the plunder of public and private property. This is what we in the media and in the global institutions that were born out of World War II mean when we say something is a war crime or a crime against humanity.

I also try to help students understand the addictiveness of conflict, how it summons soldier and journalist alike from their diverse stations in life to find a meaning that, in the words of *New York Times* correspondent Chris Hedges, "elevates life above the trivial" and demands the most we can ever give. As Hedges cautions in his book *War Is A Force That Gives Us Meaning*, "the rush of battle is a potent and often lethal addiction, for war is a drug" —one that many of us have ingested.

Being in a combat zone gives your work extra meaning, often becoming the biggest story of your career, until bad guys can no longer kill you. In 1985, after traveling for eight months with the International Committee of the Red Cross to document its humanitarian work in a dozen or more war zones, I was saying my good-byes to doctors and aid workers in El Salvador. I had an airline ticket for a flight home to Washington, DC, the following day. But our bonhomie was interrupted by a crackling radio request to mount a convoy into the contested jungle north of San Miguel to rescue a wounded anti-government guerrilla fighter with a bullet in her brain. I wrestled with my conscience for a minute or two, knowing no one

at *National Geographic* would ever be the wiser if I passed up another dangerous mission that might or might not make good pictures. "I'm in," I recall saying to the ICRC mission chief. And with that we were off the next morning on a harrowing adventure. Our convoy was fired upon by a Salvadoran or American army helicopter. We had to ford a river seeded with landmines and navigate several rebel roadblocks and checkpoints. But the rebel fighter made it to a government hospital, and, still full of adrenaline, the International Red Cross nurses and doctor were hugging me and one another. And we were all ready to do it again tomorrow if need be.

But it is wrong to think of risk-taking photojournalists, and war correspondents generally, as "adrenaline junkies." Canadian neuropsychiatrist Anthony Feinstein implicates various chemicals in our brains as key modulators of risk-seeking behavior—high levels of certain brain chemicals make some of us comfortable with a daily routine and a nine-to-five job, while high levels of others draw some to high-risk professions. Feinstein's interviews with war correspondents suggest they are more likely to have unhappy childhoods, with "divorced parents; aloof, dysfunctional military fathers; troubled families." They tend to be "rudderless young men and women in search of identity, meaning, and that missing family." In reporting on conflicts, journalists form many of the same types of emotional bonds that soldiers and pilots do. To use a cliché, these attachments are forged in blood, heartache, and a certain knowledge that your fellow photographers have your back. But Feinstein finds there are also journalists who are driven to cover conflict because they want to be eyewitnesses to history. In my experience, it is not the pay or the awards that motivate war photographers, but, as the late Howard Chapnick of the Black Star agency said, a sense of moral outrage at the obscenities of their times.

Shot in the brain while cleaning her rifle, a fighter of Farabundo Martí National Liberation Front is treated by a medical team of the International Committee of the Red Cross in a Salvadoran jungle. Between 1980 and 1992, civil war ravaged the Central American state, claiming some seventy-five thousand lives in what the *New York Times* called "the most violent theater of the East-West conflict in the hemisphere."

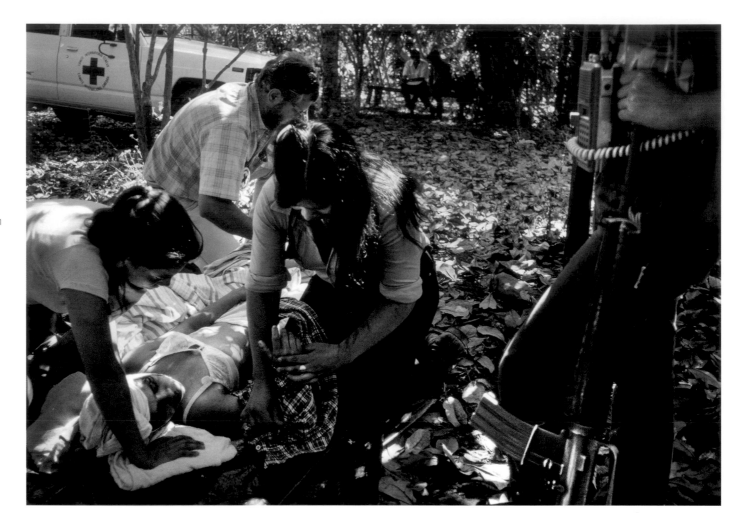

Over the years, my classes have spent a lot of time reading the words of the late Martha Gellhorn, who, as a young American in the middle of the Spanish Civil War, kept the company of Ernest Hemingway, Robert Capa, and other great war journalists. She started writing for *Colliers Weekly*, where she wrote not about strategy, battles, tanks, and bullets, but about the human toll of conflict—about the civilians caught in the middle. Her sympathies were always with the common soldier, the wounded, the young, and war's other innocent victims.

Gellhorn was never woolly or sentimental, and her writing, almost without exception, stands up extraor-

dinarily well after seven decades. Just read her *Collier's Weekly* account of being in the Dachau concentration camp the day after its liberation in April 1945. "Behind the barbed wire and the electric fence the skeletons sat in the sun and searched themselves for lice," she writes. "They have no age and no faces; they all look alike and like nothing you will ever see if you are lucky." Gellhorn told the story through close attention to detail and matter-of-fact prose that immersed the reader in the unspeakable realities of Dachau. She leaves us a legacy that is vital for students to understand. She and the men and women who followed her, like Gloria Emerson of the *New York Times*

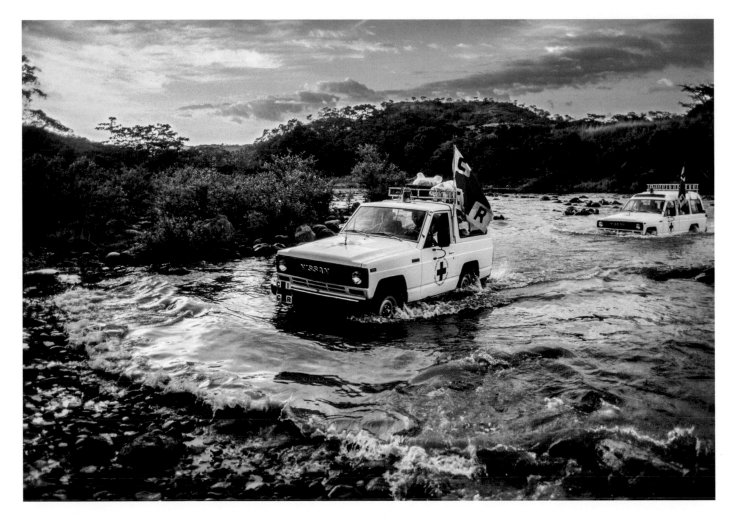

A wounded guerilla fighter (*on facing page*) is ferried in a convoy of International Red Cross vehicles to a hospital run by the Salvadoran government. Fording the Toroloa River near the Salvadoran-Honduran border, aid workers and the author sat on their bullet-proof vests to protect themselves from mines laid in the river bottom, should one explode beneath a vehicle—standard practice in war zones.

in Vietnam, believed it was essential to bear witness. Publicists, propagandists, and prevaricators are well rewarded for framing events to promote the agendas of powerful interests. Without journalists there will be no enduring public accounts to challenge their lies. Journalists may not be able to change policies or stop wars, Gellhorn said in a BBC interview late in her life, but they can get what happened on the record.

The world's most famous war photographer, Robert Capa, recorded in blurred, grainy images the American landings on Omaha Beach on June 6, 1944—the beginning of the Allied liberation of Europe—for *LIFE* magazine. Capa waded through the surf on the Normandy coast, wearing only a helmet and life jacket and carrying two small 35mm cameras, to photograph the first assault troops of the US First and Twenty-Ninth Infantry Divisions, which would suffer nearly four thousand casualties that fateful morning. Capa's name and reputation for courage live on, in part through his famous aphorism that I have many times silently repeated to myself: "If your pictures aren't good enough, you're not close enough."

Capa leaves another lesson for those of us who teach photojournalism. Born Endre Friedmann in Budapest,

Food donated by the European Union is delivered by the International Committee of the Red Cross, a neutral Swiss intermediary, to Rama, near the border between Ethiopia and Eritrea, during a 1983–85 famine that pierced the world's conscience. Human rights organizations say as many as half of the one-million famine deaths resulted from civil war and human rights abuses that aggravated food shortages.

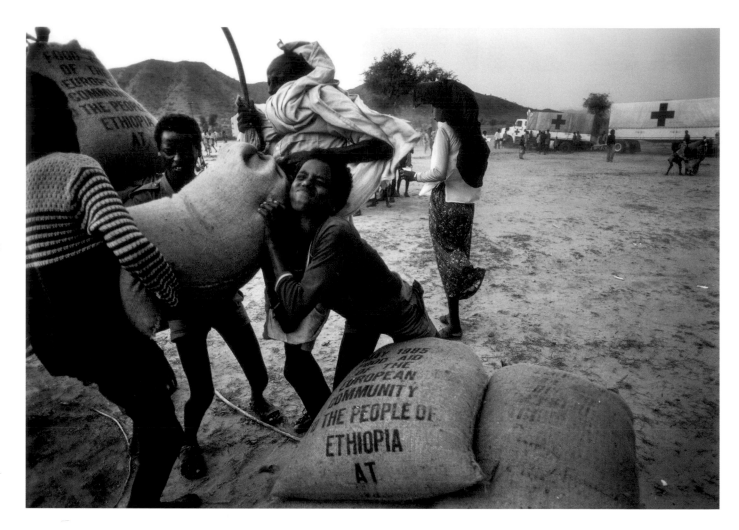

then part of the Austro-Hungarian Empire, Capa was a Jew on the run from anti-Semitism and fascism, who along the way took the nom de guerre Robert Capa and moved from conflict to conflict—from Spain and China to North Africa and through Western Europe—until his beloved Paris was liberated. For Capa this was the most important moment of the war, the vanquishing of a foe he had spent a decade fighting. As I try to help students understand, Capa was a photographer with a mission, and he lost interest in World War II once it was clear that Nazi Germany would soon be defeated. To look at Capa's pictures, not just of the D-Day invasion at Normandy,

but of resolute American paratroopers, forsaken German POWs, and weeping Parisians, is to see a photographer with extraordinary empathy and, importantly, a personal attachment to his story. There was nothing indifferent, nothing objective about Robert Capa and his pictures. As I tell students, our best work often comes when we are most involved and have clear and fixed loyalties.

Capa, like other photographers who covered World War II, was a partisan for the Allied cause. But since the Vietnam conflict, photojournalists have taken a more independent stance, eschewing as often as possible the

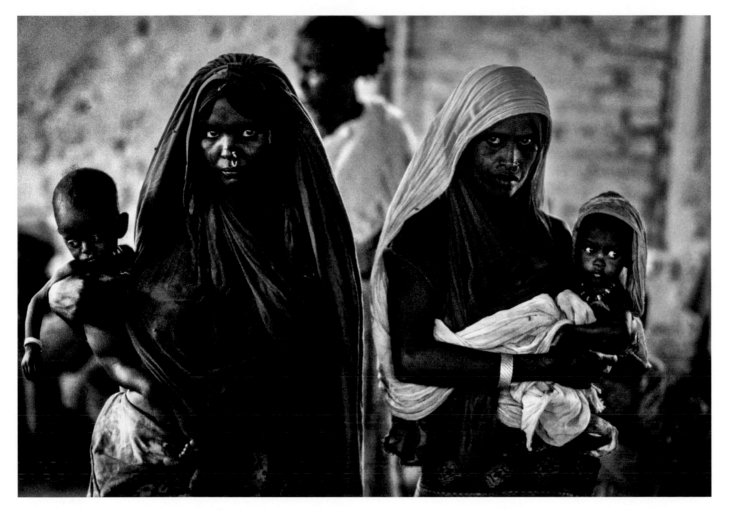

Victims of civil strife and drought, families of the nomadic Beni Amer tribe gather at a feeding center run by the International Committee of the Red Cross during the 1983–85 Ethiopian Famine. The Arabic-speaking Beni Amer live in Eritrea and Sudan, but fighting between the then-communist Ethiopian government and various insurgent groups forced the migration of minorities to the safety of Red Cross camps.

government censors and minders, focusing on civilians as often as soldiers, and telling the story from every angle, including the "enemy's." The late *New York Times* correspondent and author David Halberstam wrote eloquently of the photographers of Vietnam: "War correspondents always know who is real and who is not," Halberstam begins in his introduction to *Requiem*, a photographic tribute to the photojournalists of all sides who died in Indochina. "We who were print people and who dealt only in words and not in images always knew that the photographers were the brave ones. . . . They were real because they had to be real; they could not, as we

print people could, arrive a little late for the action, be briefed, and then, through the skilled use of interviews and journalism, re-create a scene with stunning accuracy, writing a marvelous you-are-there story that reeked of intimacy even though, in truth, we had missed it all." Some 135 photographers from all sides of the Vietnam conflict are recorded as missing or having been killed—a toll far higher than that of World War II. And today we honor the sacrifices of Vietnamese communists armed with cameras as much as our own.

Since 1992, when the Committee to Protect Journalists began keeping statistics, some 15 percent of all

journalists killed in the line of duty have been TV videographers and 10 percent still photographers. Astonishingly, some 66 percent of those killed were murdered for partisan and political reasons, while only 21 percent were caught in the crossfire of battle. In the second decade of the twenty-first century, Iraq and Syria are consistently among the deadliest countries for photojournalists. Though Afghanistan does not rank as high on the CPJ scale and Libya isn't even mentioned, I will never forget my friends and fellow professionals who perished there in recent years: David Gilkey, a veteran news photographer and video editor for National Public Radio, who was killed in 2016 while on assignment in southern Afghanistan; Anja Niedringhaus of the Associated Press, who was killed when an Afghan policeman opened fire while she was sitting in a car waiting to take pictures at an election polling place in April 2014; Chris Hondros, a brilliant young American who made his name in the Liberian Civil War and in Iraq, who was killed by a rocket-propelled grenade in Misrata, Libya, in April 2011; and Tim Hetherington, a British photojournalist, filmmaker, and human rights advocate, who was killed together with Hondros in Misrata, Libya. Hetherington produced the gripping documentary *Restrepo* that followed a platoon of the US Army's 173rd Airborne Brigade for nearly a year in Afghanistan, showing the soldiers alternately naive and weary as months of boredom and fighting took their toll.

Neuropsychiatrist Feinstein, perhaps the world's authority on war, journalism, and stress, has documented the price we pay for covering wars in essays for Toronto's *Globe and Mail* and in his book *Journalists Under Fire*. "The persona of the war reporter is well established. These men and women occupy a unique niche in the media—a small, intrepid group whose high public profile is given a vast stage by a world perpetually in conflict," writes Feinstein. "Some like Ernie Pyle, Robert Capa, and Martha

Gellhorn have attained a legendary status, their names inextricably linked to cataclysms that have shaped how we live today." And rightly so, says Feinstein: "Keeping us informed of world events that have the power to shake us loose, even momentarily, from our comfort and complacency, correspondents' work is more essential than ever before. . . . To the viewer or reader whose attention has been captured by the content of breaking news, what is not so readily apparent, for it is frequently obscured by the courage of journalists, is that this work can often come at a terrible personal cost." Ernie Pyle was killed by a Japanese sniper on the tiny island of Ie Shima near Okinawa at the end of World War II. Robert Capa stepped on a land mine in Vietnam in 1954, and Capa's great love, the photojournalist Gerda Taro, was killed by a tank in the Spanish Civil War. Martha Gellhorn committed suicide. And the legendary correspondent Marie Colvin, an American who wrote for the *Sunday Times* of London, died in a Syrian mortar attack in Homs in 2012.

Moreover, Feinstein finds that a decades-old unwritten code—one that saw journalists as non-combatant "neutrals" and allowed them to work in war zones without fear of being held ransom or executed on camera—has all but evaporated. For example, correspondents and broadcasters working in Nazi Germany and Japan were interned and eventually repatriated when the United States entered World War II. It was the Khmer Rouge more than the Vietcong or North Vietnamese who changed the equation during the war in Southeast Asia. Some thirty-two foreign and five Cambodian journalists died during the 1970 to 1975 fighting in Cambodia.

Today journalists have no neutral status in conflicts, civil or international. Moreover, unlike other professions that go into harm's way—the military, police, or firefighters—journalists have little or no training in the hazards of the battlefield. Few journalists, unless they served in

the military, could apply life-saving first aid to a sucking chest wound or use a weapon to protect themselves from a determined enemy.

As I tell students, there is an old military maximum that goes like this: "We train like we fight and fight like we train." Indeed, rigorous, realistic training pays off in winning battles for armies, navies, and air forces. I have witnessed Operation Red Flag exercises at Nellis Air Force Base outside Las Vegas, where pilots from the United States and its NATO and Asian allies go canopy-to-canopy in some of the most realistic war games in the world, across some 15,000 square miles of airspace and 4,700 square miles of restricted land. But we journalists have few war training programs and no fellow soldiers on our left and right with the know-how, equipment, and commitment to bring us home alive or dead.

Today, war correspondents face the constant threat of abduction and see mock executions and the beheadings of close colleagues shown live over the internet. And this comes with psychological consequences: post-traumatic stress disorder or PTSD, depression, deterioration of personal relationships, and substance abuse, especially alcohol. War journalists, both men and women, drink twice as much booze as their colleagues back in the home office. Moreover, few have adequate support systems in place for them—one of the major deficiencies of cash-poor newspapers, magazines, TV networks, and news websites that are often in downsize mode.

Not surprisingly, the symptoms of PTSD—hyper-vigilance, flashbacks, guilt, loneliness, insomnia, and emotional detachment—are distributed differently according to the type of journalism we practice. In studies of conflict journalists during the two decades of war in Iraq

and Afghanistan, psychologist Feinstein and others have discovered that PTSD symptoms are most frequent and intense in still photographers, followed by cameramen or videographers, then print reporters, and finally TV producers and correspondents. The necessity for photographers and cameramen to be closest to events offers the simplest, most eloquent explanation for these findings.

I saw the hyper-vigilance of war correspondents played out one spring day in Washington, DC, in almost comedic fashion. Walking to lunch with two fellow *National Geographic* photographers who had served in Vietnam, I heard a thunderous boom roll across Dupont Circle. Photographers Gordon Gahan, Dick Durrance, and I flung ourselves onto the grass and rolled into protective crouches, ready for incoming fire. We had reacted, dramatically, in the middle of one of Washington's busiest parks, to the sound of a truck backfiring. Our reactions were reflexive—a form of hyper-vigilance that can keep you alive in combat, but can dampen your attention span, learning, and memory when it comes to non-threatening events, mental health researchers say.

War correspondents and photographers show great resilience in the face of adversity. But war will take its toll in the end, and the greater the number of assignments photographing traumatic events, the greater the level of distress and PTSD photojournalists report. While servicemen and women rotate home regularly, what war photographers do is go from conflict to conflict, because it is their job. Bumper stickers expressing support for American troops in combat seem plentiful, well into the second decade after 9/11. But most war photographers remain largely unknown to the public they so unflinchingly serve.

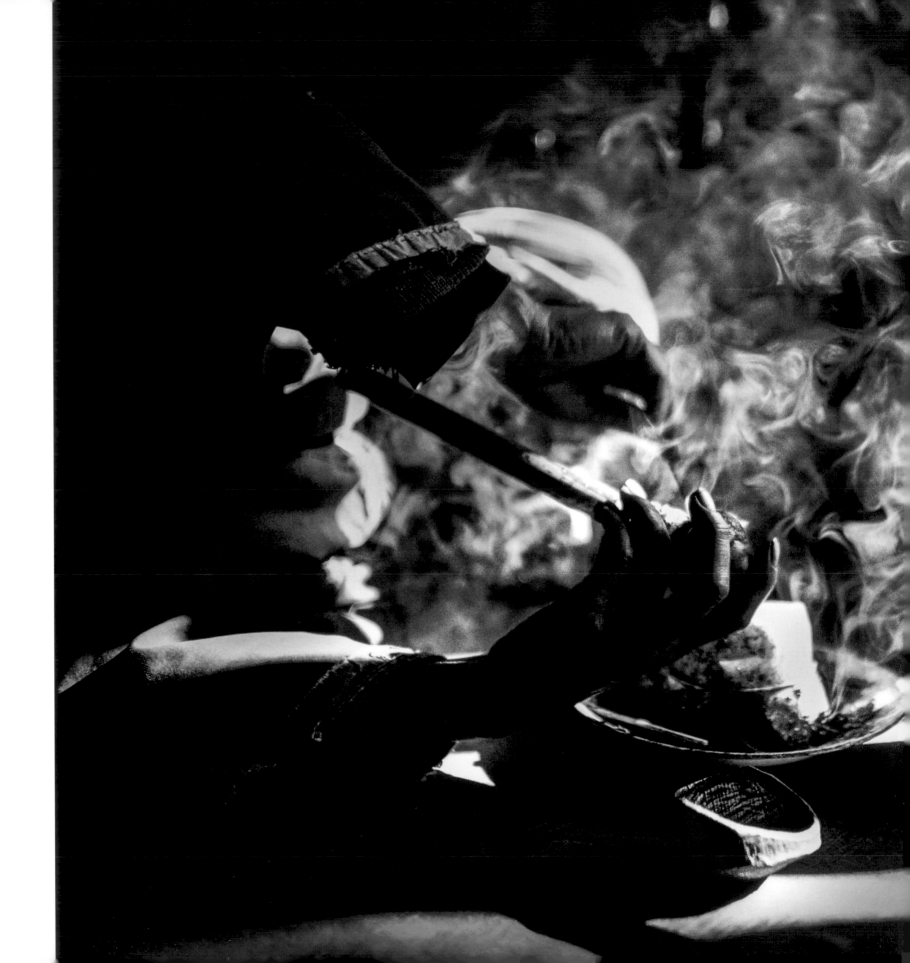

Engulfed in opium smoke, an addict of the Lisu ethnic hill tribe mixes a pipe of the narcotic in a village in the Golden Triangle of Southeast Asia, where Thailand, Laos, and Myanmar meet. The Golden Triangle was the largest supplier of opium in the world, but the region has since been eclipsed by the Golden Crescent—the poppy-growing area in and around Afghanistan.

83

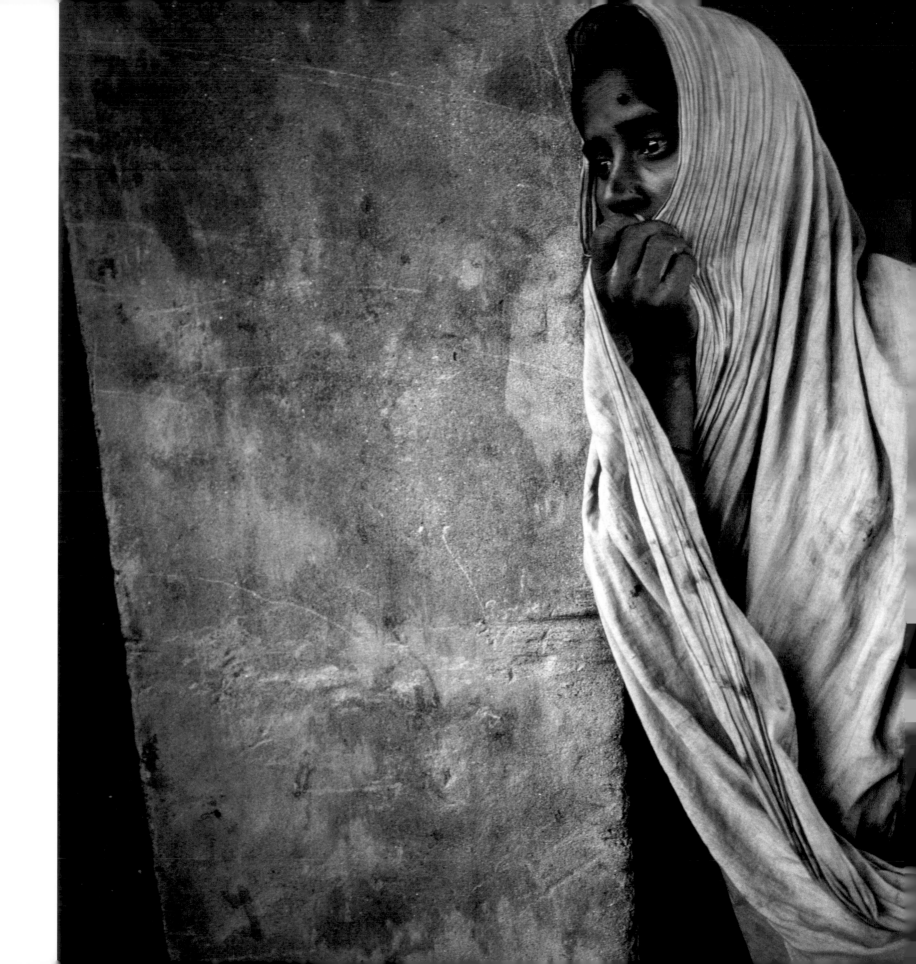

Ration card clutched in her left hand, a mother
waits with her three hungry children for powdered
milk donated by the United States and Canada and
dispensed by the Dutch Red Cross—another mind-
numbing scene in Bangladesh during the 1974 famine.
International relief experts called Bangladesh the
most underfed and overcrowded nation in the world,
while the *New York Times* reported, "Mass hunger
and starvation is no longer a threat. It is here."

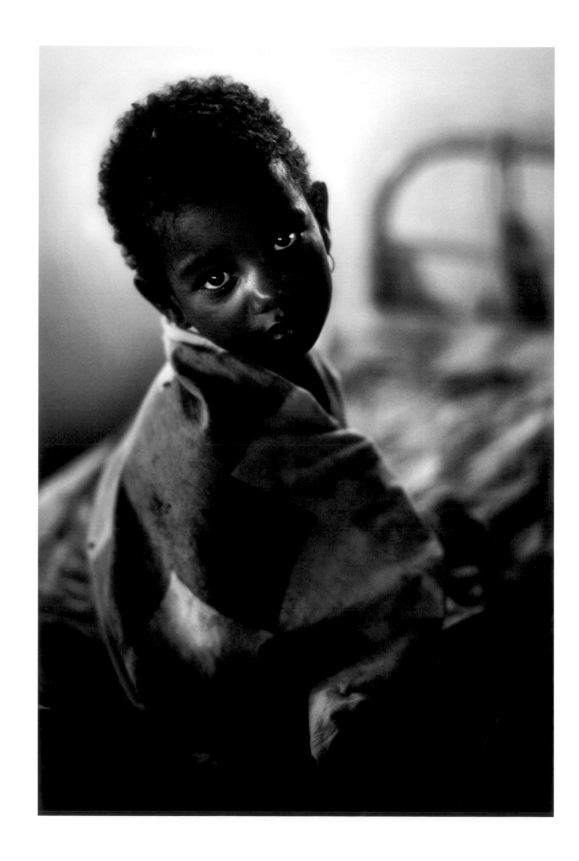

Clad in a discarded grain sack, an Ethiopian girl waits
to be examined by a doctor in a ward full of sick and
dying children. In a neighboring bed, the author
photographed a doctor holding the hand of a fragile,
skeletal patient as the child died of complications of
malnutrition—a tragic cost of famine and civil strife.

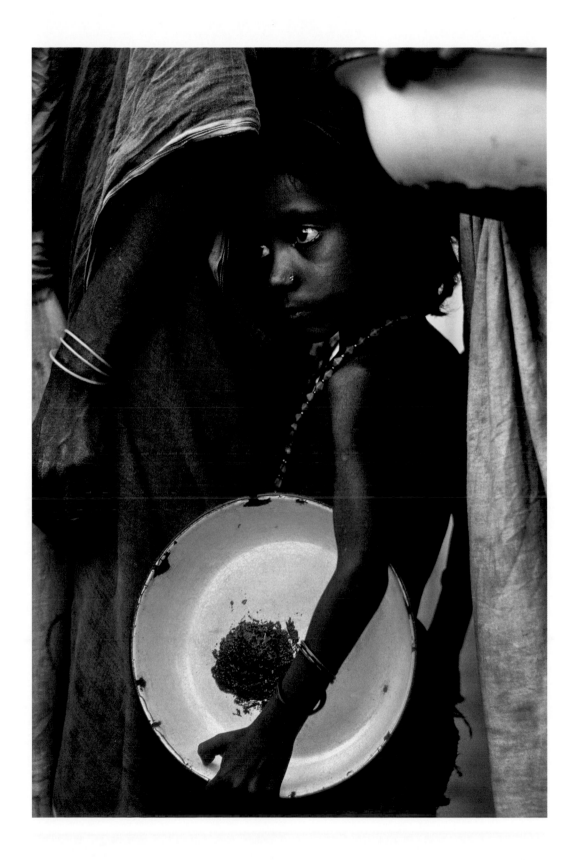

A Bangladeshi girl waits for food during a 1974 famine that killed 1.5 million people in the newly formed South Asian nation. Once desperately poor, Bangladesh has cut hunger in half since 2000. The United Nations calls Bangladesh a success story in the global effort to eradicate hunger by 2030.

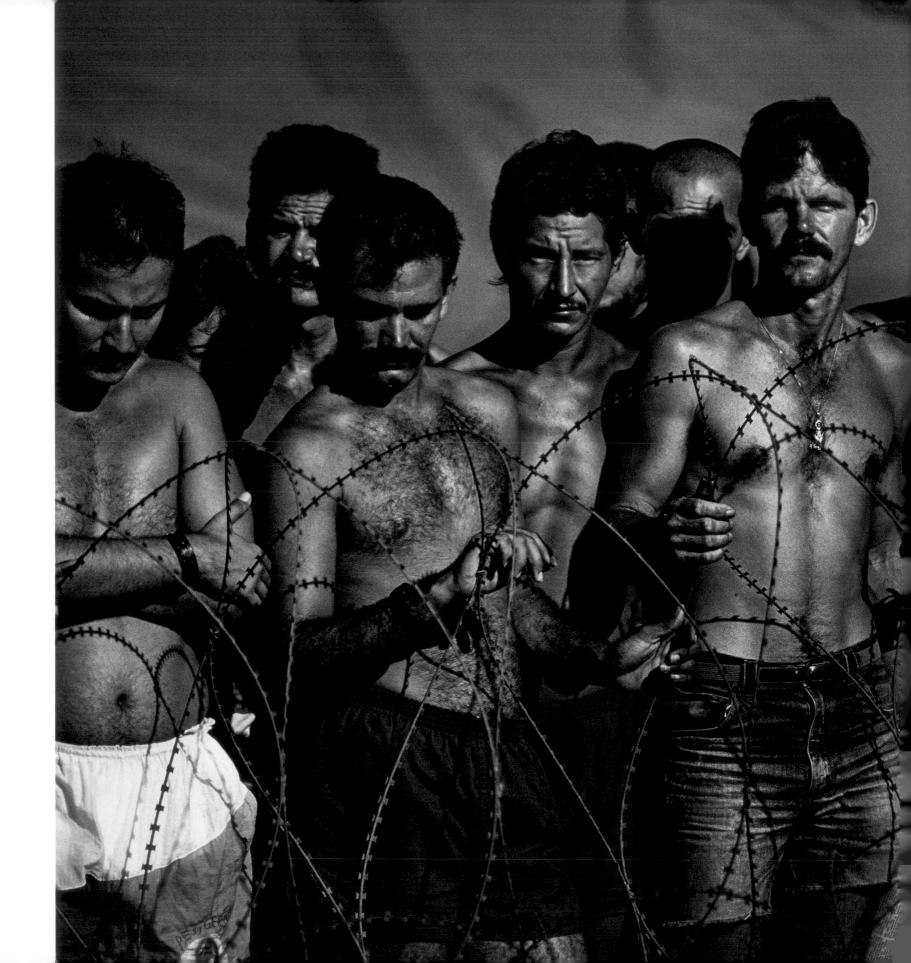

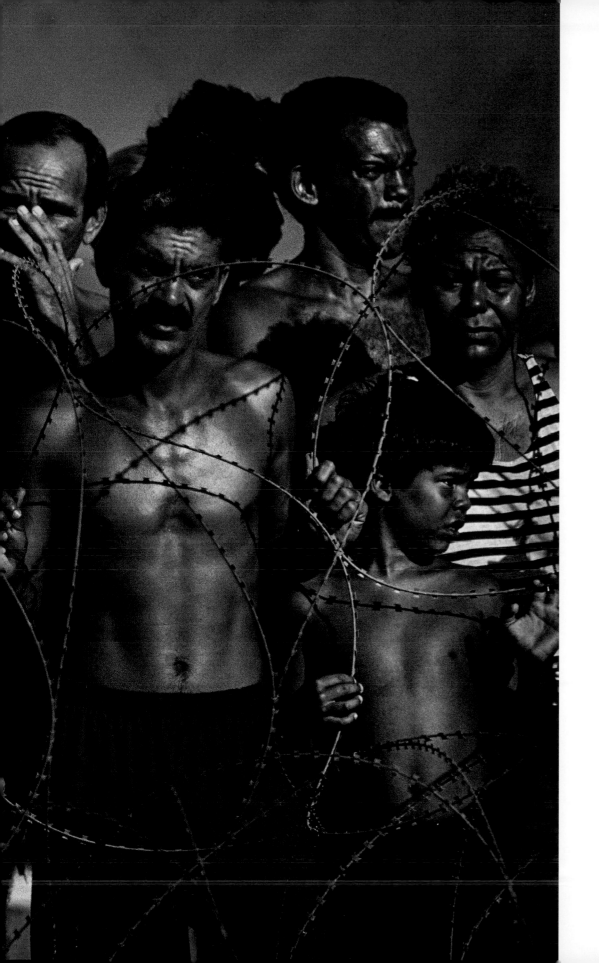

Long before US Naval Station Guantanamo Bay in Cuba became a military prison for suspected terrorists on a slice of land arguably beyond the reach of US constitutional protections, it housed some forty-seven thousand Cuban and Haitian detainees during the 1990s. These refugees were picked up at sea fleeing their homelands for the United States and held in heavily patrolled tent cities ringed with razor wire.

89

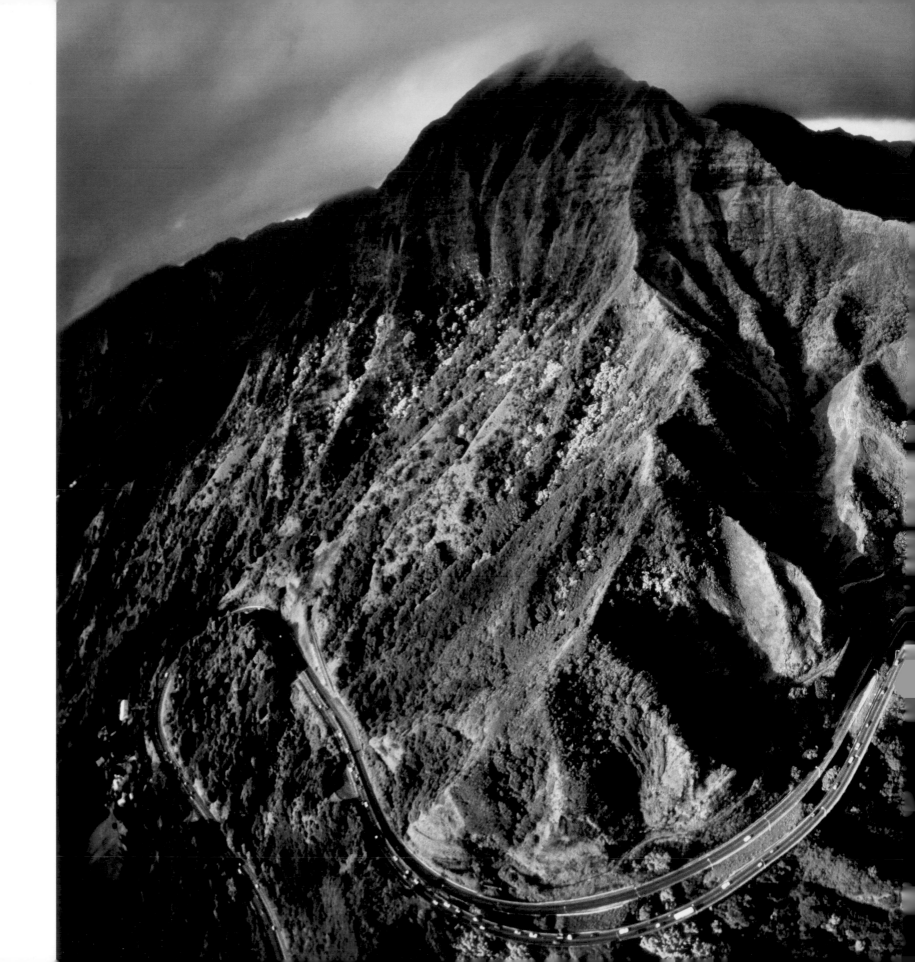

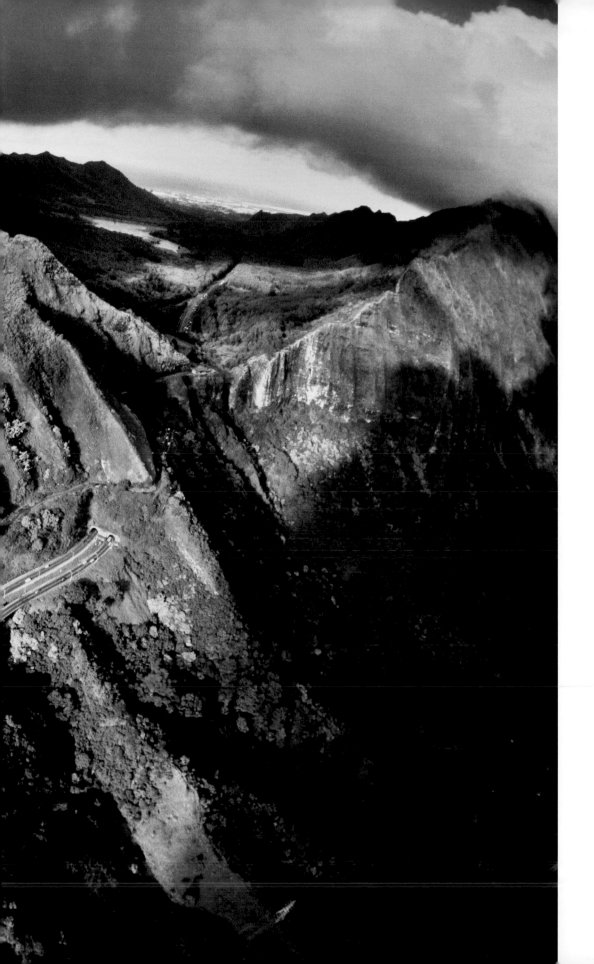

The highest peak in the Koolau Mountains, the Nuuanu Pali just outside Honolulu was the scene of King Kamehameha I's battle to unite the Hawaiian Islands under his rule. In May 1795, Kamehameha's army forced hundreds of rival warriors to leap to their deaths from the forested windswept 1,200-foot cliffs, thereby giving Kamehameha undisputed control over Oahu and adjacent islands.

91

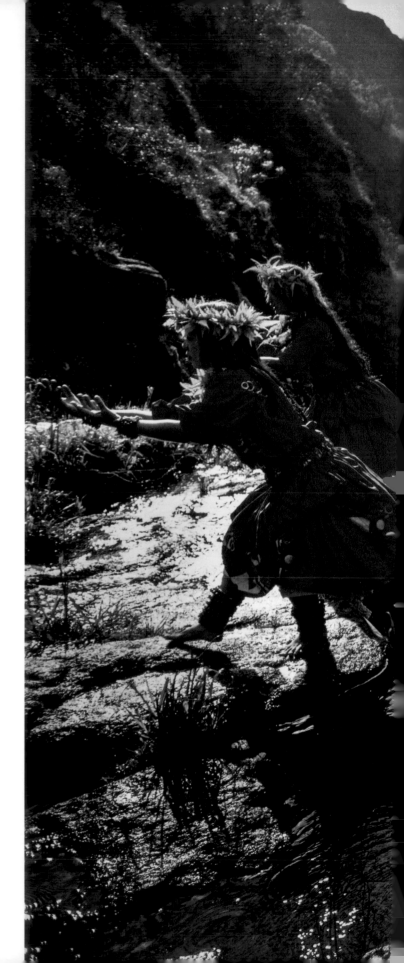

Performers dance the tango, in which the woman seduces
and the man leads, in the bodega of Café Tortoni, a
Buenos Aires institution. Popular worldwide, the tango
originated in the brothels of Buenos Aires in the 1880s
and draws upon African, Spanish, Italian, and Argentine
traditional dances. Performing the *hula kahiko*, or ancient
Hawaiian hula, dancers blend simple footwork with
hand gestures to illustrate the myths and histories of
their families on the rim of Waimea Canyon on Kauai.

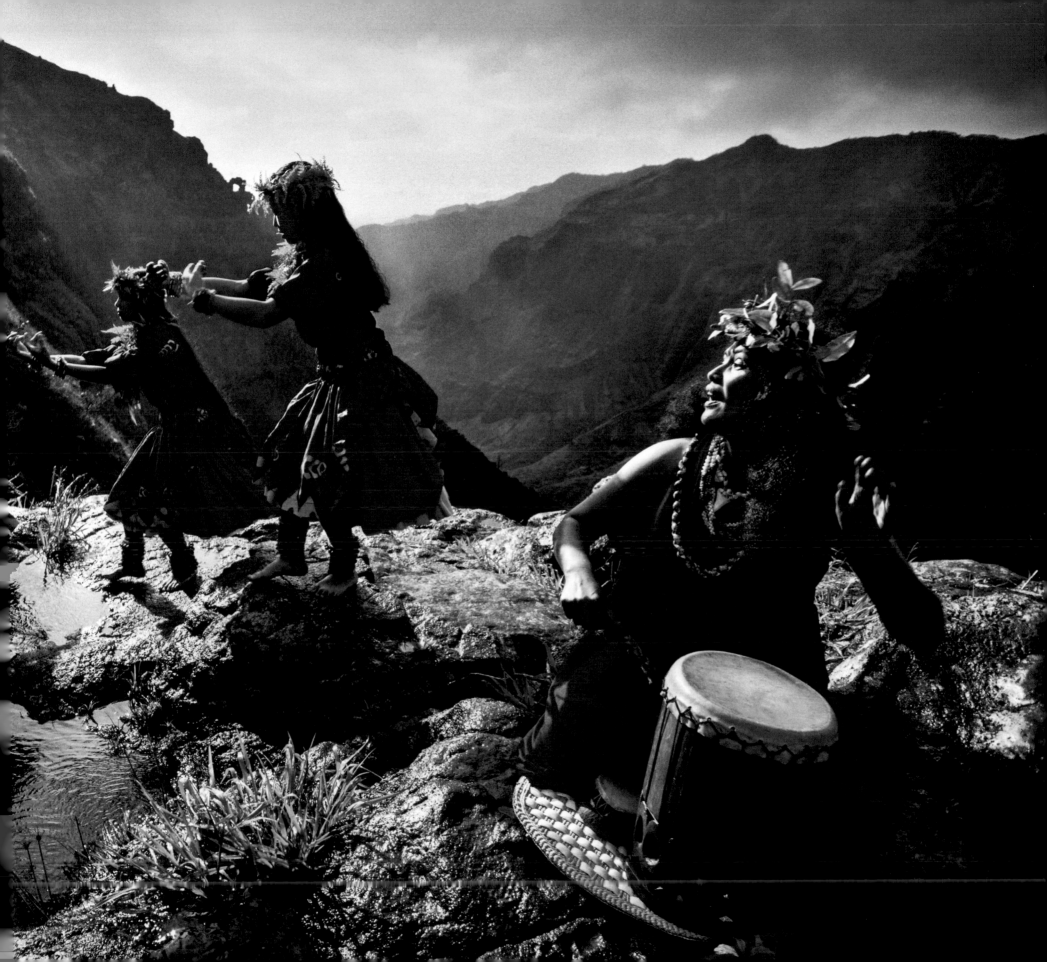

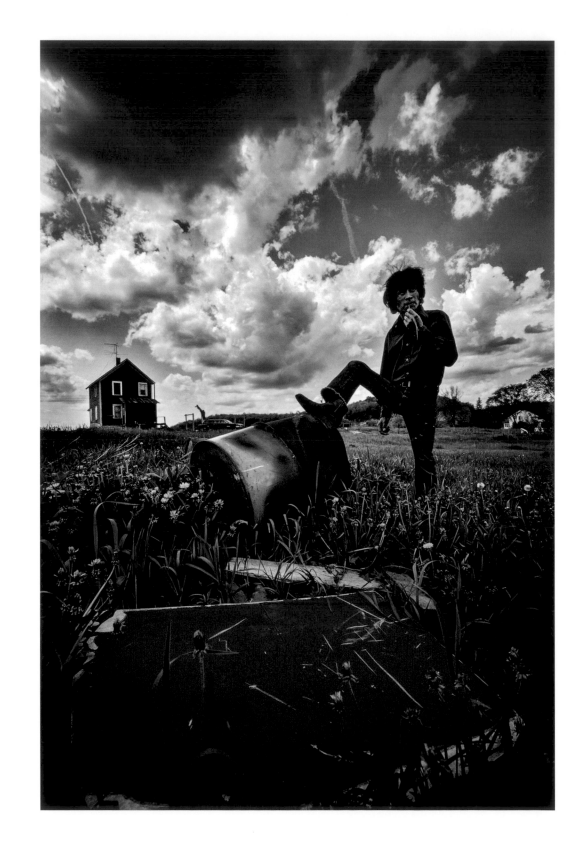

Rural poverty is a way of life for many Menominee and people of ten other federally recognized tribes in Wisconsin. While casinos generate more than $1 billion a year for the tribes, the Menominee, who once occupied nearly ten million acres in Wisconsin and the Upper Peninsula of Michigan, struggle with substandard healthcare and high unemployment.

94

Heat waves are commonplace in Chicago, prompting children to play in the cooling waters of a fire hydrant near Humboldt Park. Nearly half of young black men and 20 percent of young Latinos are out of school or out of work or both, reports the University of Illinois at Chicago's Great Cities Institute, which ranks Chicago among the worst US cities for minority youth.

Birthplace of the skyscraper in 1884, Chicago's fabled skyline is shrouded in a morning fog blowing in from Lake Michigan. With fifty-two new high-rises set to be completed before 2020, Chicago's skyline is thickening horizontally more than it is soaring skyward. All the same, Chicago—the third largest city in the United States—is home to more than 1,300 high-rises.

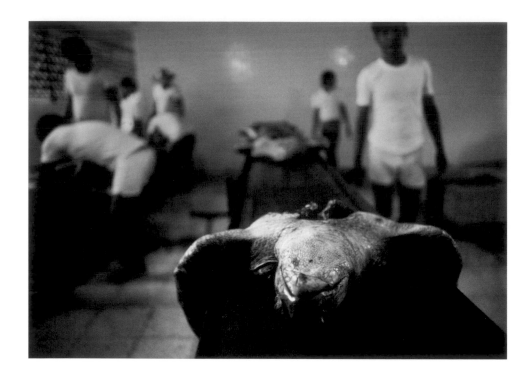

Investigating the worldwide trade in endangered wildlife, the author exposed the illegal slaughter of Pacific ridley sea turtles (*above*) at Puerto Angel on Mexico's west coast. *National Geographic* conservationist Joel Satore says that when he saw this image as a high school student, he decided to devote his life to photographing endangered animals and threatened habitat. Brought back from the edge of extinction, vicuñas—llama-like animals with fine wool that sells for three times the price of cashmere—roam the Pampa Galeras Vicuña Reserve in southern Peru. Today there are about 350,000 vicuñas living in the Andes, many grazing the barren, wind-swept mountains at 16,000 feet above sea level.

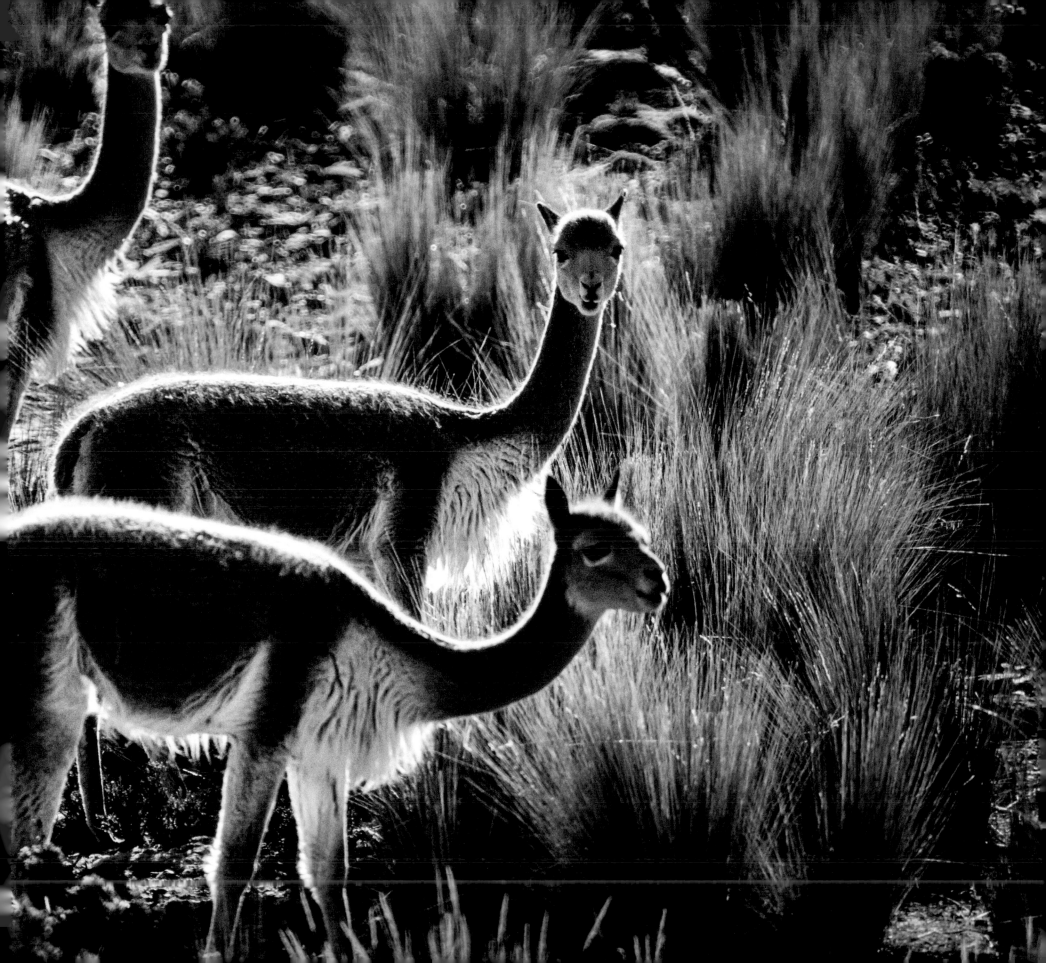

A menacing Caribbean dawn breaks over *Isla de Sacrificios*, so named because the Totonac Indians once practiced human sacrifice on the island at the entrance to the harbor at modern-day Veracruz, Mexico. The now-extinct Olmecs (1500 BCE to 400 BCE) once inhabited the island, which is today controlled by the Mexican Navy.

100

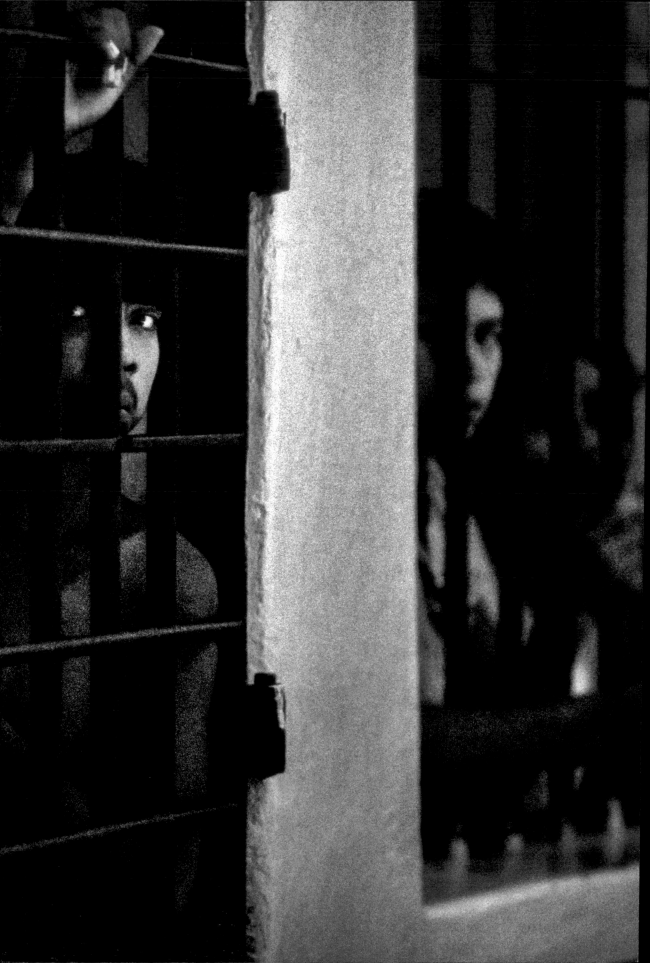

CHAPTER FOUR

AN OUTSIDER LOOKING IN

Writing about how *National Geographic* has portrayed India, Teju Cole of the *New York Times* said several years ago that Western photojournalists too often focus on the obvious: "There are Hindu festivals, men in turbans, women in saris, red-robed monks, long mustaches, large beards, preternaturally soulful children, and people in rudimentary canoes against dramatic landscapes." Indeed, the distractions for any outsider looking at the Indian subcontinent are many, including those Cole itemizes. India, especially, is vibrant, colorful, and noisy—all beguilements that can impede reporting about one of America's closest partners in a troubled and vital region of the world.

Traveling with the International Committee of the Red Cross, the author discovered torture, sexual abuse, and prisoners made to wear hoods and blindfolds inside the Chalantenango prison in El Salvador. During the 1980s, the United States, the Soviet Union, Nicaragua, and Cuba waged a proxy war that ravaged the Central American state.

103

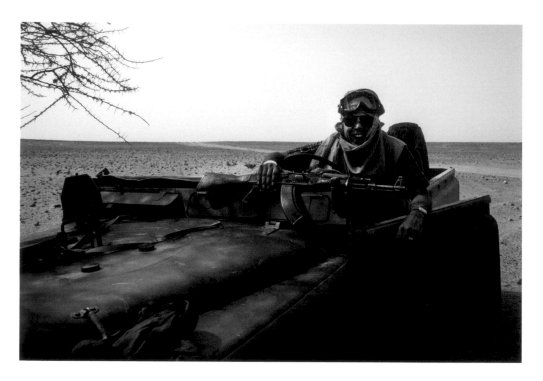

Accompanying Polisario guerrilla fighters as they crossed the Sahara Desert at night in a convoy of Land Rovers, the author and *National Geographic* writer Peter T. White had to prove their marksmanship skills with an AK-47 in case they were ambushed by the Moroccan Army. The *Geographic* team agreed they would never fire the weapons in anger.

There are scores of academic papers about how the Western media has portrayed India, and many are critical. Often the American media reinforce negative stereotypes. On US television, for example, India is presented as a land of snake charmers and call-center schemers who speak English with barely intelligible accents. And though it is all true, many Indians take exception to the Western media's focus on poverty, autocratic and corrupt leaders, wide-spread rape and sexual harassment, and the world's worst air pollution. Pick up a recent *New York Times* election analysis by Geeta Anand and you can also read about how the poorest of the poor in villages across India "have radically different aspirations for their children. Though they live far from the glittering malls and high-tech companies of India's big cities, they want their children to receive the education they need to get jobs in the modern economy they see on television." In my long association with India, I have come to accept the poverty, spirituality,

and modernity that coexist in an endlessly mesmerizing panorama—one that always beckons me to return.

My first trip to India was in 1974. For all its color and exoticism, I found a country that could barely feed itself. It was also a democracy caught up in the politics of nonalignment with East and West, though the Soviet Union seemed to hold some sway in the capital, New Delhi. Socialism and a desire to reduce foreign imports dominated economic policy, while civil servants—and requests I made of them—moved at a glacial pace. India was also divided by sectarian tensions rooted in caste and faith. And it surely was a land more rural than urban, with large parts of the country accessible only by railroad or bullock cart or on foot, so decrepit was its transportation infrastructure. I arrived at the airport in New Delhi only to have my *National Geographic* camera equipment impounded by Indian customs authorities, so strict were the laws governing imports, however temporary, of expensive, foreign-made goods. Eventually I secured a diplomatic note from US Ambassador Daniel Patrick Moynihan, a sociologist and politician, to the Indian Ministry of External Affairs to free my gear. But the experience was a harbinger of many more obstacles to overcome, both then and now.

Today India is perhaps the most complicated country in the world and a land of 1.3 billion people, or slightly more than 17 percent of the world's population. It remains a country of great cultural and geographic diversity and economic promise, with an economy that is growing faster than China's.

Usually, I have traveled to India to tell a specific journalistic story at the behest of *National Geographic* editors. The exception was a self-assigned book *Redeeming Calcutta*, now known as Kolkata, that began as a documentary project to record the decrepit colonial buildings of a city that was once the British capital of the Raj. But that book, too, morphed into a much more inclusive project that

reflected some of the major social, cultural, and political changes in the world's largest experiment in democracy.

On that first trip to India, I traveled from the capital, New Delhi, to the back reaches of the Punjab and Uttar Pradesh as part of a *National Geographic* report titled "Can the World Feed its People?" At the time the answer for India was "no" or "just barely." India was in the crosshairs of world economic development experts for failing to feed its exploding population and keep up with agricultural advances. A pestilence lay on thousands of Indian villages, as my colleague Tom Canby noted so eloquently in our 1975 report. What we saw were not the swollen bellies of neighboring Bangladesh, but something more insidious—pervasive malnutrition that dragged down the poorest of the poor and laid them open to diseases of all kinds.

How times have changed. Not only can India now feed itself, but the US Department of Agriculture's Foreign Agricultural Service says India has become the world's seventh-largest exporter of agricultural products, surpassing Australia. India is, in fact, a key player in the global food markets, exporting rice, cotton, sugar, and beef. India also has become a sizeable exporter of soybean meal, guar gum, corn, and wheat. The country's growing economy and expanding middle class also continue to fuel demand for corn and other grains for animal and poultry feed, as more Indians get their protein from chicken, lamb, and even beef. All of this is easy to see. Modern supermarkets are struggling to win customers from India's old-fashion food stalls, convenience stores, and *kiranas,* or small family-owned shops. But wherever Indians shop, they are awash in foodstuffs for every taste, caste, or faith. There is even a nascent wine culture with some excellent homegrown varietals from Maharashtra, Karnataka, and Telangana.

The New Delhi I first experienced as a young man was a city of motor scooters, bicycles, and made-in-

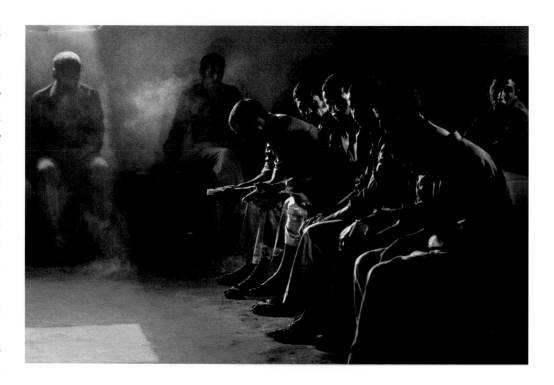

India Ambassador cars, all part of the national economic plan of self-sufficiency and restricted imports. Air pollution in the capital city—now the worst in the world, exceeding pollution levels in Beijing—was acceptable. And traffic, while slow, offered time for some reflection on what it was I was trying to say about this vast country. In the hinterlands, life moved at the pace of the oxcarts that clogged the narrow roads. In the sugarcane-growing region outside of Lucknow, capital of Uttar Pradesh, India's most populous state, I traveled door-to-door on foot with a UNICEF nurse. Her job was to bring lifesaving prenatal care to village women. The nurse also carried a large-scale model of the human reproductive system and explained how it worked and how to prevent unwanted pregnancies—all out of earshot of the generally unreceptive men at work in the fields. By the mid-1980s, I was traveling by domestic airlines and imported cars to Rajasthan and to the holy city of Varanasi on the

Between 1973 and 1991, the Algerian-backed Polisario Front first fought Spain and then the Kingdom of Morocco for control of the phosphate-rich former colony of Spanish Sahara, now called Western Sahara. Waiting to be interviewed by International Committee of the Red Cross officials, Moroccan Army soldiers were prisoners in a forgotten war.

European medical students and a Roman Catholic nun care for the terminally ill at the Home for the Sick and Dying Destitutes in Kolkata. Established in 1952 by Nobel laureate and Catholic saint Mother Teresa in what was once a pilgrim's shelter at a Hindu temple, the facility provides hospice care for the city's most needy.

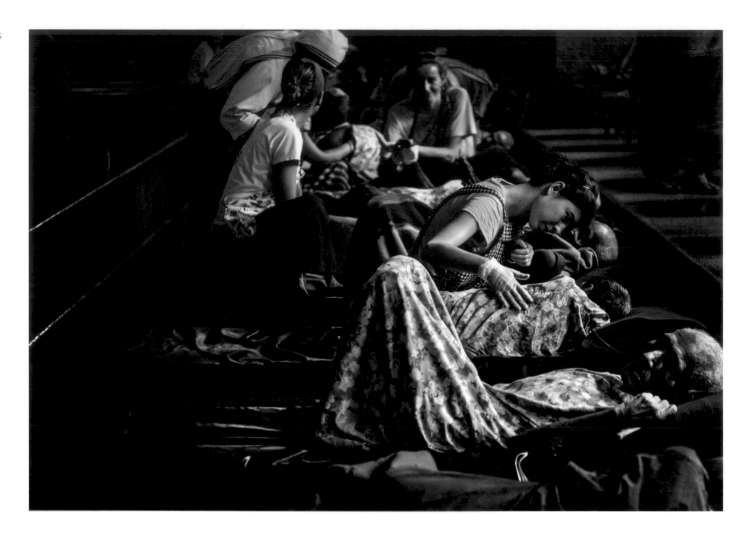

River Ganges, reporting on the legal cultivation of poppies and production of opium used for pain medications worldwide.

I also volunteered for a *National Geographic* story about New Delhi as the capital of the non-aligned world, an eclectic amalgam of some twenty-five developing countries whose primary aims, according to a manifesto written after their 1961 summit, are to protect national independence and counter the forces of imperialism. With India as a key player, prime minister Indira Gandhi professed to steer a middle course between the United States and the Soviet Union, though in truth she tilted toward

the Russians. I photographed Prime Minister Gandhi having her morning tea and reading the newspapers in the garden of her private residence in New Delhi just six weeks before she was assassinated by her two bodyguards in October 1984 in retaliation for the storming of the Sikh holy shrine of the Golden Temple in Amritsar. She inquired about the whereabouts and health of several very senior *National Geographic* colleagues, and we chatted about my close call in Afghanistan with a terrorist bomb. Gandhi is often vilified by Indians for her declaration of martial law in 1975–77 during her first term as prime minister. Linda Charlton's November 1, 1984, *New York*

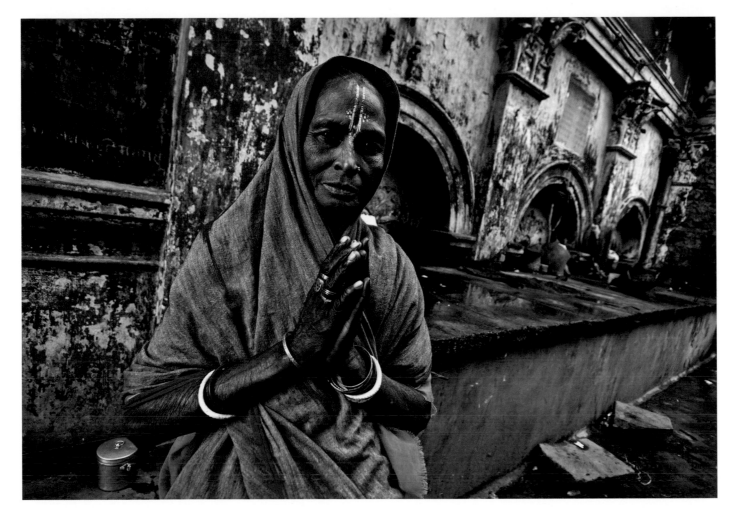

At Kolkata's Armenian Ghat, where rich Armenians once docked their ships full of precious stones and spices, a Hindu woman begs for a few rupees. Capital of British India until 1911, Kolkata is a city in decline—a rust-belt metropolis abandoned by industries and minorities denied citizenship after Indian independence.

Times obituary "Assassination in India: A Leader of Will and Force" captured the Gandhi whom I met that August morning: "Strong-willed, autocratic, and determined to govern an almost ungovernable nation that seemed always in strife."

By 2009, I was in Bangalore, the capital of India's technology and engineering sectors, and a city that rivals Silicon Valley for connectivity and IT expertise. To my delight, most of the big European airlines flew directly to Bangalore, bypassing the chaos and congestion of Delhi or Mumbai. Bangalore, it must be remembered, is the city that the *New York Times* columnist Tom Friedman

heralded in several of his recent books about globalization. And his enthusiasm for this outpost of a globalized world is not misplaced. In Bangalore, Indian entrepreneurs can prepare our taxes, read our MRIs, trace our lost airline luggage, and importantly, write new software from places like InfoSys, which employs more than fifty thousand workers on an eighty-one-acre campus with some of the smartest and greenest buildings in the world.

By contrast, I found myself spending several summers and a sabbatical leave in the decaying but still captivating city of Calcutta, India's cultural capital and perhaps the least globalized city in Asia—all of which gives Calcutta,

Hindu devotees travel from across India to bathe in the Hooghly River at the Dakshineswar Kali Temple near Kolkata. Built in 1855 by a wealthy devotee of the Goddess Kali, the temple is one of the most important holy places in Kolkata, a city where Kali—deity of time, change, and destruction— is revered as no other.

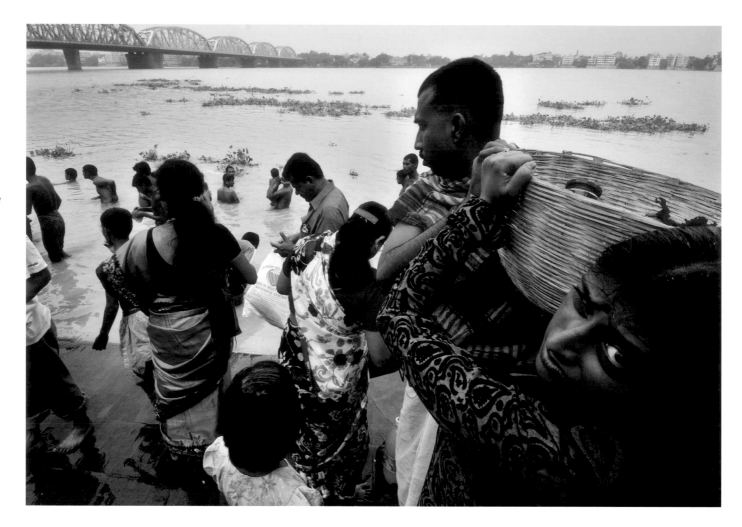

now Kolkata, its decrepit charm. Capital of the British Raj until 1911, Calcutta is a city full of splendid, though crumbling, colonial-era buildings and I wanted, among other things, to document this city of such distinctive architecture before most of it collapsed. As I would learn over five years researching and photographing the city for my book, Calcutta could inspire hope and fury in equal measure.

Calcutta's poverty is so widespread that it invades all public spaces, making coming to grips with the city perhaps the greatest professional challenge of my life. Photographing some of India's poorest of the poor in a hospice

run by the Missionaries of Charity, the order founded by Mother Teresa in 1952, put a human face on the city's suffering. Occupants were literally scooped off city streets, many in their final days of life, to be cared for by nuns and medical students from several European Union countries. The Home for the Sick and Dying Destitutes, or *Nirmal Hriday* as it is called, is a central part of Mother Teresa's legend of humanitarian service—something that earned her both a Nobel Prize and sainthood bestowed by Pope Francis. Indian friends and colleagues were disappointed that I would find the legacy of Mother Teresa worthy of inclusion in my book. They echoed sentiments reported by

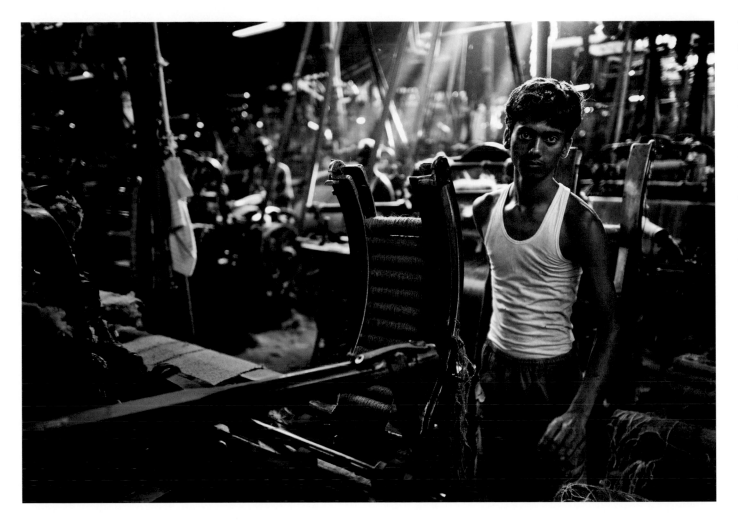

Turning raw jute into bolts of golden fiber, a laborer from the Indian state of Bihar pauses from his work inside a Kolkata mill—an industrial relic built by a Scottish miller in 1858. Kolkata remains the world capital of jute processing, making burlap bags, carpet backing, decorative fabrics, and rope.

Ellen Barry in her September 4, 2016, *New York Times* article "Kolkata Testifies to the Grace of Mother Teresa, Its New Saint": Missionaries of Charity put "too little effort into diagnosing treatable illnesses" and too much emphasis on saving souls. According to Barry, the Indian novelist Amit Chaudhuri "complained that the Western focus on Mother Teresa had reduced Calcutta, in the imagination of outsiders, to a 'black hole' peopled by the mute poor." My response was simple. Until Indians do more for their least fortunate fellow citizens, foreign missionaries and groups like Mother Teresa's will continue to fill a much-needed gap in social services for the poor.

But what is it about India that so captivates, or repels, Westerners? Certainly, the diversity of India and its population density can stop Westerners in their tracks. Writing for the Asia Society, New York University professor Ralph Buultjens describes India as a nation that can be baffling in its diversity, with fifteen official languages, over three hundred minor languages, and some three thousand dialects. Twenty-four languages have more than one million speakers each. But for a foreign journalist, India today is an easy country to navigate. While Hindi is the most widely spoken language and the first language of 41 percent of the people, English is commonly used in business,

higher education, and national politics. There is always someone who will understand you.

Certainly, the richness of India's history and cultures contrasts with some aspects of this new and rapidly modernizing nation. India only became independent from Great Britain in 1947, but it has more than four thousand years of philosophical and cultural development going back to the early Indus Valley Civilization. Since then, Hinduism, Jainism, Buddhism, Christianity, Islam, Sikhism, and other religions have all left deep imprints on society. The modern nation of India is a mix of myriad minorities. While some 80 percent of the population is Hindu, the faith accommodates diverse beliefs and practices with no set doctrine. Explaining all the conflicting elements of Hinduism is difficult for even the most learned Brahman. Another 15 percent of Indians are Muslims—some 175 million followers of Islam—making it the second largest Muslim country by population in the world after Indonesia.

One of the most newsworthy qualities of modern India is cogently described by professor Ralph Buultjens of New York University. Broadly speaking, he says, the future of India depends on integrating the rapidly modernizing cities of India, where some 20 percent of the population live, and rural India, where villagers are only now experiencing the benefits of the modern world, including everything from electricity and roads to literacy and schools. Urban India is a fast paced, modern nation with advanced technology and a sophisticated manufacturing base, fueled by an expanding economy. Moreover, India is now a nuclear power with close security ties to the United States and Japan. Rural India remains traditional, provincial, and slow to change. There are promising connections that have led to improvements in education, health care, and the strengthening of democratic institutions for Indians nationwide. But the thorny issues of family planning and population control, unemployment and underemployment, human rights, and climate change all remain impediments to India's continued growth and success. For the nation to realize its potential, says Buultjens, the gulf between city and village life in India must be bridged.

For a longtime traveler to India, the country remains a land of mixed blessings and many stories to tell. India's technology and engineering sectors are perhaps second to none, but public education is a scandal. Geeta Anand of the *New York Times* reports that rural parents say their children need to be taught English so they can get good jobs, but government schools still teach in Hindi. In addition, teachers are frequently absent. More than 31 percent of rural teachers in Uttar Pradesh are absent on any given day, compared with a nationwide rate of roughly 24 percent found in surveys by Karthik Muralidharan at the University of California. Indeed, everyone from the information-technology elite to taxi drivers want to send their children to a private school with an English-language curriculum.

Moreover, India is also blessed, if it can make use of it, with a "demographic dividend." While China and Japan are quickly aging, two-thirds of Indians are under the age of thirty-five—a labor force for far into the future if India can find ways to feed, house, and educate it. But the country continues to be plagued by corruption, narrow-minded sectarian grievances, and a lack of transparency in everything from gathering the news to awarding multi-billion-dollar contracts for mobile phone networks. And young men and women want equality of opportunity, dignity for girls and women, and civil liberties that extend to social media.

Interestingly, for a robust democracy, India's news media can appear deeply flawed when measured against

Western media outlets. Both print and broadcast media often lack the professionalism of their American, European, and Australian counterparts and struggle to operate independently without constitutional protections. I have personally tried to lecture on media ethics and values in India only to be scoffed at by faculty and students alike.

The economic vibrancy of the Indian media does not mean that it is free to report on politics and politicians, tensions between Hindus and Muslims, or relations with neighboring states like China. Even social media is constrained by laws against hate speech. In India, the government can impose restrictions on the press under the guise of state security or maintaining friendly international relations, with prohibitions against inciting public disorder, corrupting decency and morality, and publishing op-ed pieces that challenge the sovereignty and integrity of India—think of the decades-old conflict in Kashmir. And like fellow journalists and broadcasters in the West, Indian journalists and broadcasters fear more widely shared restrictions like contempt of court and defamation or libel.

Newspaper circulation is growing by more than 10 percent a year because of increased literacy and a rapidly expanding middle class that is drawn to advertising and popular culture. And Indian television now has more than one hundred all-news channels in English and various other languages, complete with the ticker or "crawl" at the bottom of the screen and breaking news alerts in English whenever anything important happens. Indians have access to newspapers in many local languages; to the cable news of the British Broadcasting Corporation, CNN, and dozens of all-news Indian channels; and to local editions of dozens of American magazines. But Indian readers and viewers are still subjected to widespread self-censorship. In recent years India has ranked in the bottom one-third of countries on the Reporters Without Borders World

Press Freedom Index: in 2017 it ranked an appalling number 136 out of 180 countries, between Palestine and Venezuela. Freedom House in the United States gives India a similarly poor score.

In British colonial times, the media played a key role in advocating independence and holding public officials to account, but today it is hobbled by frequent lawsuits from local officials and draconian libel legislation, among other restrictions. Even media access to legislative chambers is controlled in some states. Today violence has emerged as the main brake on media activity, especially for reporters in the field and investigative journalists. Oxford University Press worried about a government lawsuit for stirring up sectarian passions when I published *Redeeming Calcutta* in 2013. Editors in India eliminated any reference to the city's troubled history of conflict between Hindus and Muslims.

In the end, the ancient and the modern mix, mingle, and coexist in today's India. In Calcutta several years ago, I met a shepherd herding a flock of goats along a busy thoroughfare while he talked on his mobile telephone. For him, there was no disconnect between old and new. The tools of the modern world were merely tools, and there was little chance this shepherd would advance beyond his middle-caste status in a nearby village simply because he was wealthy enough to afford a cellphone. "It is the essence of Indian spirituality which enables even the most deprived to endure poverty," says the India scholar Buultjens. "And it is modernity that provides the prospect of improvement." Perhaps. As a journalist, I am by nature more steely-eyed.

India needs to protect human rights, clean up its air, better educate its children, and stamp out a culture of rape and sexual harassment because, in the words of Indiana University political science professor Sumit

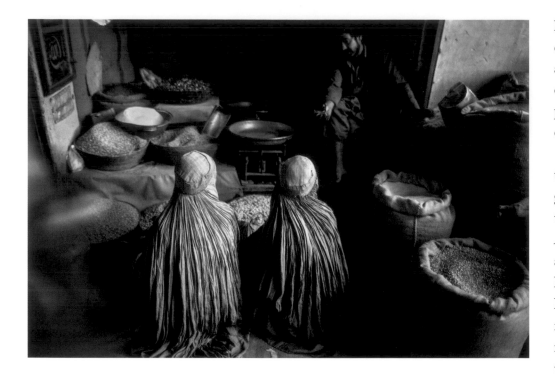

Dressed in the traditional burqa, Afghan women bargain with a merchant in Kabul's busiest open-air market. As US and NATO troops have withdrawn from Afghanistan, many women see their hard-won advances in schools and the workforce disappearing in Taliban-controlled areas of the country.

Ganguly, these initiatives "are inherently worthwhile." In other words, these are right things to do for the sake of the republic.

But India's aspirations to become a great power depend on it facing up to challenges that do not often make the headlines. "The real challenges that face India," says Ganguly, "are underemployment of its youth, the woeful quality of the vast majority of its educational institutions, growing economic inequality, its overburdened judiciary, the weaknesses and unevenness of its policing system, and the very small size of its national bureaucracy."

My early experience among the diverse cultures in India also influenced my view of Islam and religious tolerance. In my book *Living Faith: Inside the Muslim World of Southeast Asia*, which was begun before the 9/11 terrorist attacks on New York and Washington, DC, my thesis seemed simple: across much of the region, Islam was largely a syncretic and peaceful faith that incorporated elements of Hinduism, Buddhism, and animist traditions and regulated the daily lives of tens of millions of followers. And, in my view, this remains true today, despite periodic spasms of what many in the West call "Islamic extremism."

The exceptions to my thesis were parts of Indonesia, the Southern Philippines, and Malaysia, where a home-grown radical movement called Jemaah Islamiyah, or the Islamic Congregation, had affiliated itself with the Al-Qaeda terrorist network, the perpetrators of the 9/11 attacks on the United States. In recent years, Jemaah Islamiyah has spread to Singapore, while the so-called Islamic State, or ISIS, has some thirty active cells in the region. Most recently, ISIS has claimed responsibility for attacking the Jakarta business district and targets in the Philippines, including the takeover of Marawi City on the southern Philippine island of Mindanao. Indonesian extremists trained and fought in Afghanistan in the 1980s and 90s, and in the Philippines, Syria, and possibly in Bosnia.

As I hopscotched across the Islamic world in the late 1990s and the early part of the twenty-first century, I found more unsettling news. The Saudi Ministry of Islamic Affairs was busy funding new mosques and training clerics to proselytize a conservative and intolerant strain of Islam called Wahhabism. Wahhabi clerics have been active across restive parts of Southern Thailand, where there is a substantial Muslim minority, and in Indonesia, home to the world's largest Muslim population. In Southern Thailand, I traveled from city to city by taxi through vast rubber plantations and sleepy market towns, and at each stop detected a growing hostility to foreigners. There was already a long-standing animus toward the Thai military, whose heavy-handed tactics and collective

punishment meted out to whole families and villages made all non-Muslims suspect.

My last morning in Thailand some years ago, I awoke at 4:40 a.m. and hiked to the banks of the Sungai Golok River to watch Thai Muslim students slip across the international border at dawn in small boats to attend Islamic schools in Malaysia. This was something a foreigner like me was not supposed to see, let alone photograph. Yet the scarcity of Muslim schools was an open secret in Southern Thailand. After making my pictures, I returned to my hotel in the border town of Sungai Golok, packed, and took a taxi to the border crossing, where I walked across a bridge into Malaysia and hailed a taxi. Some months later when my book was published, it was banned in Thailand for bearing witness to this daily ritual.

Today, more than a decade after the publication of *Living Faith*, I could not return to many of the villages, mosques, and Islamic centers that had been open to me as an American journalist and person of curiosity and goodwill. After America's long wars in Iraq and Afghanistan, and more recently, the election of an administration in Washington, DC, that many Southeast Asians see as openly hostile to Islam, the mistrust of Americans is too great. Moreover, Ben Hubbard of the *New York Times* says that while Wahhabism has adherents around the world, many Asian Muslims reject its condemnation of Shiites and followers of other non-Sunni sects—not to mention Christians and Jews—as infidels. Sadly, the message of inclusiveness that inspired my look at Islam in Southeast Asia continues to be muted, drowned out by Saudi Arabia's promotion of Wahhabism abroad and a flood of guns and money to groups like Al-Qaeda and the Islamic State.

Over the years, I have worked often in the Arab and Muslim world despite my imperfect understanding of the faith. For many Western readers of newspapers and

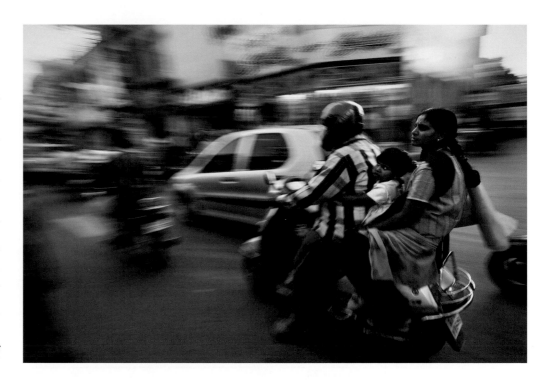

magazines, including *National Geographic*, the term "Arab and Muslim world" usually means news pictures from conflict zones. For scholars, the idea of a Western photojournalist portraying Muslims in Africa, the Middle East, and Asia often brings criticism that we photojournalists are too often looking for images of the exotic East. The late Palestinian-American scholar Edward Said of Columbia University termed this "Orientalism" and made a career out of writing about the West's patronizing depiction of exotic lands and peoples, usually Muslims. I ask students to read Said's book *Covering Islam* for his insights into how we Westerners too often see Muslims as violent and prone to extremism and to help them understand the hidden agendas that perpetuate that view. To my mind, there is little doubt that the *National Geographic* of yesterday portrayed the Middle East, including Said's native Jerusalem, as a region of exotic customs and costumes, vendors and

In India's high-technology capital of Bangalore, now officially called Bengaluru, some 1,600 vehicles a day are added to city streets—a measure of an expanding economy and rising middle class prosperity. But India's rapidly worsening air pollution is causing 1.1 million people to die prematurely each year.

In the outback of Sharjah, one of the seven sheikhdoms that make up the United Arab Emirates, a local leader arrives in a dust-covered convoy for races at Al Dhaid Camel Race Track. Since child riders were outlawed in 2002, small robots are now used instead of humans for races in which winning purses can top $2 million.

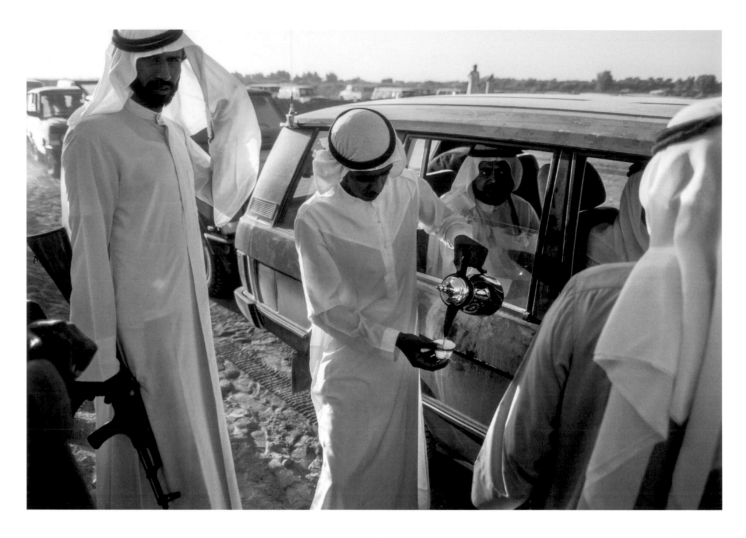

bazaars. But critics often forget that the Arab and Muslim world has had an uneasy relationship with the visual image because of long-held religious beliefs and canonical teachings. Making intimate, meaningful pictures was never easy, at least until recent years. Now we have a panoply of image-making devices and screens that connect a globalized world, and the Muslim world has joined in this proliferation of images.

In taking a hard-eyed look at the Middle East, there is, as veteran correspondent Janine di Giovanni says, a brutal cycle of heartache, in which "injustice leads to powerlessness, to frustration, to rage, and finally to acts of violence

that undercut any attempts at peace or reconciliation." If there one hopeful sign, it is a new cadre of young people of the region's dominant faiths—Judaism, Christianity, and Islam—who have taken up the camera to tell their own stories through their own eyes. It has been my privilege to teach some of them.

I did not approach this odyssey as a scholar but almost accidentally, journeying in the 1970s to early 1990s, at the behest of *National Geographic* editors, to Yemen, Saudi Arabia, across the Maghreb, to all of the states of the Persian or Arabian Gulf, as well as to Pakistan, India, and Soviet-occupied Afghanistan. At other times, I traveled to

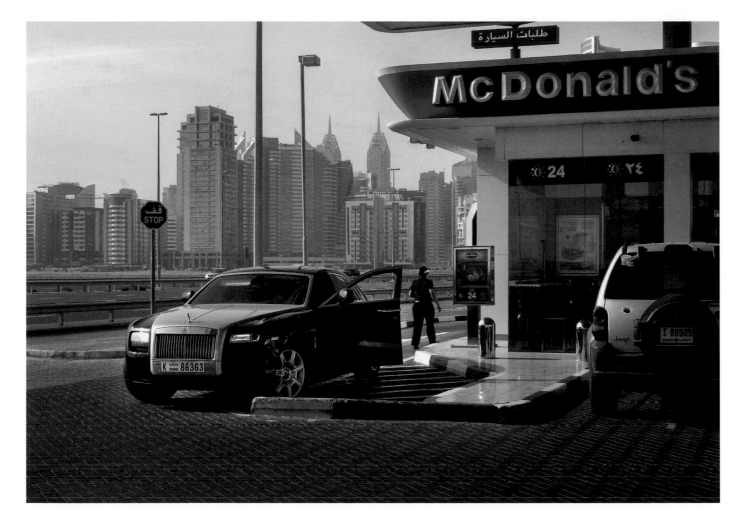

A Rolls Royce Ghost idles at a drive-through McDonald's in Dubai, one of the world's most globalized cities. Behind the glitz and glamor, the city-state tolerates no dissent, and has been criticized by international human rights groups for its treatment of South Asian workers, gays, lesbians, and transgender individuals.

Israel, Turkey, and many times to Indonesia and India—the world's two most populous Muslim nations—as an Indiana University professor. My experience with the Arab and Muslim World has also extended to the classroom, teaching journalism at Zayed University in the United Arab Emirates, a country that has been a major driver of contemporary Middle Eastern photography.

As I caution American students, there is no one prototypical Arab or Muslim nation. With more than two hundred million Muslim citizens, Indonesia is thousands of miles from the Middle East and is best known for its beaches, volcanoes, and jungles, sheltering elephants,

orangutans, Komodo dragons, and tigers. Indonesia's assortment of ethnic groups and languages, as well as its sheer size, presents its own set of challenges for a photojournalist that go well beyond faith. And India, the world's second most populous Muslim nation, with some 172 million adherents of Islam, is a land that I have seen evolve from barely being able to feed itself in the 1970s to today challenging China for the world's fastest rate of economic growth. Throughout these travels, I have tried to stay true to the ideals of the profession and practice of journalism: being truthful and fair to the facts; adding meaning and context to what I saw through the lens;

Dubai claims the moniker "City of Gold" with its luxury shopping centers, ultra-high-rise architecture, and lively nightlife, but the Persian Gulf island sheikdom of Bahrain moves at a more relaxed pace. The *souk* or market in the capital of Manama sells a plethora of Arab essentials, including gold, locally blended perfumes, saffron, and other spices.

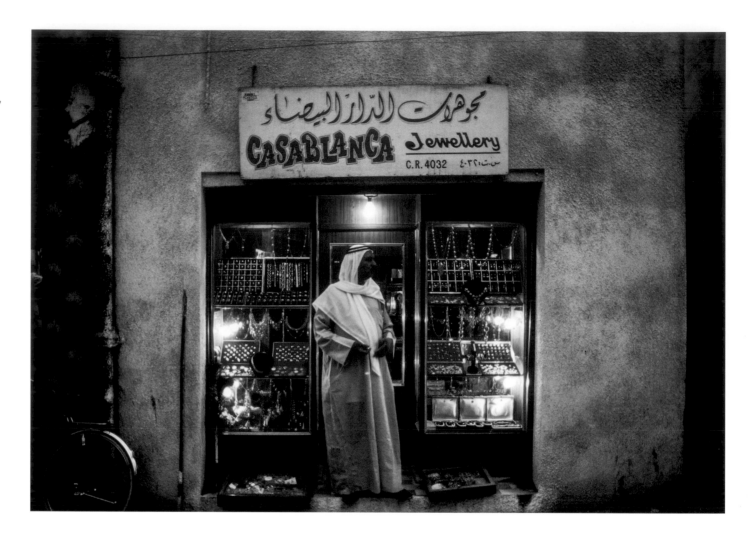

holding governments and public officials accountable for their actions; and, importantly, giving voice to the voiceless—the people who rarely make the news.

My first foray in the Muslim World was to Yemen, now described by the BBC as one of the Arab world's poorest countries, wracked by a civil war between forces loyal to the internationally recognized government and those allied to the Iranian-backed rebel movement. More than seven thousand people have been killed, most of them in air strikes by a Saudi-led multinational coalition supporting the president. The conflict has also resulted in a humanitarian crisis that has left 80 percent of the population in need of aid. The United States is also embroiled in Yemen, supplying the militaries of Saudi Arabia and the United Arab Emirates, and attacking terrorists and suspected terrorists and terrorist training sites of Al-Qaeda in the Arabian Peninsula and the so-called Islamic State. Yemen's embattled capital, Sana'a, which has been inhabited for more than 2,500 years, today is one of three ancient Arab cities largely destroyed by sectarian fighting, along with Aleppo in Syria and Mosul in Iraq.

When I set foot in Sana'a in the mid-1970s, I felt like an extra in a John Wayne Western. On the city's dusty unpaved streets, nearly every Yemeni man was armed, some

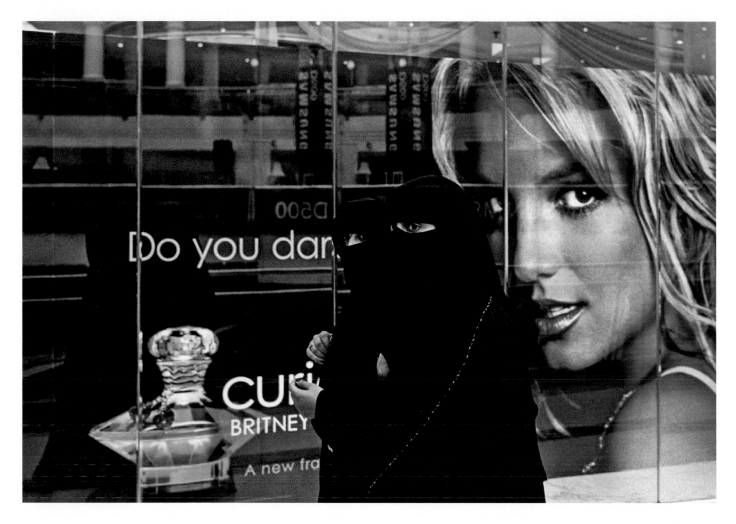

Straddling two cultures, Arab women in the black abaya cloak and niqab that partially covers the face stroll by a photograph of pop singer Britney Spears in a Dubai shopping mall. Despite advances in employment, women in many Persian Gulf states remain second-class citizen in matters of dress, political participation, and selecting whom to marry.

with ancient British Enfield rifles, others with Kalashnikov AK-47 assault rifles, and virtually all with the traditional *jambiya* dagger made with a rhinoceros-horn handle. I stayed in an ancient multistoried tower house turned into a hotel and made of mud and alabaster. And when I needed to communicate with my family and *National Geographic*, I walked to the British Cable and Wireless office and sat down at an old-fashioned teletype machine that punched holes in paper tape that would produce words at the other end of the line. I would then hand over the tape to a functionary with a pistol in his belt and he would eventually send my telegram to Washington, DC.

Moreover, the American Embassy had warned me in advance that there were no rental cars in Yemen, an ancient, fertile land now marred by internal strife and hostile neighbors. So, I brought ten thousand US dollars in travelers checks that, after turning them into several paper bags full of Yemeni riyals at a local bank, I used to buy a Toyota Land Cruiser. My colleague Noel Grove and I drove this trusty steed all over the country, from the Red Sea coast to the mountainous south. But Yemen being a tribal society, ruled more by the gun than the law, it was more dangerous that we imagined. We had the SUV hijacked twice: once by police demanding a bribe for license plates—few

vehicles in this Wild West environment were licensed—and once by tribesmen at a roadblock who thought two foreigners were easy prey for a holdup. Each time we recovered the Land Cruiser, though not without having to pay a ransom.

When we finished our assignment, I sold the rig to a University of Chicago team of archeologists headed by professor "Mac" McGuire Gibson, a noted Mesopotamian specialist of surprising goodwill and magnanimity in such unforgiving circumstances. Mac allowed me to accompany his team to Marib, the capital of the Sabaean kingdom, which some scholars believe to be the ancient Sheba of biblical fame. And through Mac Gibson I began to develop an interest in both the history of the region and the Islamic faith of most of its inhabitants. For me, documenting the rough and unforgiving land of Yemen was a turning point, a time when the proverbial "*National Geographic* adventure tale" turned into a quest for a greater understanding of the Arab and Muslim world.

On another occasion, I accompanied delegates of the International Committee of the Red Cross, the neutral Swiss intermediary that tries to uphold the Geneva Conventions in international and civil conflicts, to Southern Algeria to meet guerrilla fighters of the Polisario Front. My colleague Peter White and I arrived in Tindouf, close to the Mauritanian, Western Saharan, and Moroccan borders, minus our luggage—through some mix-up with Air Algérie—to be met by commanders of a ragtag rebel army of some fifteen thousand motorized troops. They were fighting to end Moroccan control of the former Spanish colony of Western Sahara, a phosphate-rich strip of land on the Atlantic coast of Africa. I quickly learned that the Polisario was the military wing of the Sahrawi people, the indigenous inhabitants of Western Sahara. While waiting for our bags to catch up with us, Peter and I visited refugee camps that housed tens of thousands of Sahrawi, civilians

who had been pushed into the arid back-reaches of Algeria after Morocco annexed the former Spanish colony in 1975. The Red Cross officials wanted to interview several thousand Moroccan Army prisoners of war being held by the Polisario in underground jails somewhere in Western Sahara. These so-called interviews without witness are mandated in the Geneva Conventions, a set of agreements that underpin international humanitarian law and apply to wounded and captured combatants who can no longer fight and, importantly, to civilians caught in the middle of international and civil wars. Since this was a Muslim-versus-Muslim conflict, the Polisario were keen to be seen observing the Geneva Accords.

But before Peter and I could accompany the Red Cross to see the Geneva Conventions being applied—in this case, to a conflict few Americans had ever heard of—the Polisario fighters had their own plans for us. A Polisario comandante explained that we would be crossing the Sahara at night in a convoy of Land Rovers equipped with blackout lights and 50-calibre machine guns. Peter and I would have to take turns driving the vehicle—a rugged, British-built, military version of a Jeep. So first we had to practice driving over the sand dunes in the pitch dark. Mastering the sticky manual gear shift and following the Land Rover in front of us on a moonless night were never skills I imagined I would need in order to be a *Geographic* photographer. Or so I muttered to Peter as we bumped along rough trails in the dark near Tindouf, Algeria.

Moreover, despite our status as "neutrals"—at least to our minds—Peter and I were required to show the Polisario that we could defend ourselves if ambushed by the Moroccan Army. So we practiced firing Kalashnikov AK-47 assault rifles, first at twenty meters, then fifty meters, and so on. Peter, a Holocaust survivor in his youth who went on to become a combat engineer on the Normandy beaches in 1944, was a crack shot. Compared to

the lighter US-made M-16 assault rifle that I carried in the Army, the AK-47 seemed crudely built and less accurate—and it packed a wallop of a recoil that nearly separated my shoulder with the first shot. On full automatic, its muzzle climbed with each 7.62-mm bullet that I fired. But in this unforgiving desert environment, it was reliable and rarely required cleaning. I, too, passed the Polisario marksmanship test. Ever the journalist concerned about being independent of his sources, I reimbursed our hosts with several $100 bills for the ammunition.

After several days and nights of this "training," we were cleared to drive in a convoy of some twenty vehicles that left Tindouf at twilight and ploughed through the desert wilderness of Mauritania and into disputed Western Sahara. The journey took two days and nights, stopping each day at dawn to spread camouflage netting over our vehicles and tents and doze in blistering 100-degree Fahrenheit heat under full sun. My cameras were wrapped in several layers of plastic bags to keep out the sand and survived the journey intact. Sadly, my gastrointestinal tract did not.

I became badly dehydrated, spiked a high fever, and was certain that I was fated to die in the Western Sahara. Mercifully, a Swiss doctor who was part of the International Red Cross team forced me to drink liters of intravenous fluid directly from the plastic bags in his medical kit and pumped me with antibiotics—just in time to see hundreds of Moroccan POWs jammed into dilapidated huts at a Polisario camp somewhere in the Western Saharan desert. Red Cross officials heard from each prisoner about unspeakable living conditions and took notes of each POWs name, condition, hometown, and relatives to notify. Throughout the long nights of interviews, I could smell the desperation of men who had been imprisoned for a decade or more.

Despite the rough ride to get to the Western Sahara and back, I came away with profound respect for the work of the International Committee of the Red Cross, those neutral Swiss intermediaries whom Peter would call in his article on the ICRC in *National Geographic* the "conscience of an imperfect world." My only regret, as we reached the International Red Cross headquarters a week later in Geneva, is that years earlier, the ICRC was forbidden to visit captured American pilots who were beaten and tortured in North Vietnamese prisons. Meantime, as of this writing, Zohra Bensemra of Reuters reports that the flag of Western Sahara still flutters over school playgrounds of the Sahrawi refugee camps in Southern Algeria and "a mural painted on a wall of the National Union of Sahrawi Women headquarters in Boudjdour camp [near Tindouf] reads in Spanish, 'If the present is a struggle, the future is ours.'" The insurgency in the Western Sahara officially ended when the United Nations brokered a truce in 1991 with the promise of a referendum on independence. This referendum has yet to take place. Although under the de facto control of Morocco, the status and sovereignty of Western Sahara remains one of the world's unresolved and forgotten conflicts.

As if in a scene from the early twentieth century,
rickshaw-pullers rest on a backstreet in Calcutta,
now renamed Kolkata, capital of the Indian state of
West Bengal. The city's some six thousand licensed
rickshaw drivers are often called "human horses" and
generally earn less than five dollars a day navigating
the city's crowded and sometimes flooded streets.

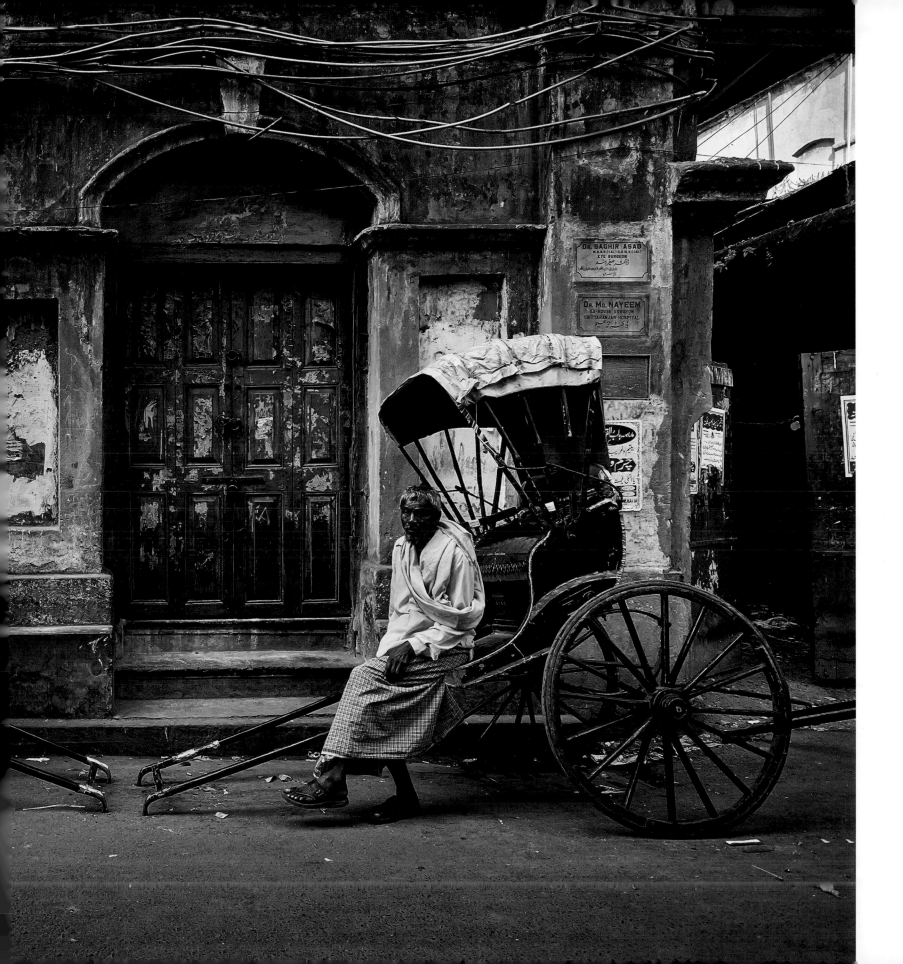

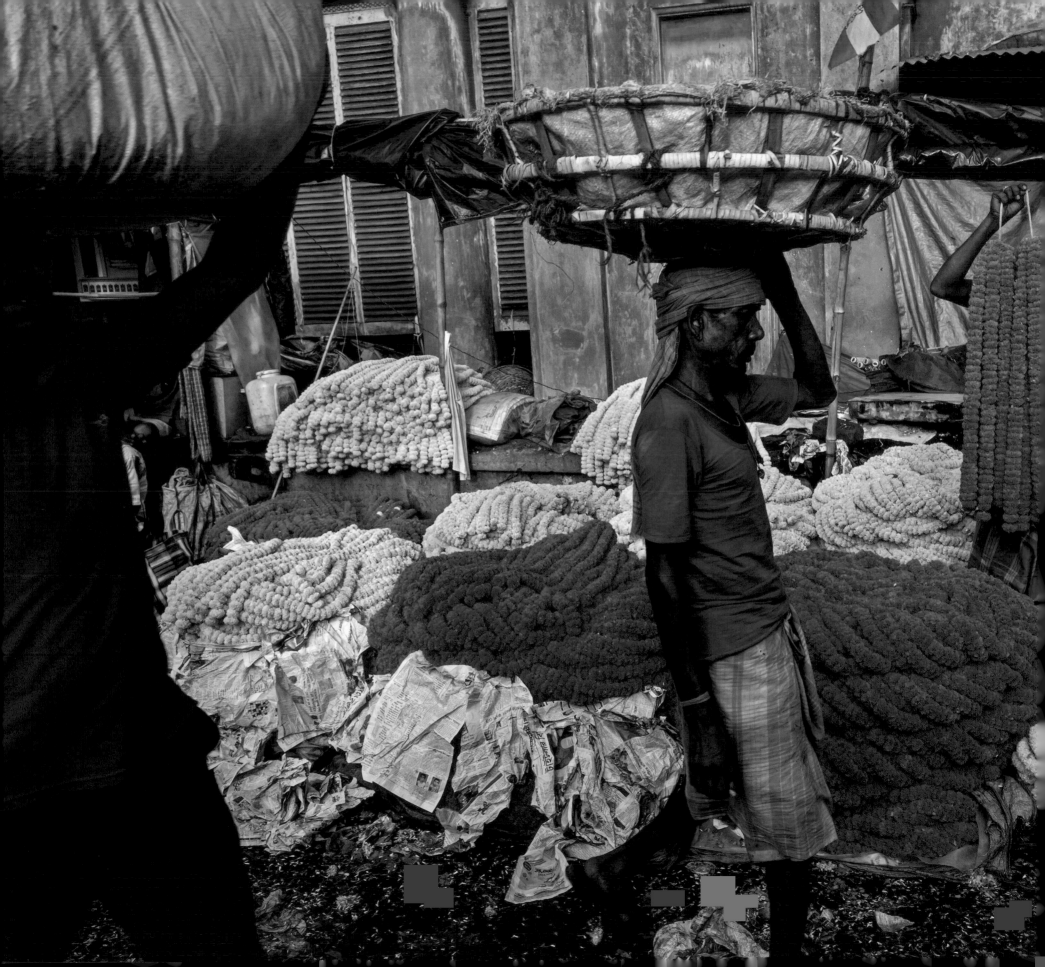

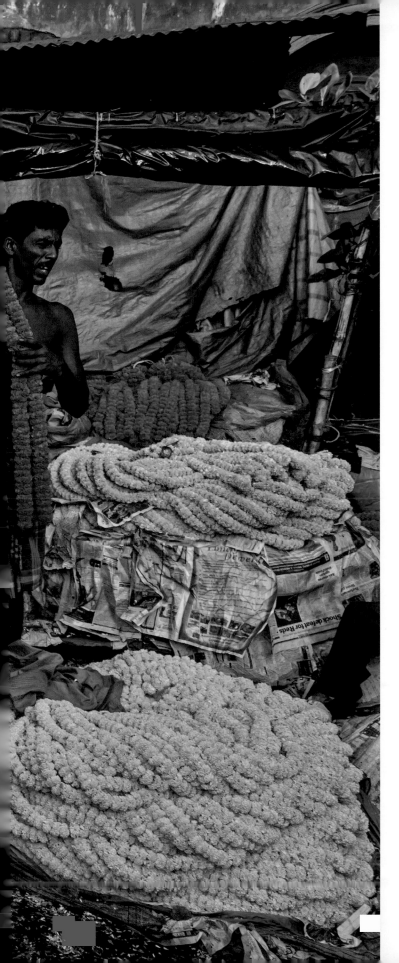

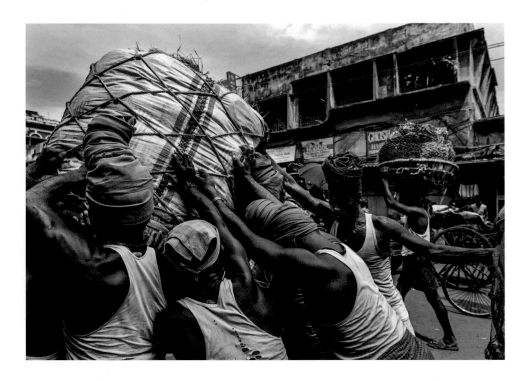

Vendors sell garlands made of marigolds in Kolkata's
Malik Ghat flower market (*left*). The centuries-old market
is eastern India's largest flower bazaar with as many
as 2,000 merchants hawking their wares for weddings,
festivals, and religious rituals. Called "human forklifts,"
porters wrestle bundles weighing hundreds of pounds
onto the turban-wrapped heads of fellow workers
at the Kolay Market in Kolkata. Indian wholesalers
fear the demise of traditional markets if retail giants
like Walmart and Tesco are allowed into India.

Calcutta's greatest thoroughfare, Chitpur Road,
winds through the city center, where Muslim
families of modest means and wealthy Marwari
merchants and their extended families live side by
side. From this and nearby neighborhoods sprang
the Bengali Renaissance, a reform movement of
the nineteenth and early twentieth centuries that
championed social justice in caste-plagued India.

124

A bold-featured Yemeni shepherd watches his flock wearing a traditional *jambiya* dagger. A man's status can be discerned from these double-sided knives, which vary in price from a few dollars to a million. The most expensive *jambiya* have handles made of African rhinoceros horn, though the government has banned the rhino horn trade.

126

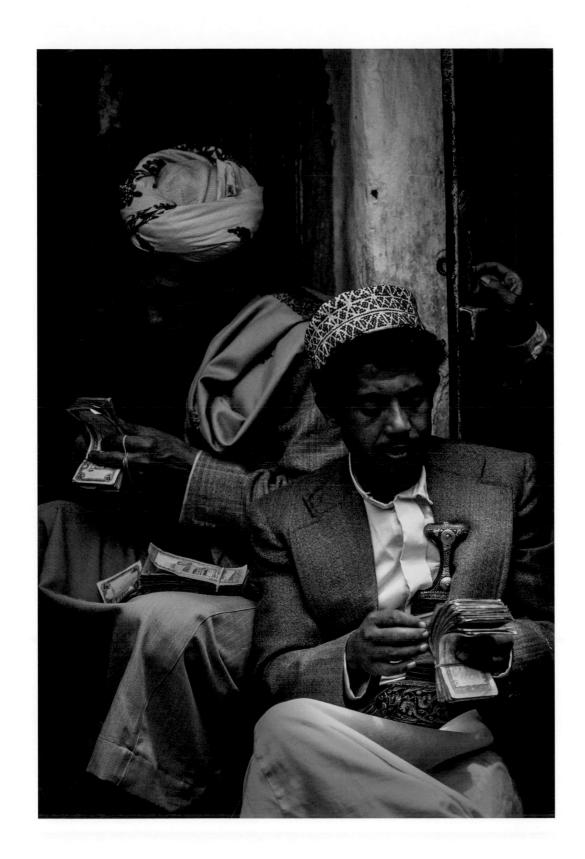

Yemeni moneychangers count rials inside the walls
of the Old City of Sana'a. Protests in 2011, inspired
by the Arab Spring uprisings in Tunisia and Egypt,
created a series of political crises that have since
escalated into an all out civil war and staggering
humanitarian crises. Yemen has also become a base for
the militant groups Al Qaeda and the Islamic State.

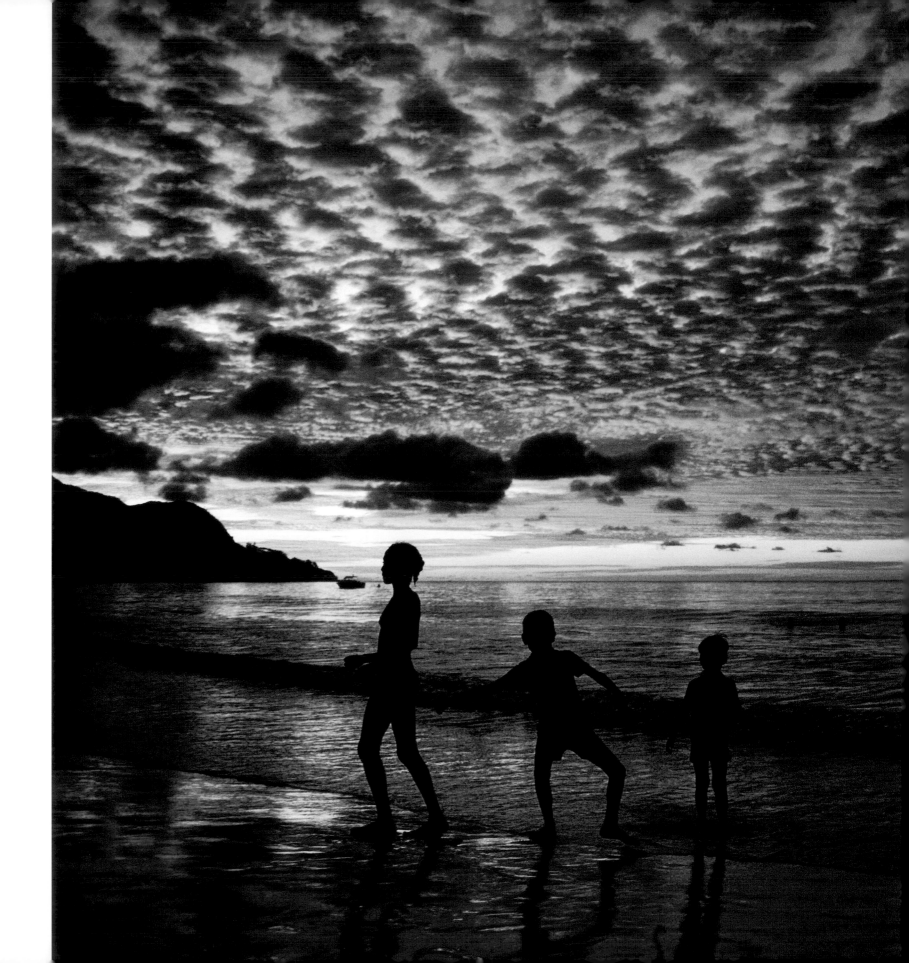

A high-end vacation paradise, the 155 volcanic islands
of the Republic of Seychelles in the Indian Ocean
cater to Europeans and expatriate workers from
Africa and the Middle East. Aptly named, Silhouette
Island (*right*) lies some twelve miles off the beach at
Mahé, the largest island and home to Victoria, the
capital of the Seychelles. The former British colony
had a difficult post-independence beginning that
included a coup, an invasion by mercenaries, an army
mutiny, and an influx of Cuban military advisors.

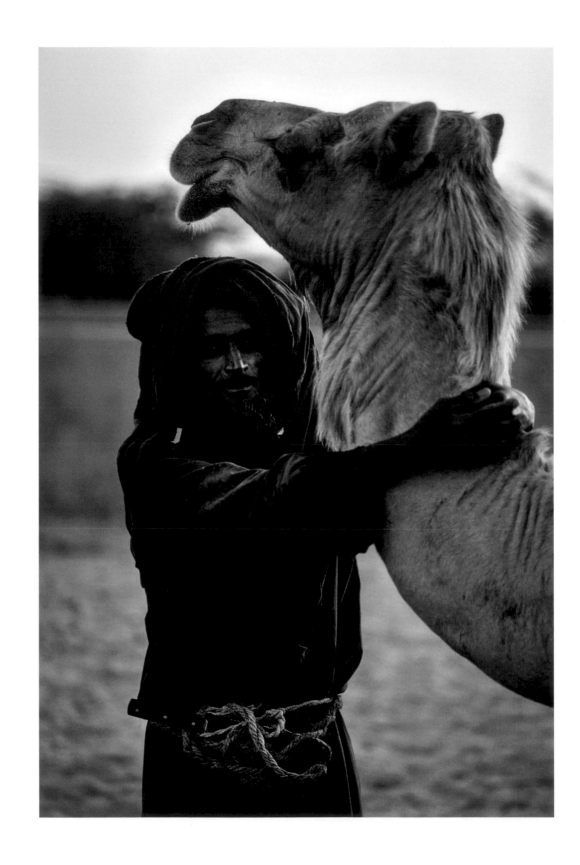

In Bahrain, near burial mounds associated with the enigmatic Dilmun civilization, one of the few remaining Bedouin tends his camel. The only Arab country where the Bedouin have been almost completely assimilated, Sunni-led Bahrain is the smallest of the Persian Gulf states—and also the first to discover oil in 1932.

130

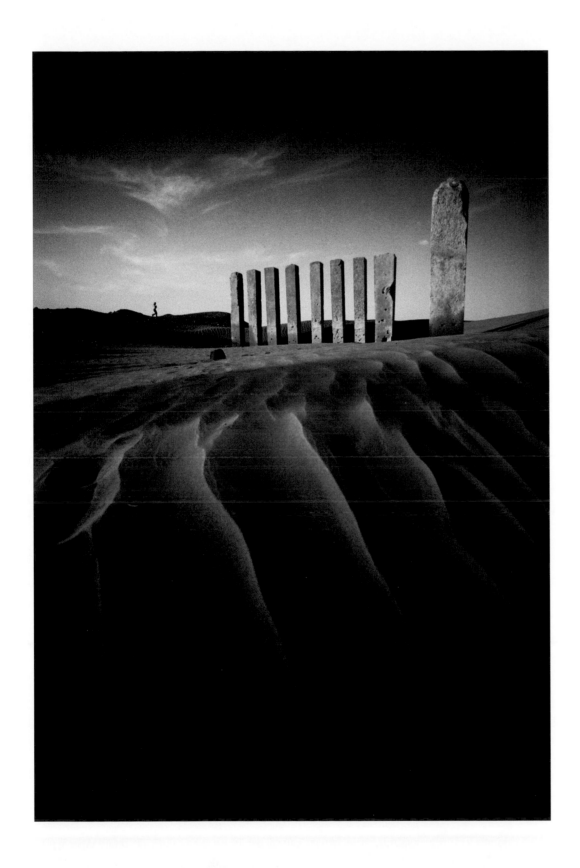

In the desert outback of Yemen near Marib, relics of
a lost civilization jut from the sand. These golden
pillars are all that remain of a moon-god temple built
by the ancient Sabaeans—a kingdom that prospered
for more than a thousand years and is thought to
have once been ruled by the Queen of Sheba.

Typical of the British Raj architectural style, spires of the old Kuala Lumpur Railway Station (*foreground*) frame the soaring skyscrapers of a modern Islamic city in Kuala Lumpur, capital of Malaysia. British colonial architects favored the domes, arches, and airy interiors typical of Muslim India and the Middle East, but today's sleek office towers of glass, steel, and concrete put a premium on function over form—a trend that has transformed the skylines of Asian cities.

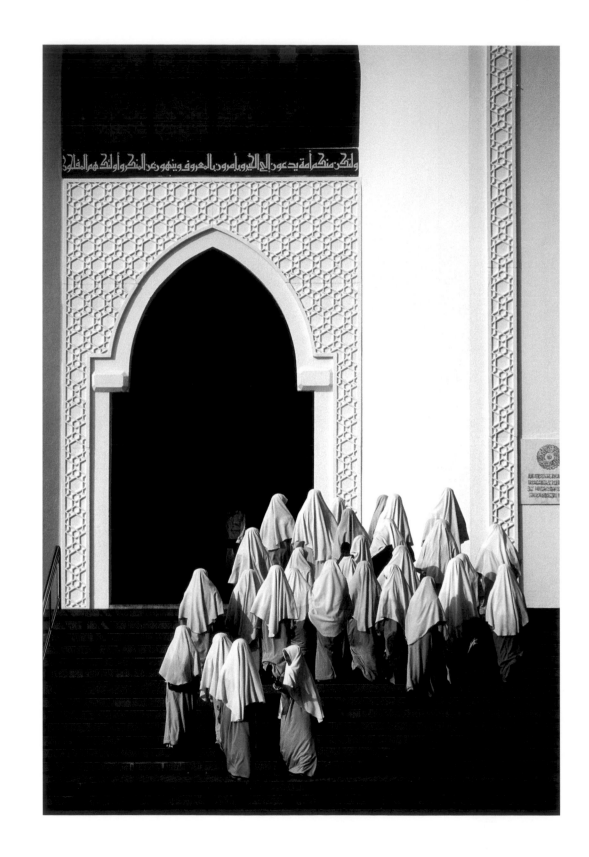

Muslim women in scarves and prayer robes ascend the steps of Malaysia's National Islamic Center in Kuala Lumpur. Malaysia, which boasts one of Southeast Asia's most vibrant economies, has a 61.3 percent Muslim-majority population. Muslim Malays dominate the country's politics and benefit from their majority status in business, education, and the civil service, but an ethnic Chinese minority holds economic power.

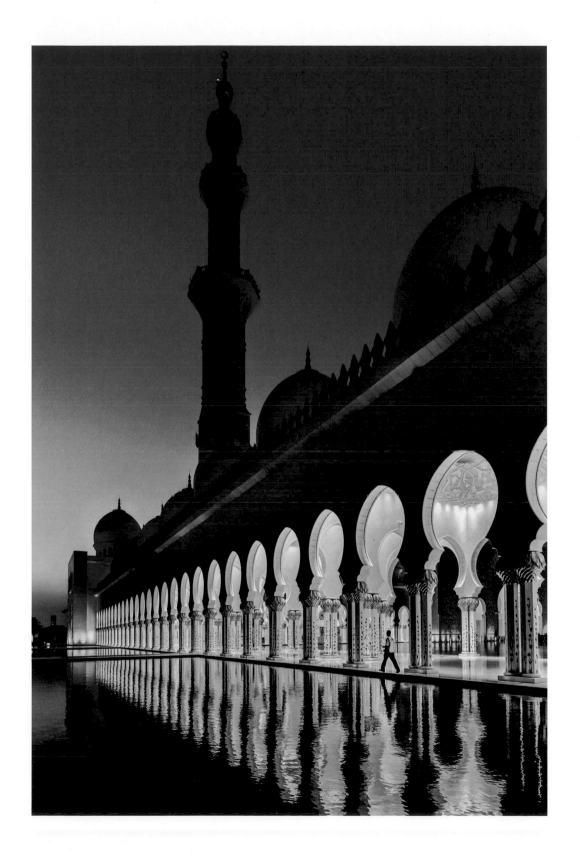

One of the world's largest mosques, the Sheikh Zayed Grand Mosque in Abu Dhabi can accommodate more than forty thousand worshippers. In 2017, the mosque was ceremonially renamed after the mother of Jesus Christ—*Mariam, Umm Eisa,* Arabic for "Mary, the mother of Jesus." Sheikh Mohammed Bin Zayed Al Nahyan, crown prince of Abu Dhabi, says he ordered the change to build bridges to other religions.

135

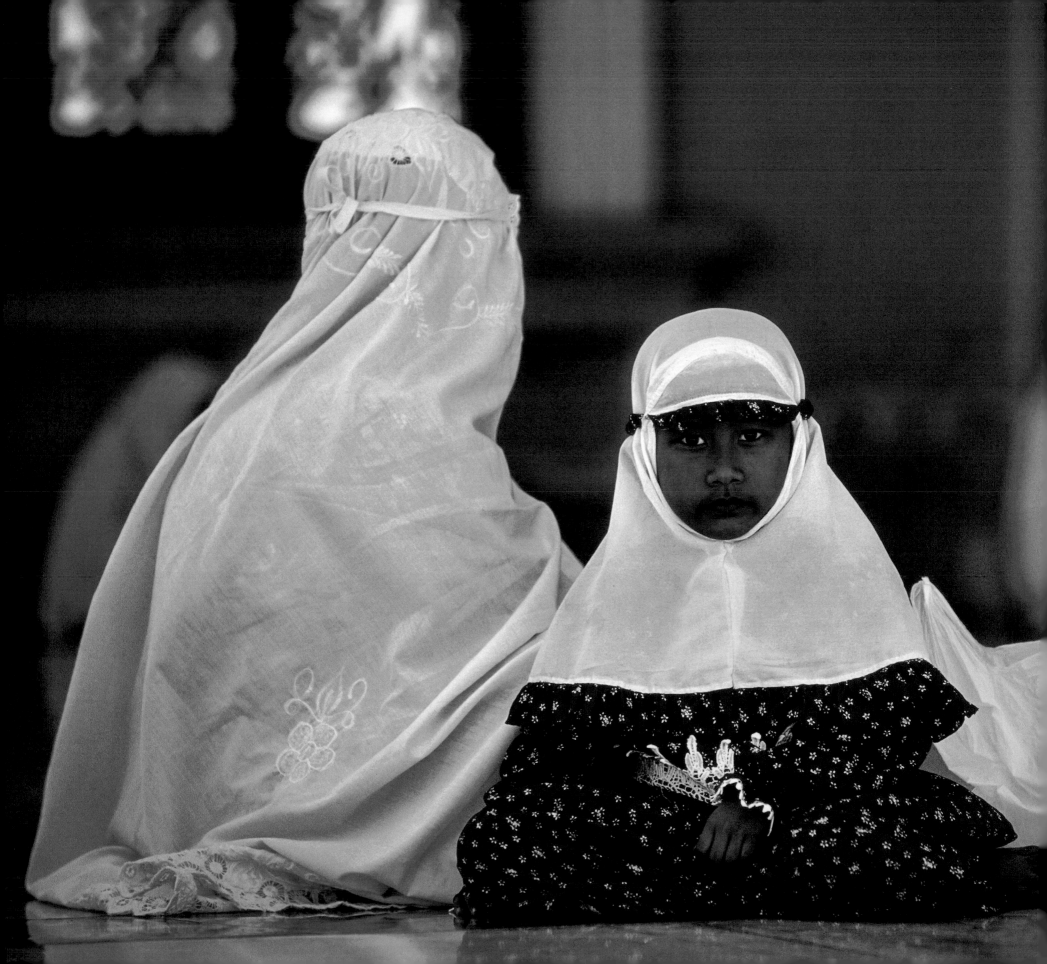

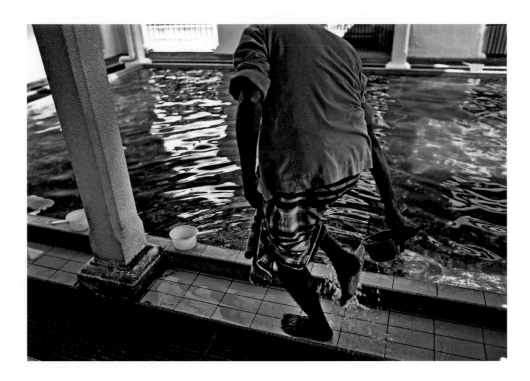

From the Malay Peninsula to the Indonesian archipelago,
Islam came to Southeast Asia through trade, not
conquest. Dressed in prayer robes called *mukenahs*
or *kerudungs*, a Muslim girl and her mother savor the
serenity of the Baiturrahman Great Mosque at Banda
Aceh on Sumatra. Adhering to the ritual of ablution,
a Muslim of Indian descent splashes water on his
feet before prayers at the Kapitan Keling Mosque in
George Town on Malaysia's Penang Island.

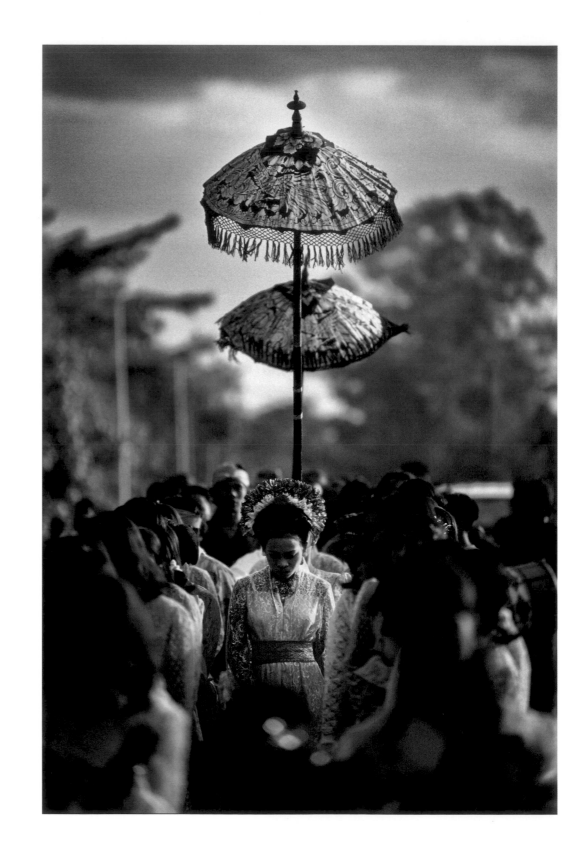

Musicians lead a wedding procession on Lombok,
an island in the vast Indonesian archipelago, where
Muslim and Hindu traditions are intertwined. Beneath
a canopy, the bride walks with female attendants
to the groom's home, where a Muslim cleric will
perform the relatively short Islamic ceremony.

138

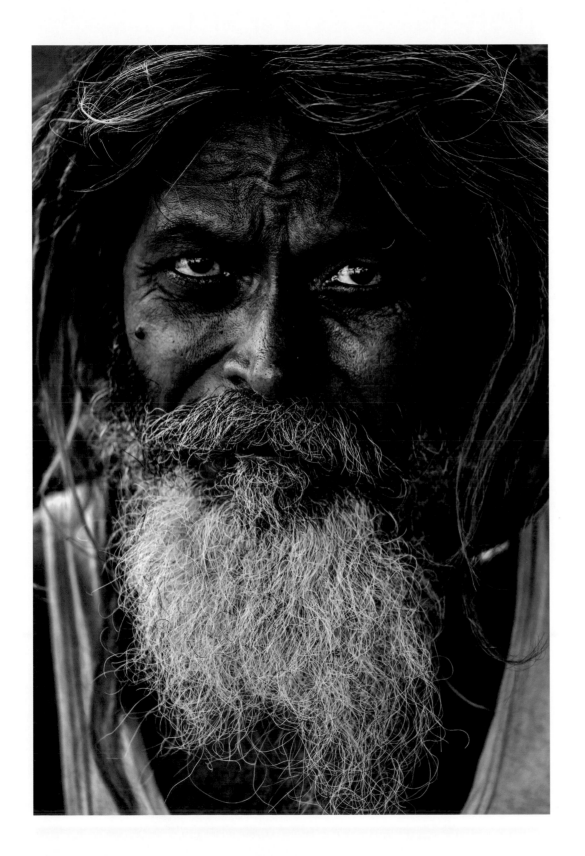

An elderly beggar is emblematic of Kolkata, a city that has become synonymous with poverty. For much of the world, Kolkata conjures images of a black hole of suffering—a city where thousands of humanitarian aid workers and Christian missionaries toil endlessly on behalf of the poor

Shafts of light pierce the windows of Istanbul's Church of
the Holy Wisdom or Hagia Sophia—a former Byzantine
church turned Ottoman Empire mosque. Once a secular
state, Turkey has experienced an Islamic resurgence in
recent years and formal prayers are once again held in
Hagia Sophia. In the Pera neighborhood of Istanbul, a tram
trundles along the *Grande Rue de Péra* or *İstiklâl Caddesi*,
the region's most famous pedestrian shopping street.

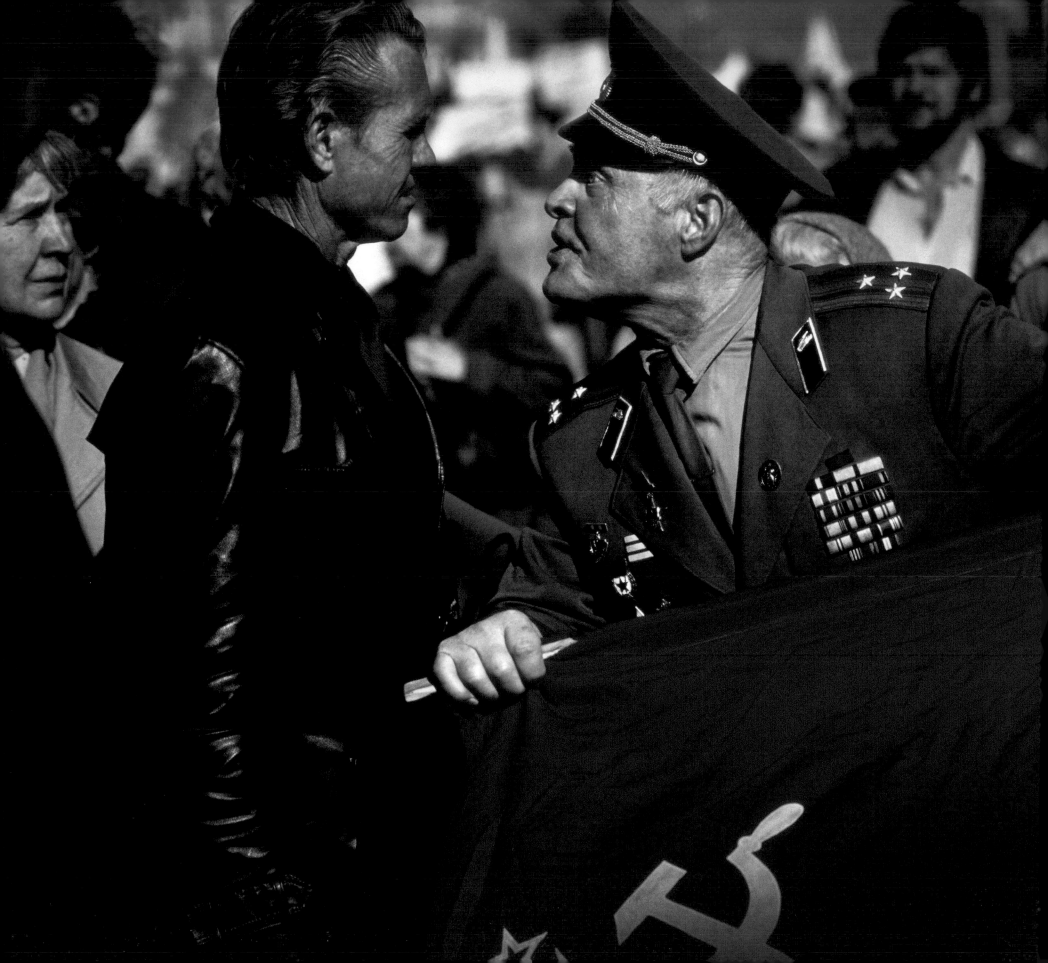

THE END OF THE COLD WAR

Spending a year at Stanford University studying Russia and committing myself—sight unseen—to reporting on the former Soviet Union was one of those wagers on the future we all make from time to time. But after working for more than a decade in the developing world, chasing often obscure conflicts or issues that showed us the worst of the human condition, I was ready for a new and perhaps higher profile assignment. And to my mind, the Soviet Union was a Cold War adversary and existential threat to everything that we held dear. Hence the importance of this new posting. While I had never set foot in Russia until 1986, I had seen the Soviets stirring up trouble in Germany at the Berlin Wall, and in Ethiopia, Madagascar, Egypt, Yemen, and, of course, Afghanistan.

Shouting "traitor," a flag-waving colonel of the Soviet Army confronts a pro-democracy demonstrator at a May Day parade on Red Square in 1990. Hundreds of thousands of Soviet citizens turned a working-class holiday into an angry display of popular discontent with communist rule—a movement that would lead to the dissolution of the Soviet Union in December 1991.

With rotor blades turning, a Russian helicopter waits for the author, his wife Barbara Skinner, who worked as a Russian interpreter for *National Geographic*, and Soviet government minder Mikhail Derevyanko to depart the Siberian nickel mining city of Norilsk. The team logged several hundred hours of flight time in aging Soviet military and civilian helicopters reporting from Siberia.

Today one of Berlin's most colorful tourist attractions is the old US Army Checkpoint Charlie on Friedrichstrasse, a historic street in what was once the American-occupied part of the city. But this is not the way I remember it. One of the defining symbols of the Cold War, the white guard post in the middle of the divided city was manned by American, British, and French troops and was the only approved way Allied diplomats, military personnel, and foreign tourists could enter Soviet-occupied East Berlin. It was here, on October 22, 1961, that one of the two most visible armed confrontations of the Cold War played out in front of the Western media. The other

was the Cuban Missile Crisis. The sixteen-hour standoff started when East German border guards demanded to see the passport of US diplomat E. Allan Lightner Jr., who wanted to pass through Checkpoint Charlie to attend the opera in East Berlin. Lightner refused and tensions escalated to the point where United States Army M48 Patton tanks, their engines idling and guns loaded, stood gun-barrel-to-gun-barrel against an equal number of Soviet T-55 tanks. As we now know, neither president John F. Kennedy nor Soviet leader Nikita Krushchev wanted an armed confrontation. World War III was averted when Khrushchev ordered his tanks to stand down and the

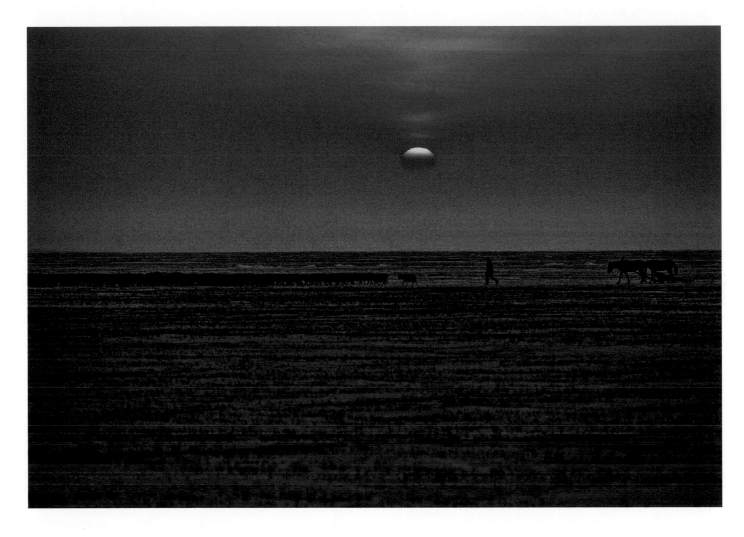

A shepherd near Abakan, capital city of the Republic of Khakassia in southwestern Siberia, drives his flock home across the endless steppe in a land that, despite efforts to tap its riches, is still defined by its overwhelming emptiness. The Khakass people, traditionally nomadic farmers and hunters, are a minority inside the Russian-dominated republic.

American commander, General Lucius Clay—hero of the Berlin airlift—followed suit.

Reporting on the bicentennial of the French Revolution, I spent a week with French and American troops in their separate sectors of the divided city—some of it at Checkpoint Charlie—and will never forget the cold, menacing stares of the East German border guards and their Soviet Comrades as I looked at life beyond the Berlin Wall inside communist East Berlin. Between 1961 and 1989, at least 139 people were killed or died trying to escape through the border fortifications that made up the wall. When the wall fell in 1989, pieces of it were sold

at the Newseum, the museum of news in Washington, DC. I bought a chunk for my father, Larry, a small town Wisconsin newspaper editor, who considered it a prized possession—a symbol of a better world.

Cold war tensions had intensified in the Reagan era when I arrived at Moscow's Sheremetyevo International Airport in early 1986 to consult with Russian officials about a pending *National Geographic* story on the Soviet space program. With my colleague Tom Canby, the magazine's space expert, we carried heavy cardboard tubes containing dozens of drawings and paintings by Western illustrators and engineers, all hired by *National*

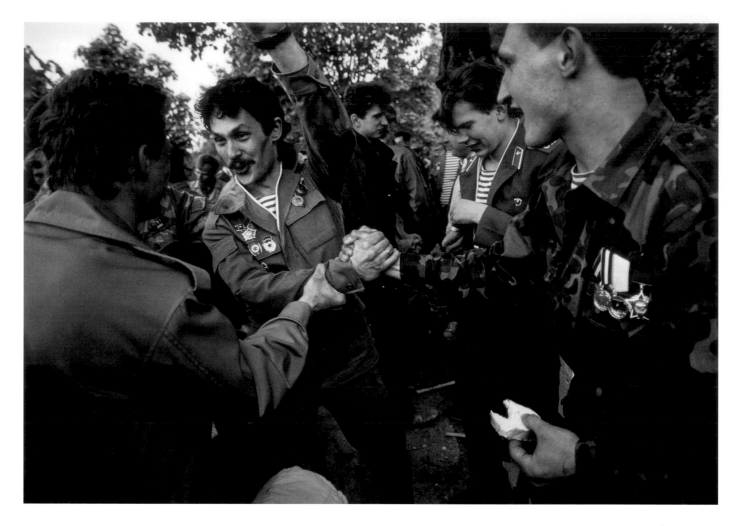

Veterans of a war gone wrong in Afghanistan gather in Moscow's Gorky Park to celebrate surviving a conflict in which some 14,500 Soviet soldiers were killed. The Soviet Union invaded Afghanistan to prop up a pro-Moscow regime, but Muslim rebels—supported by Iran, Pakistan, China, and the United States—drove out the Red Army in 1989.

Geographic, that depicted Soviet rockets, satellites, possible weapons, and heroic cosmonauts. Our mission was to show them to Soviet experts and obtain their feedback. Instead, I was barely able to get past Soviet customs officers, who wanted to know if I was just a naive spy on his first mission abroad or some eccentric who should be carted off to a hospital for a mental health evaluation. After many phone calls to Russian border guards and the KGB, we established our legitimacy and were allowed into the country. A senior official said, "I guess this is permissible, Comrade, so long as you are bringing these documents into the Soviet Union and not taking them

out." He did, however, confiscate my copy of *Time* magazine. Welcome to Russia!

In the end, there was little to be learned in Moscow about the Soviets in space. Officials were mute when shown our paintings and illustrations, believing the worst of us—that somehow *National Geographic* was an arm of the US intelligence community. And the story did nothing to quash those misconceptions when it was published some months later. The best pictures came from deep inside the Cheyenne Mountain Complex in Colorado Springs, Colorado—headquarters, at the time, of the US Space Command. I was photographing in a dimly lit

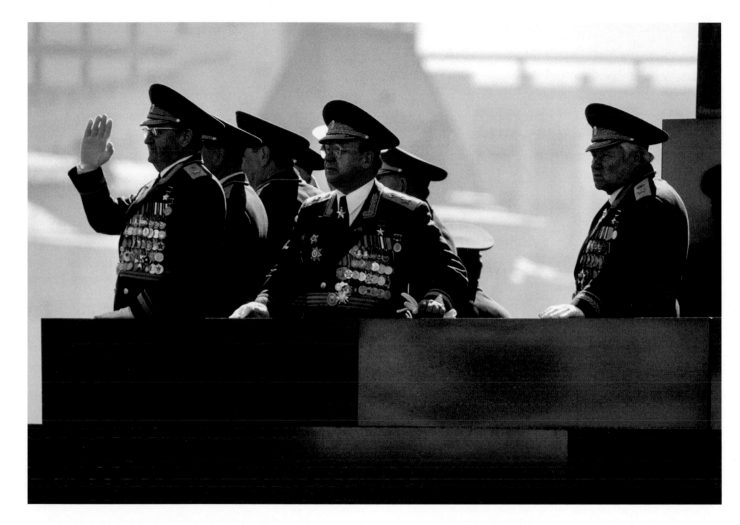

Generals of the Red Army that defeated Nazi Germany stand atop Lenin's Tomb in Moscow to mark a great victory. Every May 9, the Kremlin stages a military parade on Red Square to commemorate German capitulation in 1945, showing off ballistic missiles, heavily-armored tanks, and new fighter jets and bombers.

command center when the Soviets launched a missile into space and I made pictures of the beginning of a well-rehearsed drill to determine if it was an attack on the United States or its NATO allies or a scientific test. A minute into the alert, with sirens wailing and a general officer calmly issuing orders, military police officers escorted me from the command center. What ended up surprising me and readers of the *National Geographic* story most was how much stuff the Russians had launched into space, from satellites to discarded booster rockets—space junk.

Some months later I arrived in Ukraine, to do a *National Geographic* story about the agricultural breadbasket of the USSR. No sooner had I arrived than the Chernobyl nuclear power plant near the capital of Kyiv exploded on April 26, 1986. Suddenly our story had an edge to it. Our theme: How could a flawed reactor design, coupled with poorly trained personnel, lead to a reactor meltdown and the worst peacetime nuclear disaster in human history? Thirty people died in the blast and fire or were exposed to lethal radiation. The destroyed hulk of reactor number four burned for ten days, contaminating tens of thousands of square miles in northern Ukraine, southern Belarus, and Russia's Bryansk region. Ten days after the blast, iodine-131 and cesium 137, the most lethal of the Chernobyl

contaminants released into the atmosphere, had spread around the globe as far as Alaska, California, and several other states in the American West. Eventually Soviet authorities allowed my colleague Mike Edwards and me, accompanied by nearly a dozen security officials, into the exclusion zone around Chernobyl. Some ten miles from the smoldering power plant there was enough background radiation to give us each the equivalent of a chest X-ray every fifteen minutes, according to the dosimeters that we had sent to us from Washington. Mike and I stayed for an hour.

Meanwhile, I collected photographs from Russian and Ukrainian photographers who had documented the heroic cleanup by Soviet Army troops, police, and firemen. To obtain the most complete picture of the disaster that any magazine had at the time, Mike and I also traveled to Vienna to gather information at the International Atomic Energy Agency, and I went to the Lawrence Livermore National Laboratory near San Francisco. There scientists were developing a blood test for radiation exposure with blood from Chernobyl victims. But the jackpot came during a seemingly routine visit to the office of a government scientist at Lawrence Livermore. Reading a map upside down on his desk—something reporters train themselves to do—I naively inquired if it had anything to do with Chernobyl. He showed me the enormous computer-generated world map that plotted the dispersal of radioactive clouds from Chernobyl on days two, six, and ten after the explosion. After I twisted his arm a bit—stressing the map's value to *Geographic* readers across the globe and its importance to the public, not just scientists—the official rolled it up, put a rubber band around it, and escorted me through security and to my rented car. I was quickly on the way to the San Francisco International Airport with what would become a centerpiece illustration for our story, which was published in May 1987.

One of my principal missions, unlike the international press corps based in Moscow, was to go to the far corners of Russia and the other states of the USSR. But I couldn't have done this without my wife Barbara, a fluent Russian speaker and university professor with a PhD from Georgetown University. Together we had the opportunity to travel throughout the vast four thousand miles of Siberia, an area that encompasses tundra, coniferous forest, and several mountain ranges. We also found old gulags, or labor camps, for political prisoners from Stalin's reign of terror in the 1930s. Forced by bad weather over the Ural Mountains to land in the closed-to-foreigners city of Sverdlovsk, now renamed Yekaterinburg after the wife of Tsar Peter the Great's wife, Catherine, Barbara led our *National Geographic* reporting team to a local restaurant, where an orchestra was playing, couples were dancing, and as far as we could tell, no one had ever seen an American before. Barbara explained our mission and the work of *National Geographic*, and answered numerous questions from restaurant-goers about the United States, Soviet-American relations, and why I had a bottle of French Beaujolais wine tucked in my camera bag for unforeseen occasions traveling in Siberia. It was one of the few unscripted moments in the six months we spent in Siberia under the ever-watchful gaze of plain-clothed security agents, minders, and local Communist Party officials.

Siberia today is a place where president Vladimir Putin is immensely popular, a vast interior space whose industries grew during World War II, a region rich in rare minerals, timber, oil, diamonds, and gold. As former National Public Radio correspondent Anne Garrels writes in her book *Putin Country*, Siberia is sort of like America's rustbelt: it is industrial and its people are genuine, salt-of-the-earth folk who work with their hands as much as their minds and computers. Apart from its stunning lakes and forests, Siberia is burdened by shuttered factories,

mysterious closed cities that foreigners must have permission to visit, and some of the most polluted places on earth—much of it the result of weapons testing and production. It is a place distant from Moscow and the life in a fishbowl that most foreign correspondents lived in the late 1980s and early 1990s. All the same, Barbara and I succeeded in opening to foreign journalists several previously inaccessible areas in Siberia. We made trips to Norilsk, an enormous mining center above the Arctic Circle; to the Kola Peninsula—usually only seen by American spy satellites looking for Russian submarines making a break for the deep water of the Barents Sea; and to the Solovetsky Islands on the White Sea, with its tiny community of farmers and monks who care for its fifteenth-century Russian Orthodox monastery. We also saw a Russian prison deep in Siberia near the border with China, but Russians authorities warned there could be a riot if Barb was allowed inside. Staff writer Mike Edwards and I walked from cellblock to cellblock as prisoners hurled verbal abuse and pieces of food at us. Apparently, they hadn't received word that the Cold War was winding down.

With the exception of the visit to the prison, at every stop we felt as much like American goodwill ambassadors as journalists, so novel was it for ordinary citizens to meet their first Americans. Yet some encounters were more successful than others. At a dreary apartment block in the coal-mining city of Novokuznetsk in southern Siberia, we were invited to meet and photograph a typical working-class family. Delicious plates of zakuski (hors d'oeuvres) were passed around and toasts of vodka exchanged, while our minders from Moscow and the local Communist Party in Novokuznetsk tried to guide the conversation toward the virtues of life in the Soviet Union. We tried as best we could to explain that no serious American wanted nuclear war with the Soviet Union

and that homelessness at home in Washington, DC, was a problem, but not to the extent that Russian state television portrayed it. The family, with several beautiful children, hardly seemed affluent enough to afford black and red caviar, a luxury by any measure, and the apartment building was freshly painted, a fact confirmed when I brushed up against a stairwell wall and got wet paint all over my camera bag—a souvenir of one more photo op in the controlled media environment that was Soviet Russia.

On another occasion near Lake Baikal, the world's largest fresh water lake in the mountainous region north of the Mongolian border, a peasant woman asked Barbara if she might see a US dollar. Our currency was by then much talked about in the newspapers and on television, though officials in the Kremlin never lost an opportunity to call us the "main enemy" on the nightly news. When Barbara offered her a dollar, she carefully took it, inspected both sides of it, and handed it back. The Siberian woman's refusal to accept the token gift was easy to understand—at the time, it was still illegal for ordinary Russian citizens to own foreign currency. Still, Barbara, with her knack for meeting people and starting conversations in fluent, unaccented Russian, was able to lead us to more productive venues—usually people's cramped apartments—where we met bear hunters, steel-mill workers, and scientists. These surreptitious meetings were all out of range of our minders, to whom we sometimes gave the slip for several hours by buying them expensive booze at stores for the privileged that accepted only foreign currency.

Superficially, our time in Moscow was like that of most other foreign correspondents. But since we traveled to and from Washington, DC, we had no permanently assigned apartment in one of the drab housing blocks reserved for foreign diplomats and journalists. Often we stayed in the comfortable digs of the Hotel National

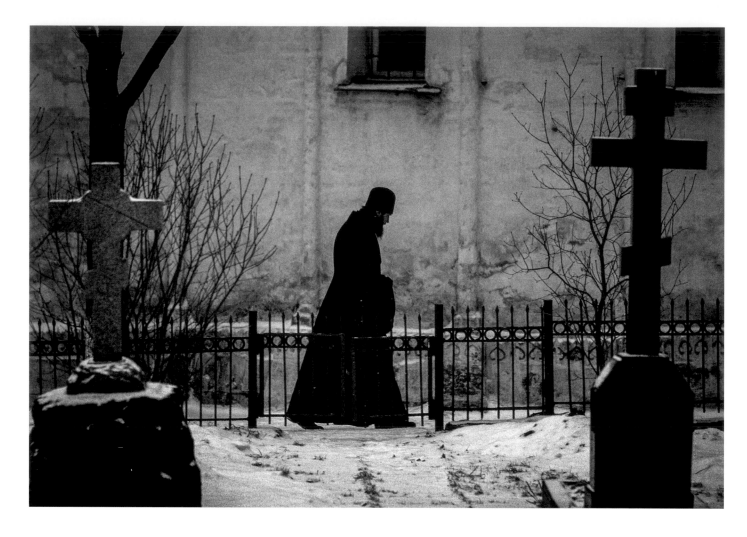

Near Moscow, a monk walks past the cemetery at Trinity Lavra of St. Sergius — Russia's holiest religious site — in the city of Sergiev Posad. Today the Russian Orthodox church finds itself allied with Kremlin politics, with both President Putin and Patriarch Kirill opposing gay rights and supporting a muscular foreign policy.

with its spectacular views of the Kremlin and Red Square. While there was no access to Western radio, television, or newspapers, Barbara had a grand piano in the room at the National. I recall one evening when she played Rachmaninoff and Scriabin well into the night as the snow silently fell on the Kremlin's nineteen towers.

But otherwise, we were subjected to the same rules as other Western correspondents and life was much like the spy novels and TV documentaries on the Cold War. Our telephone calls, telegrams to Washington, and faxes were censored. Every hotel room we ever stayed in, be it the National in Moscow or rustic rooms at the top of

the world in the oil-and-gas-rich areas of the Arctic, was bugged with audio and sometimes video surveillance. If we went for a walk to shop or visit Russian friends, the KGB secret police (there also was a foreign intelligence gathering branch of the KGB) would follow us. When I first arrived in Moscow, I recall going for a walk with the late Bill Eaton, the *Los Angeles Times* bureau chief who would go on to become a popular professor at the University of Maryland. "You have to remember that Moscow Rules apply 24-7," Eaton cautioned. "Never discuss work in a restaurant or at home. Never let your guard down—always assume you are being watched or listened

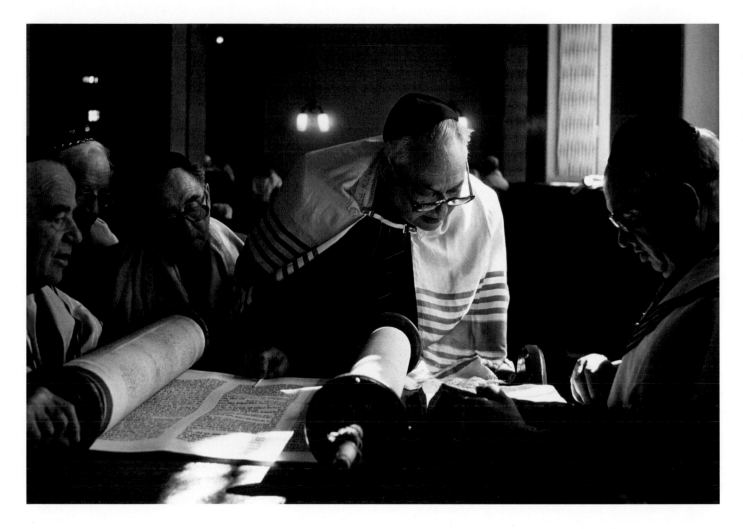

Reading from the Torah, Jews celebrate the Sabbath at the Choral Synagogue in Moscow. During the Cold War, the status of Jews was a major human rights issue. Beginning in 1988, Soviet President Mikhail Gorbachev relaxed restrictions on religious practice, which led to a massive Jewish exodus to Israel and the United States.

to." Eaton suggested that when I walked down the street, I should try to look into a shop window to see if I was being followed—standard Moscow spycraft right out of CIA manuals. "If you are beaten up on a back street, always assume it's official," was one of Bill's famous lines. In the end, we all knew the Soviets would like nothing better than to arrest us on trumped-up charges of espionage or exchanging currency on the black market in order to trade us for one of their spies jailed in the United States.

Soon after I arrived in Moscow in 1986 from a trip to Ukraine, American correspondent Nicholas Daniloff of *US News and World Report* magazine was arrested. He was taken into custody on September 2 and charged with espionage. He was released on September 23 in a spy swap with Washington, but the crisis triggered by Daniloff's arrest dragged on with more expulsions of diplomats and suspected spies on both sides. In fact, it escalated to the point that by the end of October 1986, one hundred Soviets, including some eighty suspected Russian intelligence agents, were expelled from the United States. The Soviets in turn expelled ten US diplomats and withdrew all two hundred and sixty of the Russian support staff working for the US embassy in Moscow. As I learned in numerous encounters, official and unofficial, with Soviet journalists

and Kremlin bureaucrats, we American journalists were considered spies first, writers, broadcasters, or photographers second. And why not? The KGB had planted hundreds of undercover intelligence agents abroad working as journalists for TASS, the Soviet news agency; one of their state-controlled newspapers like *Pravda* (Truth) or *Izvestiya*; or Radio Moscow, their overseas broadcasting arm. And at home, Russian journalists, as I saw firsthand on a visit to the headquarters of the Communist Party newspaper *Pravda*, received their daily marching orders from the propaganda department of the Communist Party Central Committee on Stary Ploshchad near the Kremlin.

Our time in the Soviet Union coincided with president Mikhail Gorbachev's signature policies of glasnost, or openness, in Soviet society, and perestroika, the restructuring of the Soviet economy and government. On some counts Gorbachev succeeded in transforming Soviet society. But his restructuring of the corrupt and fragile economy created more problems than it solved. Moreover, by the late 1980s, Russians were able to learn about their own history and social failings. An increasingly free press churned out tens of millions of words about environmental disasters, alcoholism, juvenile delinquency, shabby public housing, and seventy years of totalitarian rule by fear, torture, and murder. Russians wanted to know about the political prisons, why their standard of living was so far behind that of the West, and why they should continue to be ruled by a privileged elite. They also wanted some of the immediate icons of Western culture, and Barbara and I were on hand when the Soviet Union's first McDonald's fast-food restaurant opened in Moscow on January 31, 1990. Thousands of people lined up to pay the equivalent of several days' wages for Big Macs, shakes, and French fries. In the end, Gorbachev couldn't deliver a higher standard of living fast enough and all of the fifteen republics that made up

the Soviet Union wanted some form of independence from Mother Russia.

As Gorbachev's USSR continued to unravel, Barbara and I strolled the streets near Red Square in Moscow on May 1, 1990, for what was billed as the once-a-year, perfunctory tribute to the laboring classes. But we had heard rumors of a planned protest. This was something of an understatement, as more than two hundred thousand people from across Russia and a number of other Soviet republics converged on Red Square to demand an end to Communist Party rule. KGB secret policemen pushed and shoved us, but did not prevent me from taking pictures of Gorbachev and his ruling politburo cronies being shouted down from atop their privileged viewing stand on Lenin's mausoleum in front of the Kremlin. After twenty minutes of chants and angry shouts of "Down with Soviet Power," Gorbachev turned on his heel and walked away, followed by his subalterns. When demonstrators finally broke up some hours later, Barbara and I retired to the pub in the basement of the Hotel National with Strobe Talbott, then a *Time* magazine correspondent and later president Bill Clinton's deputy secretary of state. "Mark this day," said Talbott. "The genie is out of the bottle and they'll never get it back in." On December 25, 1991, Gorbachev resigned the presidency of the Soviet Union and handed over the nuclear codes to Russian president Boris Yeltsin.

Slowly the Soviet Union was becoming less a Cold War enemy than a country of well-meaning Slavs and numerous other ethnic groups, including Muslims and Buddhists, who, like most of us, yearned for a better life for themselves and their children. It remained a state with a divided government, parts of it wanting to reform the tyrannical Soviet system, other parts wanting to reform the economy, and still others wanting to maintain the rock-solid political and ideological control of nearly three hundred million people. In Russia proper, the core of the

USSR, we saw people searching for their roots, looking for long suppressed Russian culture and traditions. Visually, this phenomenon often took the form of a revival in Christianity, a faith long-denied and tightly controlled. In the early 1990s, Barbara and I could go to virtually any city on a Sunday morning and find lines of hundreds of Russians waiting to be baptized in the Russian Orthodox Church, often not because they knew what the sacrament meant, but because it had been denied to them and they knew it was part of being Russian.

Even as the Cold War was drawing to a close, I had begun a book about Saint Petersburg, a daunting project about Russia's imperial capital that was teaming with some of the most treasured art and architecture in the Western World. Saint Petersburg was Russia's window on the West, built by Tsar Peter the Great on the marshes of the Neva River along the Baltic Sea coast. To try to make sense of this visual feast for the eye, I consulted one of Barbara's professors at Yale University, the late Jaroslav Pelikan, a historian and scholar of Christianity. Pelikan was a real character, who could speak about the ancient and medieval worlds extemporaneously for hours. He also wrote a bestseller called *Jesus Through the Centuries* that made him into something of a cult figure on television and interview shows for his ability, as Wolfgang Saxon of the *New York Times* wrote, "to interpret Christian tenets to a vast lay audience in the English-speaking world."

Pelikan told me to read everything I could about Tsar Peter the Great's vision for Saint Petersburg, whose foundation cornerstone was laid in 1703 at the Peter and Paul Fortress on the north bank of the Neva River. Next—and this was the key to Pelikan's professorial genius—he said my mission was to discover what remained today of Peter's grand vision for a "Venice of the North." After all, Saint Petersburg enjoyed a nearly continuous building boom for almost two hundred years, much of it based on

Peter's design, and was the capital of the Russian Empire until 1917, when the communists took control of the government and moved the capital inland to Moscow. For Barbara and me, the Saint Petersburg book was full of "firsts," including, by the summer of 1992, being able to rent our own apartment and freely roam the city without government minders and KGB surveillance. Our accommodations were surprisingly comfortable and down to earth. Through friends of Barbara's, we rented an apartment from a member of the former Russian nobility, a bureaucrat who needed US dollars and willingly slept in his office while we stayed in his flat in a turn-of-the-century building not far from the US consulate.

But trying to make sense of what seemed like a living museum of grand buildings, palaces, formal gardens, and canals still required using some reporting skills sharpened during the Cold War. Barbara and I worked the local bureau chief of the government newspaper *Izvestia*, who happily accepted one hundred dollar bills in return for unfettered access to the great State Hermitage Museum and other cultural treasures, to Saint Isaac's Cathedral and other ecclesiastical institutions, and to the Kirov tank factory and a naval shipyard founded by Tsar Peter. Our go-between spoke no English, but Barbara would relay my requests, the local fixer would set up a visit to this place or that "in principle," and then Barbara would follow up with specific arrangements, always emphasizing that I was a photojournalist and needed to see things to be successful in my work, not to sit at a conference table and endlessly discuss statistics as the Russians are wont to do.

Frustrated that I could not understand where most of the city's five million citizens worked, I consulted a friend at CIA headquarters in Langley, Virginia, and asked for help in explaining the city's labor force. A CIA national intelligence officer telephoned and suggested we meet at a Chinese restaurant in Arlington, Virginia, just across the

In 1990, after Soviet President Mikhail Gorbachev ended decades of religious repression, tens of thousands of Russians crowded Orthodox churches to profess their faith in an officially atheistic country. At the Cathedral of the Transfiguration in Saint Petersburg, group weddings helped accommodate a renewed spiritual identity.

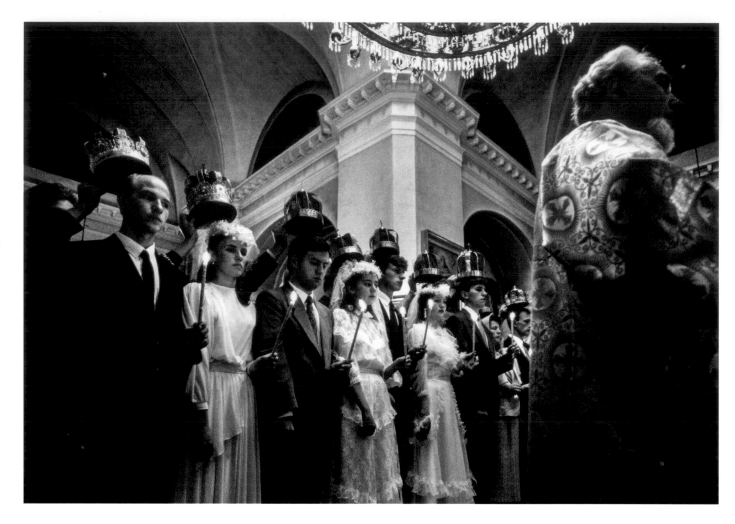

Potomac River from Washington, DC. An affable young man whom I had met socially under another name—it is nothing out of the ordinary in our nation's capital to have friends and neighbors who work in the intelligence community—produced a document on plain white paper that listed every important business and industry in Saint Petersburg and the number of employees at each institution. I was astonished. The Kirov Metalworks employed some fifty thousand workers, the Klimov Aircraft Engine Factory another thirty-five thousand, and some 80 percent of the city's two hundred and fifty thousand scientists and technicians worked in military plants or on military

research. The conditions for accepting this information were simple. It was a classified document being leaked to me on the condition that I never reveal its source. In other words, this knowledge was so-called "deep background," as if someone had divined it to me in a dream. Also in Washington, where Russians were freer to speak, I found a researcher from the city's Institute of Science and Technology who told me that Leningrad, as Saint Petersburg was called in Soviet times, "was like the whole state of California during the Cold War." It was the USSR's principal center of military research and development, which went a long way toward explaining all the military officers

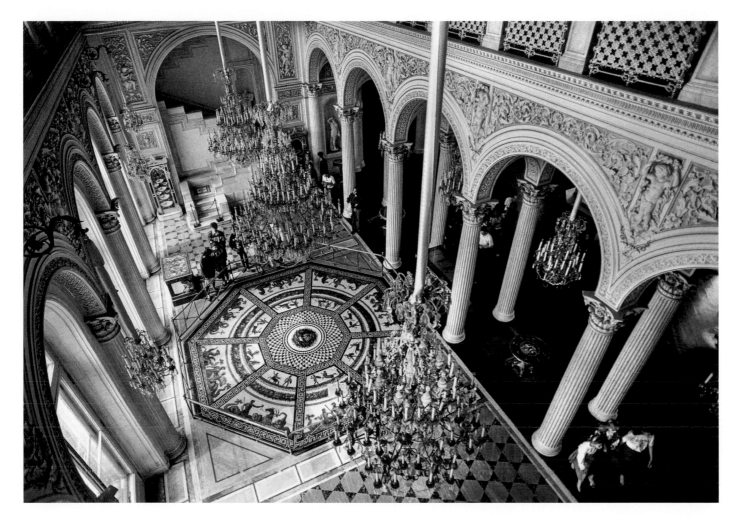

"I have a whole labyrinth of rooms . . . and all of them are filled with luxuries," wrote Catherine the Great of the Winter Palace and the adjoining Hermitage, where Pavilion Hall fills one small corner. Designed by the Frenchman Jean Baptiste de la Mothe, the hall incorporates elements of Moresque, Renaissance, and Classical architecture.

in their long wool overcoats strutting around the campus of Saint Petersburg State University. The CIA document said the Vavilov State Optical Institute was located on the campus and its job was to design all of the sensors and lenses for Soviet spy satellites.

Meanwhile, I remained loosely connected to Alaska. In June of 1988, three years before the end of the Cold War, I documented the opening of a Bering Sea air corridor for Alaskan Native Americans and their kin in Siberia, then part of the Soviet Union. In a specially configured Alaska Airlines Boeing 737 jet that could land on a gravel runway, I flew the short 220 miles across the Bering Strait

from Nome, Alaska, to Provideniya, Russia, with *National Geographic* editor Bill Garrett, some eighty-two dignitaries, and dozens of Yupik-speaking Alaskan natives, to be the first Americans since the beginning of the Cold War to land at the far edge of the Soviet Union—more than a year before the Berlin Wall came crashing down. The so-called "Ice Curtain" melted away during our fourteen-hour visit to the Siberian seaport town of several thousand Russians and hundreds more indigenous Siberians. School children met our passenger jet holding hand-drawn American flags and signs that read "Peace" and "No to War," while Alaskan natives discovered great-aunts and great-uncles,

Once the summer residence of Catherine the Great, the palace that bears her name in the Saint Petersburg suburbs—and its elaborately domed chapel—has been stunningly restored, thanks mainly to a massive postwar restoration effort by the former Soviet government. Beneath an Italian masterpiece, a Russian couple watch their time inside the State Hermitage Museum, one of the world's great treasure houses of art.

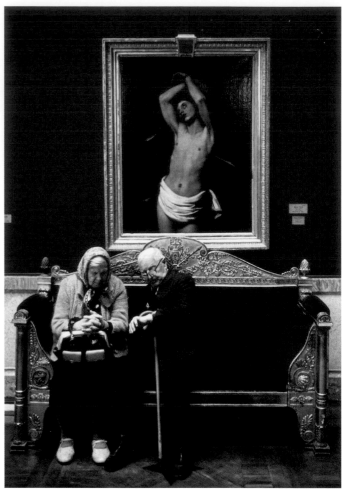

cousins, and others who were part of their family stories and legends. The event concluded with impromptu native dancing, endless toasts with vodka to peace and friendships, and a genuine feeling that we had broken the ice on this forgotten frontier that had seen no cross-border air traffic since the end of World War II.

Behind the scenes, I had worked with Ginna Brelsford of the Alaska governor's office and former Alaska lieutenant governor Mead Treadwell to set the stage for this thaw in US-Soviet relations. My fulltime assignment was the Soviet Union, including developing stories in the USSR that would open the door into previously unseen

parts of the fifteen-nation empire. When I got wind of a homegrown, all-Alaskan initiative to open the closed frontier, I traveled to Anchorage to investigate. Such was the autonomy that a number of us on the staff of *National Geographic* enjoyed during the so-called golden age of magazine photojournalism.

Brelsford, Treadwell, and community leaders in Nome on the Bering Strait knew that Gennady Gerasimov, spokesman for Soviet Communist Party leader Mikhail Gorbachev, would be traveling to Anchorage and that it might be possible to interest him in extending his stay to visit the icy, wind-washed border. Gerasimov

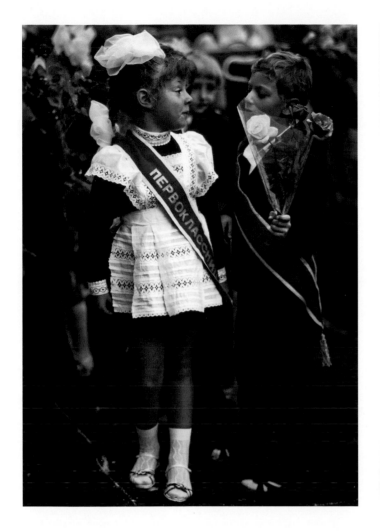

September 1 marks the first day of school in Russia and Ukraine, with children ready to give flowers to their teachers. In the Ukrainian port city of Odessa, children once wore sashes that read "first grader" in Russian. A Soviet-era monument to the Bolshevik unification of Russia and Ukraine, which ended in 1991 with Ukrainian independence, is the backdrop for a tender moment at in Kyiv, the Ukrainian capital.

told a Chamber of Commerce lunch crowd in Anchorage that he spent his childhood in far eastern Siberia, and "often wondered what lay across the Bering Sea on the US side." Often considered the public face of Gorbachev's new openness with the West, Gerasimov allowed as how the Russian people had a romantic attachment to Alaska, in part because Russia sold to it the United States in 1867 for $7.2 million and that in parts of the Soviet Union the state was still called "Russian America." In private meetings with governor Steve Cowper, Gerasimov counseled patience, but said he was "enthusiastic about the many ideas for opening Siberia." The predicament was how to

help the ever-quotable Gerasimov to understand how physically close were the two Cold War foes.

Going beyond the bounds of traditional reporting, ABC News producer Robin Gradison and I offered to pay to fly Gerasimov from Anchorage to Little Diomede Island, a rocky outcropping in the Bering Strait. To my mind, an investment of a few thousand dollars might pay off with a scoop that only ABC News, *National Geographic*, and a few local reporters would have. Perhaps naively, I focused only on the possibility of a good outcome and not on the possibility of tensions hardening if something were to go wrong.

On a clear and sunny Sunday afternoon, we arrived on the mesa-like outcropping of Little Diomede Island. Our expedition, led by Alaska natives, Brelsford, and Tredwell, escorted Gerasimov into an Alaska Army National Guard bunker. Here military police and intelligence officers kept watch on their Soviet Army counterparts some two miles distant—and across the international dateline—on Big Diomede Island, or to the Russians, Ratmanov Island. Gerasimov was moved by what he saw—a battle-ready, 24-hour-a-day standoff that was virtually unknown outside of Alaska and the highest circles in the Kremlin. Yupik-speaking Alaskan natives also told Gerasimov of informal visits to their Siberian relatives using small boats—a risky and potentially dangerous proposition at best—and of their desire to reestablish cultural ties. He promised to see what he could do to open the border, at least to native Alaskans, and kept his word. Years later, Brelsford called the Friendship Flight a "frontier adventure." "After all," the Anchorage native asked me, "is that not the definition of our frontier spirit?"

Journalism ethicists can rightly fault my personal involvement in the Friendship Flight, including the use of my *National Geographic* American Express card to help fly Gerasimov to Little Diomede in the expectation of jump-starting the border opening. The job of a journalist is supposed to be to stand back and record history, to be the proverbial fly on the wall as the story unfolds. Journalists are expected to maintain a level of distance and refrain from personal engagement in most controversies they cover. Yet in rare cases—when the stakes are high, lives are at risk, or perhaps history is in the making—we can justify getting involved because if we don't, either some harm will be done or some important good not done.

As I tell students, 99 percent of the time our job is to separate our personal values from the verified facts. And that objectivity is not the same thing as neutrality. There

are times when we journalists cannot sit by and grant a moral equivalency to both sides of an issue. In this case, the right thing to do was to make sure a senior Soviet official understood how important it was to the majority of Alaskans to bring down the Ice Curtain. In the moment, it seemed vital to do what I could to help open this Cold War barrier rather than let a historic opportunity slip through our fingers for lack of interest or a chartered airplane to take Gerasimov into the Bering Strait.

Professor emeritis David Boeyink of the Indiana University Media School is a national authority on media ethics and values and coauthor of the textbook *Making Hard Choices in Journalism Ethics*. When I discussed this case with him, Boeyink rightly asked if the outcome justified my actions. "It's pretty easy to feel good about what you did," he said, "but things could have turned out differently. Suppose news of this had leaked and there had been unforeseen ramifications in the Soviet Union or in the States—perhaps even a hardening of attitudes, more militancy on the border. What looks benign now might not have been if things had gone differently." And he was, of course, correct. What I failed to consider were my divided loyalties at the beginning of the adventure. Ideally, we journalists are loyal to the public first and foremost, but perhaps in this case I failed to recognize that I was also caught up in publishing an exclusive story—one that turned out to be overwhelmingly popular with readers.

In my defense, this historic thaw in Cold War relations on America's last frontier seemed to me, and to my editors, to be in the tradition of *National Geographic's* first-person style of participant journalism. All the same, my experience on the Bering Strait begs the question, What is an acceptable level of personal involvement to get a set of pictures or a good story? In this case, I not only helped make the news, but, along with my friend Robin Gradison from ABC News, ended up with exclusive access to

the story we helped create. On reflection, the moral and ethical theories that I use in the classroom suggest that my loyalties were to my employer, my politics, and myself—that breaking down barriers between the peoples of the United States and the Soviet Union was a good thing and a good story. But what about the readers of *National Geographic*? How loyal had I been to them by failing to disclose my role in bringing about this historic occasion?

As a teacher, I am quick to point out that journalism has come comparatively late to caring about ethics, values, moral theory, and loyalties to ideals like truth, accuracy, and independence. Compared to the professions of medicine, law, business, and the military, we journalists are ethical neophytes. The Emir of Bahrain, the ruler of a tiny Persian Gulf sheikhdom, once offered me a diamond-encrusted Rolex watch at the end of a reporting stay. Having taken no courses in media ethics—there were none when I was a student—all I could do was ask myself, What would the *Washington Post*'s Bob Woodward and Carl Bernstein of Watergate fame do if they were in my shoes? I politely turned down the watch, suspecting the ostentatious gift would compromise my independence. Fortunately for today's generation of journalists, courses in media ethics and values are now standard in communications schools. But few of us veterans would want our professional lives examined through the lens of today's high ethical standards.

Looking back on these adventures, my time in Moscow and the former Soviet Union was an important personal milestone, one spent trying to fulfill my responsibilities as a professional eyewitness—being a voice and pair of eyes independent of government and all sides in a conflict, controversy, trend, or debate. I often reminded myself, knowing the KGB was listening, that our job was to hold the powerful to account for their actions, as well as to give some voice to the less powerful.

Moreover, seeing the final days of the Cold War gave me a better grasp of what it meant to be a professional. We journalists are unlicensed, there is no body of knowledge to be professed or practiced, there are no governing organizations or norms that if broken could lead to sanctions. Anyone can call himself or herself a journalist if they get their pictures and stories published. But unlike other professionals—say doctors or lawyers—we journalists are focused on being loyal to the truth, the public, and a functioning democracy, not a client, a patient, or a company. As journalism ethicist Stephen Ward says, being a journalist today is about holding ourselves to ideals that are morally permissible *in ways beyond*—key words—what the law, the market, morality, and public opinion would otherwise require. A professional journalist is no longer defined by where they work or for whom they work, but by how they work. In fact, the overwhelming majority of our professional codes of ethics are what we call aspirational: short and to the point in defining our ideal behavior and leaving it to us to sort out our ethical challenges on a case-by-case basis.

Being a photojournalist in Russia was a constant ethical challenge. In photographing people and places previously unseen by Western audiences, we had to protect the identities of citizens who offered friendship along with their insights into the political and social upheavals of Gorbachev's Russia. There were constant demands from Russian officials to pay for information and access, as some Asian and European journalists do. And there was the problem of obtaining information from US government sources without compromising our independence too much—perhaps the most difficult of all ethical challenges.

Today scholars, pundits, and many in the media say we have entered a Cold War 2.0, and unfortunately, they may be correct. But it is one almost entirely of Russian

In Russia's impoverished heartland near Volgograd, Raya Ragoshkina cherishes visits from her granddaughter Yana from the big city. Since the collapse of Soviet power in 1991, successive governments have said they wanted to make peasants "masters of the land," but large government-run farms continue to control most of Russia's agricultural acreage.

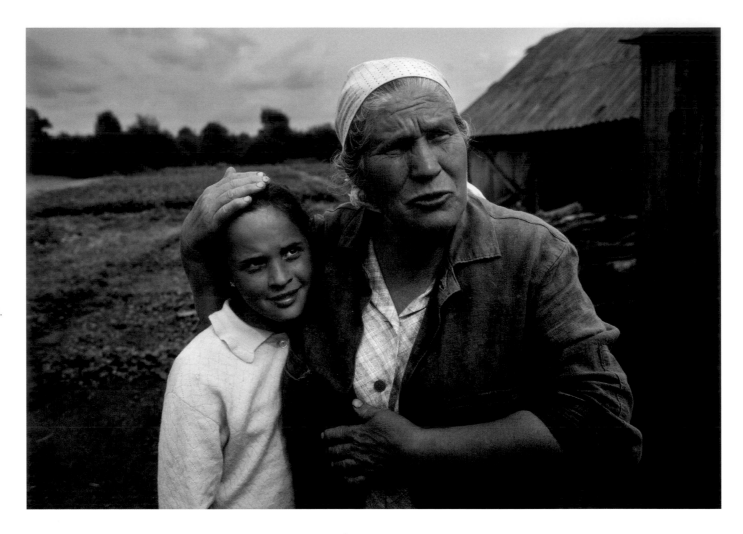

president Vladimir Putin's own making. He invaded and annexed the Crimean Peninsula, the first change in a European border at the point of a gun since the end of World War II. Putin's anti-Western policies and rhetoric, his crackdowns on a free and independent news media, jailing of political rivals and dissidents, and dangerous military challenges to NATO warplanes and ships at Russia's periphery have created renewed tensions. While we no longer have massive numbers of nuclear warheads pointed at one another—in 1985, the US had 21,392, the Soviets 39,197 nuclear weapons—we do see a dangerous rise in Russian nationalism and assertiveness. Arms control

treaties have been broken, new intermediate-range nuclear missiles deployed, and Russian naval and air forces regularly challenge NATO patrols in international waters and airspace. Add to this the well-documented interference in the 2016 presidential election in the United States. Meanwhile, ordinary Russians are fed a steady stream of news broadcasts vilifying the United States and its European allies on the state-controlled TV channels.

And what of it? We in the West know comparatively little of Russia and the fourteen other countries that once comprised the Soviet Union. During the Cold War, all of the major US and European news agencies, newspapers,

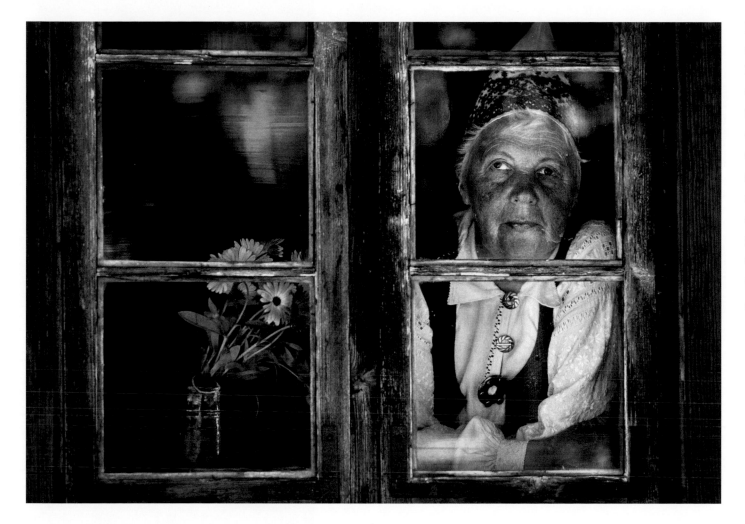

Recreating the past in an era of rising tensions, a Latvian woman wears a dress typical of bygone times at a museum outside Riga. Latvia, along with neighboring Estonia and Lithuania, are now members of NATO—the only former Soviet states to have troops from Western Europe, the United States, and Canada stationed on their soil.

and TV networks maintained bureaus in Moscow. Today, Western news organizations have retreated from the world and there are just a dozen or so American and British newspapers and broadcasters keeping full-time staffers in the Russian capital. Managers say it is too expensive to post correspondents and their families abroad; too expensive to train them in languages, history, and culture before sending them overseas; and that, in the end, fewer and fewer of us care about international news anyway. But whose fault is this? Perhaps our inattention to foreign affairs is a result of a turning inward of Americans and our European allies. Perhaps it is our dependence on social media for more and more news or personal email networks of friends and colleagues. Or maybe it is our tendency to read and watch only the news that conforms to our political viewpoints and interests.

Whatever the reason, we now face a resurgent Russia on the doorstep of the NATO alliance. Troops and warplanes have been deployed from the United States, Canada, Britain, France, and Norway to the Baltic States and Poland. And scholars and politicians rightly ask if we have a new Cold War on our hands. But in looking at my Facebook news feed, I would never know it.

Founder of the Soviet state, Vladimir Lenin looms over passersby on Lubyanka Square in central Moscow. During the Cold War, the yellow brick Lubyanka building was the headquarters of the KGB secret police and foreign intelligence service. "The Lubyanka," as it was ominously called, also was an infamous prison that held thousands of Russians considered "enemies of the people," as well as captured Western spies. A Red Army soldier guards the Kremlin—one of some four million Soviets under arms at the end of the Cold War.

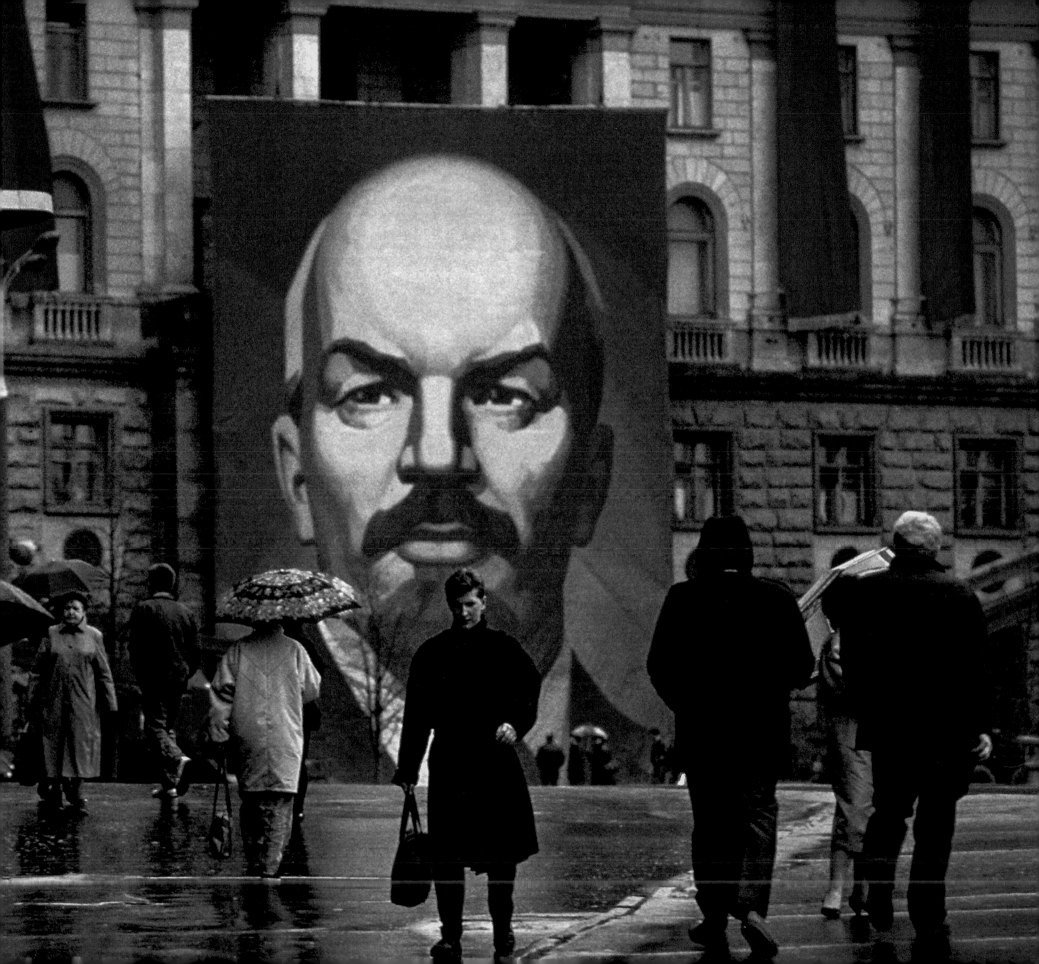

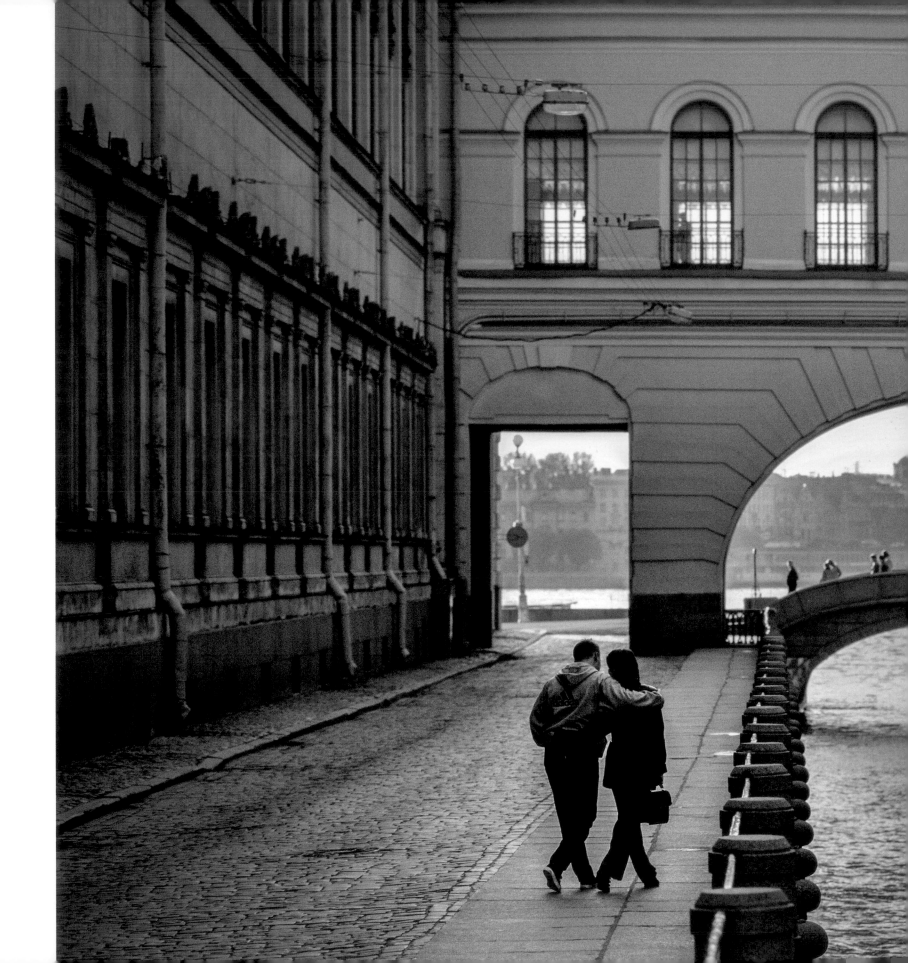

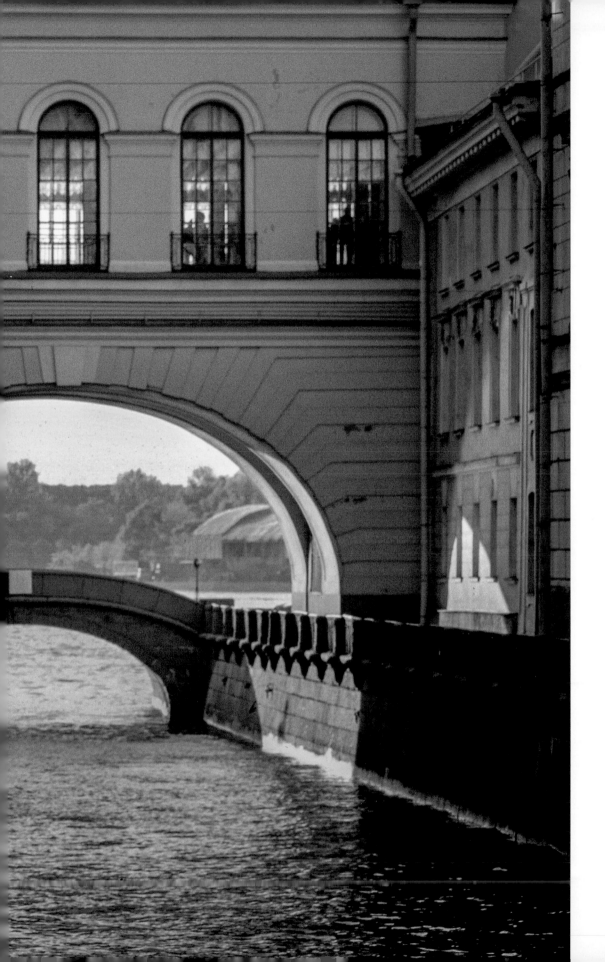

In a city of more than five million residents, a couple steals a moment along the Winter Canal at the Hermitage—the world's second-largest art museum after the Louvre in Paris. Saint Petersburg, northernmost metropolis of its size, was created by Peter the Great in 1703 as a small river fort only seven degrees south of the Arctic Circle. This outpost in the marshy wilderness of the Neva River Delta was Russia's imperial capital until 1917.

165

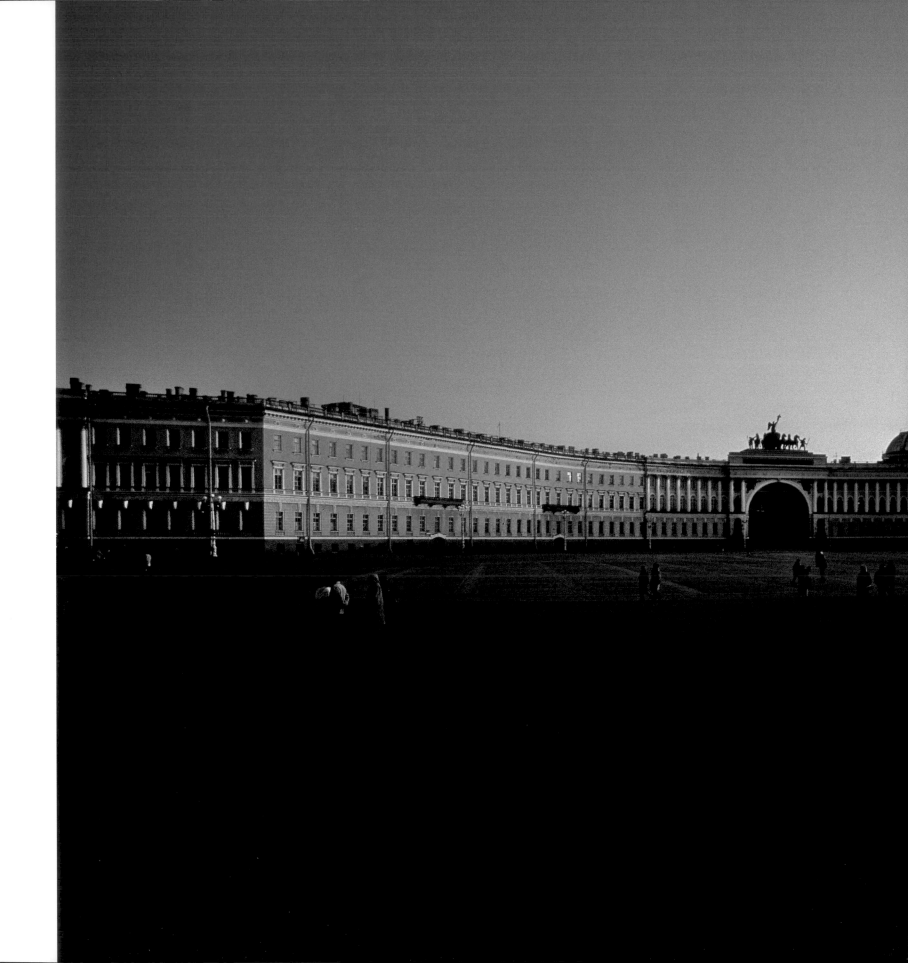

Scene of parades and political uprisings, Palace
Square in Saint Petersburg fronts on the Imperial
General Staff Building and the Alexander Column—a
monument to Russia's triumph over Napoleon in
1812. Almost a century later, Tsarist troops murdered
several hundred unarmed demonstrators on Palace
Square in what become known as the Bloody Sunday
Massacre, setting off the Revolution of 1905.

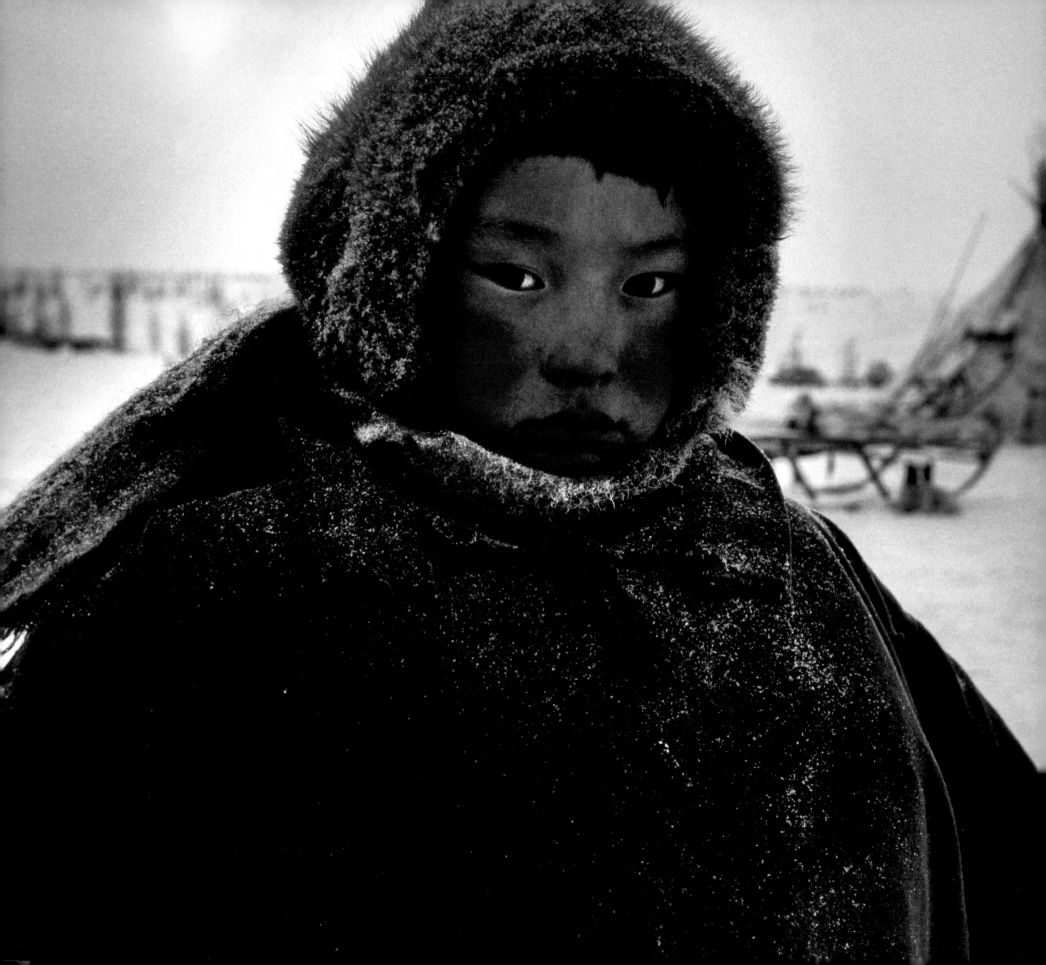

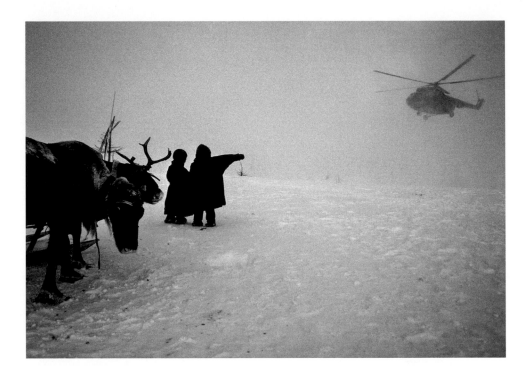

At home above the Arctic Circle, this Nentsy boy and
his family live in a *chum*, a tepee-like shelter made
of reindeer hide. Soviet officials tried to organize the
nomadic Nentsy into collectivized farms, but the Nentsy
of the Yamal Peninsula continue to migrate with their
herds more than 600 miles each year. Nentsy children
welcome a supply helicopter to northwest Siberia, a region
of oil and natural gas riches where winter temperatures
can plummet to minus 58 degrees Fahrenheit.

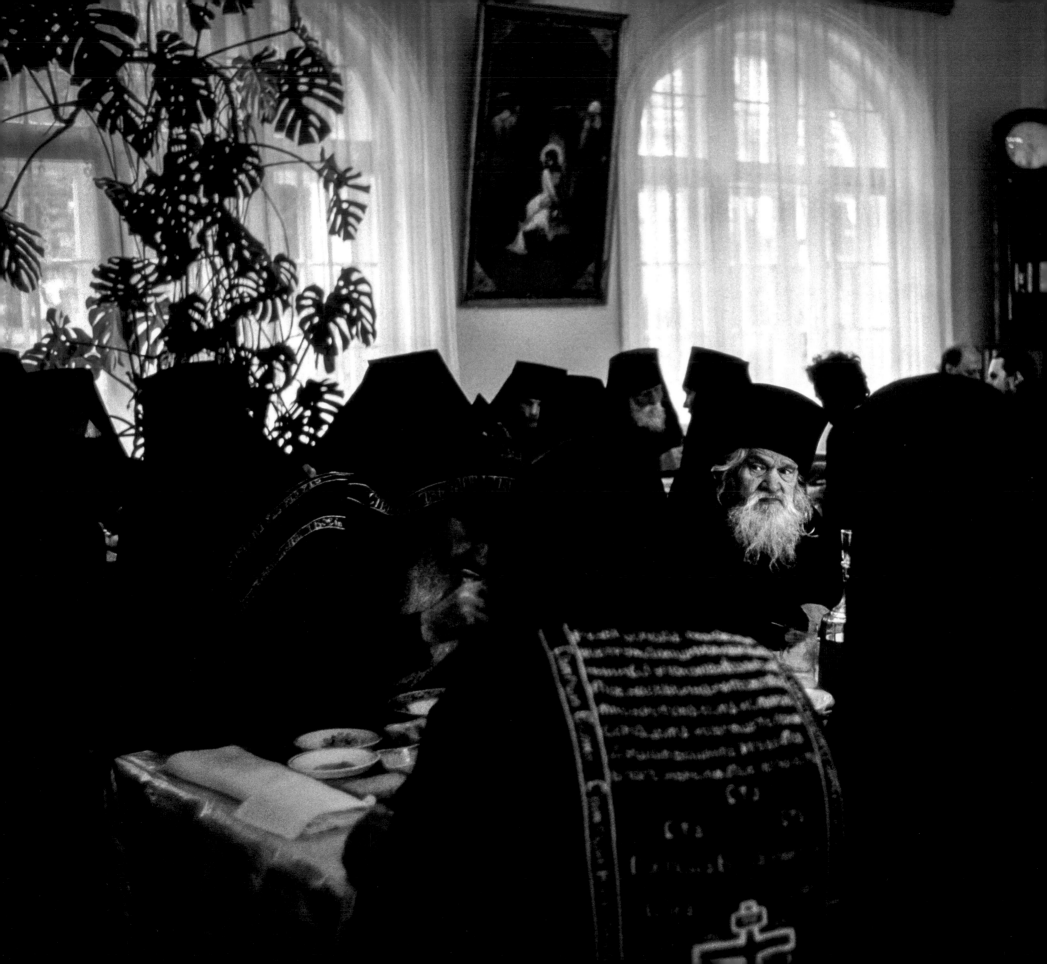

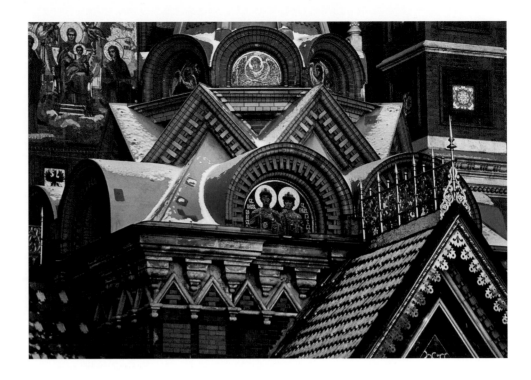

Elders of the Russian Orthodox Pskovo-Pechersky Monastery
are obligated to a code of silence while scriptures are
read during lunch. Repressed in the 1920s and 30s, when
thousands of priests and monks were killed, today the
Orthodox Church and the Kremlin, ruled by the strong
hand of president Vladimir Putin, work together to promote
conservative social values in Russia. In Saint Petersburg, the
Church of the Resurrection of Christ (*above*), often called the
Church on the Blood, marks the spot where Tsar Alexander
II was assassinated by revolutionaries on March 1, 1881.

The elite *corps de ballet* of the Mariinsky Ballet Theatre, formerly the Kirov, warms up for *Swan Lake*. In the eighteenth and nineteenth centuries, Russian rulers brought mentors from abroad to Saint Petersburg to foster European sophistication in the arts in rough-hewn Russia. Saint Petersburg has hosted an impressive roll call of ballet stars, including Vaslav Nijinsky, Anna Pavlova, and Mikhail Baryshnikov.

EPILOGUE

I started classes as a seventeen-year-old at the University of Wisconsin–Madison on a scholarship from the National Press Photographers Association thanks to a journalistic legend named Rich Clarkson. Now an octogenarian, Rich is a renowned sports photographer and magazine photojournalist and editor whose Denver home bristles with awards and honors. In 1963, Rich selected me to be the NPPA High School Photographer of the Year after looking at pictures in high school newspapers from across the nation, noting a certain promise in the way I saw the world. Fast-forward thirty plus years, and Rich would become my boss at *National Geographic* in 1985 and a demanding supporter

The cozy Peveril of the Peak pub in Manchester takes its name from a horse-drawn stagecoach that ran between Manchester and London in the early nineteenth century. Yet across Great Britain, historic pubs are closing at record rates—victims of social and economic changes that make a pint of beer a luxury for many Britons.

175

The author notes inscriptions at the Cambridge American Cemetery and Memorial near Cambridge, England. The cemetery pays silent testimony to the "friendly invasion" of millions of Americans who flooded Great Britain during World War II to defend the British Isles and liberate Nazi-occupied Europe. Among the 3,812 American dead is Joseph P. Kennedy Jr., brother of the late president John F. Kennedy.

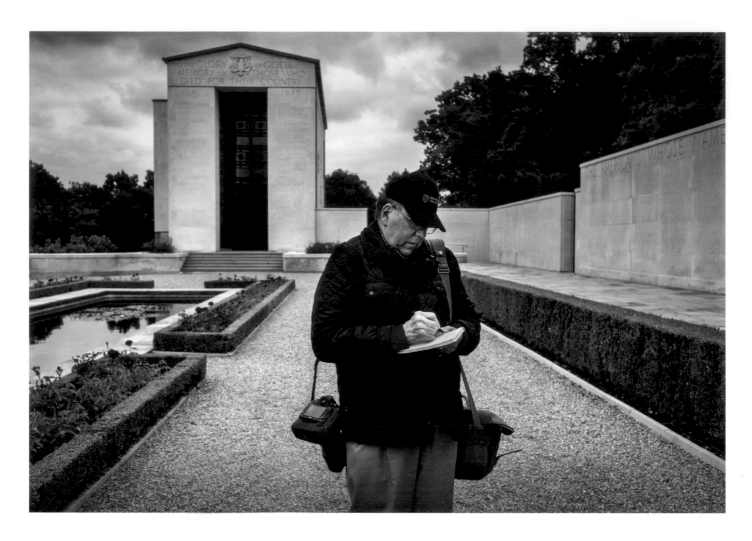

with high expectations. Rich's instructions in 1985 were simple and came with wide latitude: "Be in the Soviet Union as often as possible." Daunting marching orders, given the difficulties of access for journalists.

Reporting on the collapse of communism—as an idea and terrifying system of totalitarian government across Eastern Europe, Russia, and beyond—was the greatest story of my career. With stunning speed, the Berlin Wall came down, the Iron Curtain was lifted, and the Cold War came to an end. As Serge Schmemann of the *New York Times* wrote in "The End of the Soviet Union"

from Moscow on December 25, 1991, "The Soviet state, marked throughout its brief but tumultuous history by great achievement and terrible suffering, died today after a long and painful decline. It was 74 years old. Conceived in utopian promise and born in the violent upheavals of the 'Great October Revolution of 1917,' the union heaved its last in the dreary darkness of late December 1991, stripped of ideology, dismembered, bankrupt and hungry—but awe-inspiring even in its fall. . . . There was no ceremony, only the tolling of chimes from the Spassky Gate, cheers from a handful of surprised foreigners and an

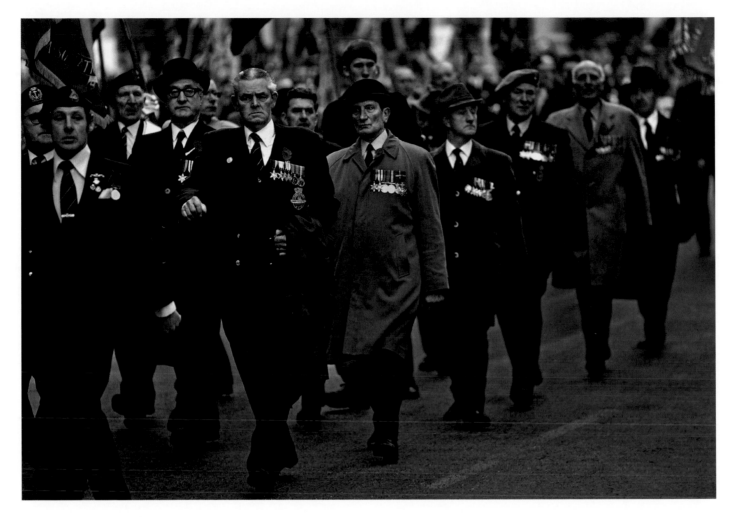

British veterans of World War II, in which nearly a half-million Britons—military and civilian—were killed, parade through London on November 11, 1976, after the National Service of Remembrance. Much like Veterans Day in the United States, Remembrance Day pays tribute to the people who have died in all of Britain's wars—not just World War I—with a royal ceremony at the Cenotaph War Memorial on Whitehall.

angry tirade from a lone war veteran." Schmemann, one of the greatest Moscow correspondents, forgot one important fact in his lead paragraphs. The Soviet Union was a superpower with thousands of nuclear warheads aimed at the United States, our allies, and China. On that fateful day many of us said silent prayers of hope that the threat of a nuclear holocaust would become but a memory.

In a matter of a few years, I swapped Moscow and Washington, DC, for a new career as a professor, author, and photographer at Indiana University Bloomington. Barbara became a professor and scholar of Russian

imperial history—the time of the tsars, before the rise of communism. The years passed swiftly, and when I became a septuagenarian, I retired to become a photographer again, devote more time to long put-off projects, and to do a little teaching of favorite subjects.

At the top of the list is a book about one of the greatest of all British institutions—the public house or pub. I had wanted to do this book since 1976, when a kindhearted publican took me in from the cold in a Glasgow slum called the Gorbals, a pair of Nikons around my neck and a gang of Glaswegian thugs on my tail in the

shipbuilding docks along the River Clyde. My refuge was a centuries-old boozer named the Granite City. Like most pubs of its time, the Granite City served beer, ale, stout, porter, bitters, whiskey, and spirits—but not coffee. But the publican did make me a cup of coffee, touting his gratitude for Americans and their help during World War II. Through this kindhearted man, I was introduced to the pub—an institution that has functioned for centuries as a refuge and center of community life across the British Isles. All these years later, the British pub is now more gentrified and celebrated as one of Great Britain's most popular tourist attractions, visited by some thirteen million foreign travelers to the United Kingdom of Great Britain and Northern Ireland each year.

Still, in Great Britain a good pub is becoming harder to find. I have discovered a pub scene that is endangered by villains such as social media, nightclubs, television, high taxes on beer, a ban on smoking, and rapacious corporate developers, who would rather tear down a historic pub, build condominiums, and sell them to rich Russians, Chinese, Arabs, and an assortment of ne'er-do-well speculators. If there has been satisfaction in this investigation into what is happening to the pub, it is in capturing with my cameras a sense of determination to keep alive this fundamental piece of community life, one that allows people to be alone together, to have a place where they can socialize or have a quiet pint, to converse or simply reflect. And my work comes just in time. Some nineteen thousand public houses have shuttered their doors since 1980, leaving more than half of the villages in England, Wales, Scotland, and Northern Ireland without a "local," as pubs are known, for the first time since the Norman Conquest. Pubs are now closing at the rate of twenty-one per week, according to the Campaign for Real Ale, a nonprofit that promotes "real ale, real cider and the traditional

British pub." Thousands more pubs are expected to close in the coming years, and with their shuttering goes a piece of British culture, one pub at a time.

So, in retirement, what keeps me returning to the British Isles, a place beset with many of the same problems that we have here at home? After all, do I need to go as far as London's posh West End or Scotland to find the same glaring income inequality, the same repulsive racism and xenophobia, the same troubled relations with Britain's neighbors that exist right here in the United States? Where is the draw?

I could just as easily travel to France, where the Raymer family is firmly rooted in Alsace and Loraine, where the culture of the photograph and the photographer have a long and proud tradition, and where French women dress with a certain indefinable je ne sais quoi that distracts me so easily. I have worked the runways and photographed inside the design studio of Christian Dior in Paris and understand that subtle sexiness and elegance are the name of the game in Paris—even from the circumspect distance of a happily married man. And then I adore the food and wine of France, especially the culture of the brasseries, with steak frites, cassoulet, and a good bottle of slightly chilled Beaujolais. My tastes are simple.

But in the end, the British Isles are where I feel a sense of belonging to a tribe or two. There are the brawling newspapers and scuffling House of Commons in the Palace of Westminster, along with the erudition of the BBC and a near-universal pride of language whatever one's social class, including among the Cockneys. Moreover, the Magna Carta or "great charter" of 1215 established the principle that everyone is subject to the law, even the king. I tell students that the Magna Carta has gone through several incarnations, was ignored by various sovereigns, and, it turns out, is one of many documents from the period

that codified limitations on government power. That said, University of Chicago professor Tom Ginsburg reminds us in a June 14, 2015, *New York Times* opinion piece that "Americans aren't alone in revering Magna Carta. Mohandas K. Gandhi cited it in arguing for racial equality in South Africa. Nelson Mandela invoked it at the trial that sent him to prison for twenty-seven years. We are not the only ones, it seems, willing to stretch old legal texts beyond their original meaning." Our search for what it means to be Western has many turns, but often its takes us back to Runnymede, the field where the original Magna Carta was sealed.

I also feel comfortable at Britain's ancient universities—homes of liberal thought and democracy for a very long time—and have visited them all. Moreover, Britain is a land of many of my intellectual and folk heroes—Winston Churchill, Charles Darwin, William Shakespeare, Sir Isaac Newton, Captain James Cook, Jane Austen, John Lennon and the Beatles, and the Rolling Stones, along with the poet and man of letters John Milton and the philosopher John Stuart Mill. Best known for his epic poem *Paradise Lost*, Milton gained international acclaim for a pamphlet he wrote in 1644, in which he argued against censorship and defended free speech and freedom of the press. Mill will long be celebrated for his belief that truth will emerge from the competition of ideas in free, transparent public debate. Our American tradition of a free and unrestrained news media, one that serves up a veritable marketplace of ideas every minute, owes a great debt to John Milton and John Stuart Mill.

Of course, colleagues will say, yes, but look at how the British Empire subjugated and exploited millions around the world. Aside from a few holdouts like the Cayman Islands, Bermuda, the British Virgin Islands, and Gibraltar that service the international financial class, the empire is gone. I saw some of the last of the crown colonies, with their British Union Jacks flying in front of Government Houses in Africa, Asia, and the South Atlantic. Yet today there is something called the Commonwealth of Nations, says Daniel Howden of the *Independent*: the old club of the United Kingdom, Canada, Australia, New Zealand, and South Africa now includes fifty-four countries. Like the United Nations, says Howden, "the Commonwealth stands for world peace, economic development, the rule of law, a narrowing of the wealth gap, an end to racial discrimination, liberty regardless of race or creed, and the 'inalienable right to free democratic processes.'" All very high-minded, I know, except that the Commonwealth provides a forum where, as Howden notes, "big and small nations can speak as equals" and developing member countries are encouraged to "raise their standards of democracy, rights, and governance." And these are all good things.

I could go on. The cut of a fine tweed sport jacket is never better than in England. Or a bespoke dress shirt on Jermyn Street in London. Scotland's finest products—single-malt Scotch whiskies—never fail to please when the television news from Washington, DC, seems disastrous or the weather outside wretched. And the craft beers have never been better in the British pubs. I never tire of a good India Pale Ale. Unfailingly, I am drawn to the English countryside, the winter light falling on stately homes and their lush interiors as well as the glistening green pastures. There is nothing so pure to a photographer's eye.

And, too, there are friends of a lifetime. On November 11, 1976, I gathered with other photographers in the "press pen" at the Cenotaph war memorial in Whitehall for the National Service of Remembrance. At precisely 11 a.m., buglers drew the crowd to its feet with a playing of "The Last Post," much like the mournful "Taps"

The London Eye, a giant Ferris wheel on the South Bank of the River Thames, is to the British capital what the Eiffel Tower is to Paris—a landmark that allows not just the wealthy but everyone to see and understand the city in a new way. A world apart from the rest of England, London is one of the wealthiest and most diverse cities in the world, and absorbs more than half of all immigrants to Great Britain.

in American military tradition. Her Majesty Queen Elizabeth laid a wreath and there followed two-minutes of silence to mark the end of the First World War at the eleventh hour of the eleventh day of the eleventh month of 1918. The British do this probably better than any other nation: they remember and honor those who have paid the price for their—and our—freedoms.

Sadly, on this day, the only sounds visitors could hear during the two-minutes of silence along Whitehall—the main thoroughfare running from Trafalgar Square toward the seat of power in Parliament Square—were my Nikon camera's noisy clicks on full motor drive. In the United States photojournalists are free to make pictures of the president and other officials during patriotic ceremonies, including the playing of "The Star-Spangled Banner" and moments of silence. But not in Britain, where a ceremonial two minutes of silence is indeed two minutes of silence. My embarrassment was acute, my face as red as the Union Jack flags that adorned the Cenotaph. But an easygoing young man with several Nikon cameras hanging from his shoulders came to my rescue. He introduced himself as Brian Harris of the *Times of London*, inquired about my nationality, said he understood, and calmed the situation with other photographers and military officials.

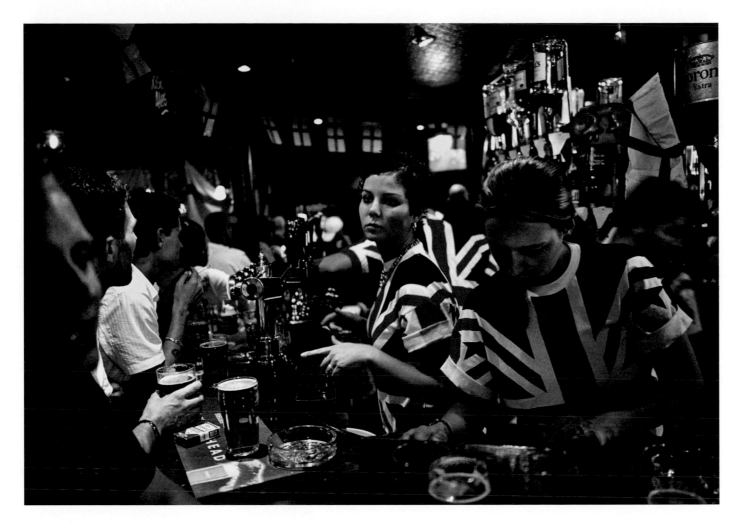

Bartenders wearing British Union Jack shirts serve fans the Zetland Arms pub in the London borough of South Kensington during a EuroCup football match. Once the center of neighborhood or community life, pubs are closing at a rate of 21 per week, reflecting the cheaper price of beer in supermarkets, strict drunk-driving laws, a 2007 smoking ban, and less alcohol consumption by young people.

I suggested a beer or coffee. Brian and I have been friends for more than forty years, through professional and personal upheavals, wars and political campaigns, good times and bad, and many tricky professional moments in between.

Our beloved Jennifer Moseley, who ran the *National Geographic* office in London for many years, once sent me a telegram to Kyiv in Ukraine, saying that I had to drop everything and come to London for a fancy party at a posh club on Pall Mall to mark the publication of a *Geographic* story on Parliament. Management wanted as many photographers on hand as possible, even though I

had nothing whatsoever to do with the story. I was only too eager to leave the dreariness of Eastern Europe and hop on a plane to London to be an "extra" on a set right out of *Masterpiece Theatre*. But my one question was what to wear. Jenny knew the answer down to the last cufflink. And she advised me on just how to make a proper entrance, with your invitation in hand, your suitcoat buttoned, and your cravat tied neatly. As an official in white tie and tails announced to the partygoers, in a booming, sonorous voice, the arrival of "The photographer, Mister Steven Laurence Raymer, Esquire," I said to myself, "No one stands on ceremony like the British."

In a city haunted by history, the Reichstag in Berlin—home of the German Parliament—has been reconstructed with a glass dome that symbolizes the transparency of a thriving parliamentary democracy. Increasingly the Western alliance looks to Germany—Europe's economic giant—to show firmness in the face of a belligerent Russia and compassion to immigrants from the Middle East and Africa. In Paris (*above*), a model walks the runway of a ready-to-wear fashion show. Today, the City of Light finds itself at the center of a transformation of the French political system and economy by French President Emmanuel Macron.

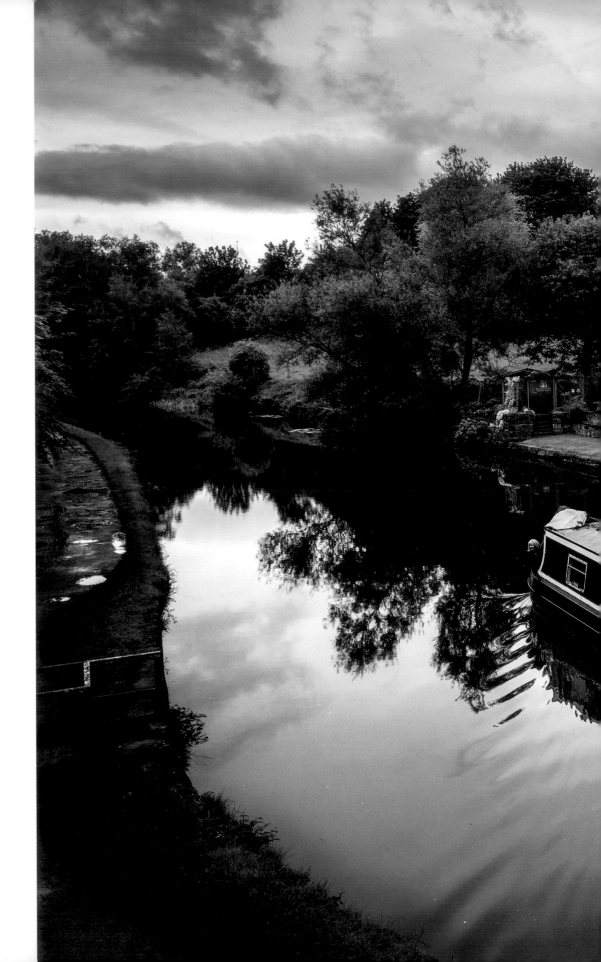

Near Wigan, where George Orwell wrote about the plight of the working class some seventy-five years ago, a pleasure boat cruises the Leeds-Liverpool Canal, the longest in Northern England at 127 miles. More than eleven million Britons live in the countryside of England, Scotland, Wales, and Northern Ireland—about 17 percent of the United Kingdom's population, according to the World Bank. But the idyllic landscape is plagued by a shortage of affordable housing, cuts to social services, large gaps in broadband internet coverage, and the closure of hundreds of village pubs.

184

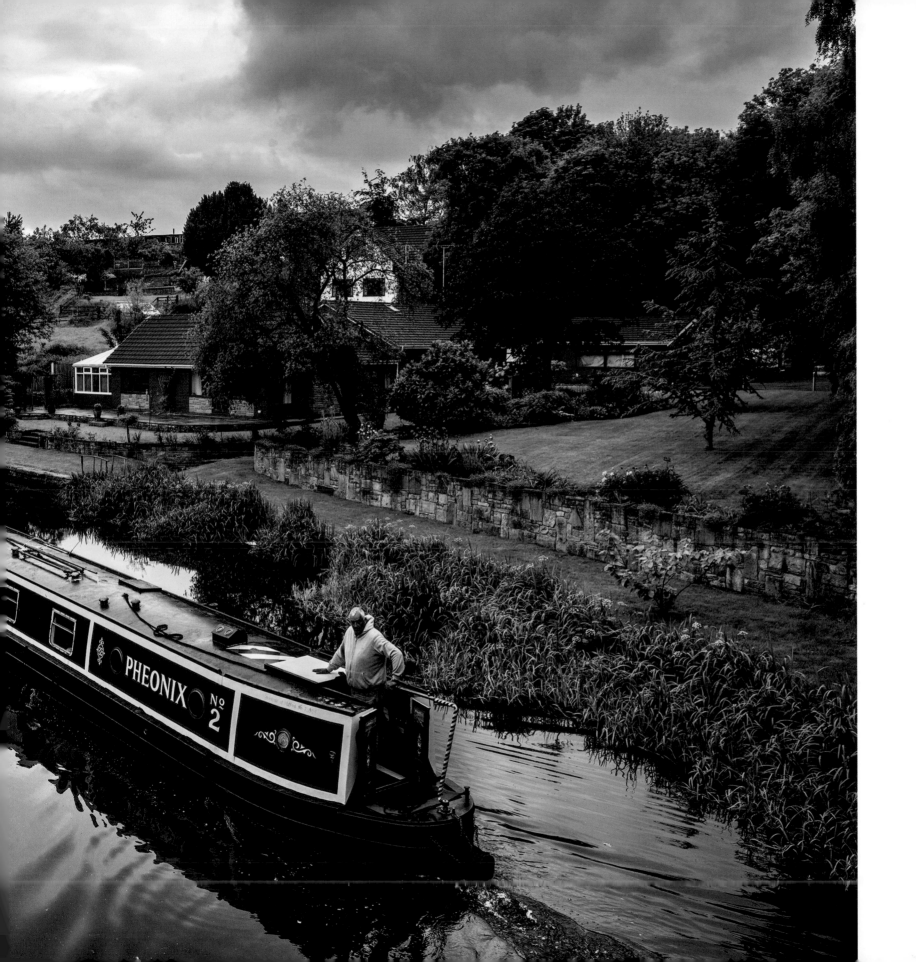

A white-collar crowd mingles with tourists at Ye Olde
Cheshire Cheese, which survived the Great Fire of
London in 1666. Locals say the pub's lack of natural
lighting generates a gloomy charm, something that
appealed to authors such as Charles Dickens, Mark
Twain, Alfred Tennyson, Sir Arthur Conan Doyle,
and G. K. Chesterton, who were all regulars. The
pub is alluded to in Dickens's *A Tale of Two Cities*
as a haunt where a gentleman could recoup "his
strength with a good plain dinner and good wine."

Jets of the Red Arrows, the British Royal Air Force
aerobatic team, pull through a loop above Duxford
Airfield, home of the American Air Museum near
Cambridge. During World War II, British, American,
Polish, and Czechoslovakian pilots flew out of Duxford,
first during the Battle of Britain in 1940 and later
to bomb Nazi Germany. The author was surprised
by this spectacular display while drinking a beer at
the nearby John Barleycorn pub, a favorite watering
hole for RAF and American pilots during the war.

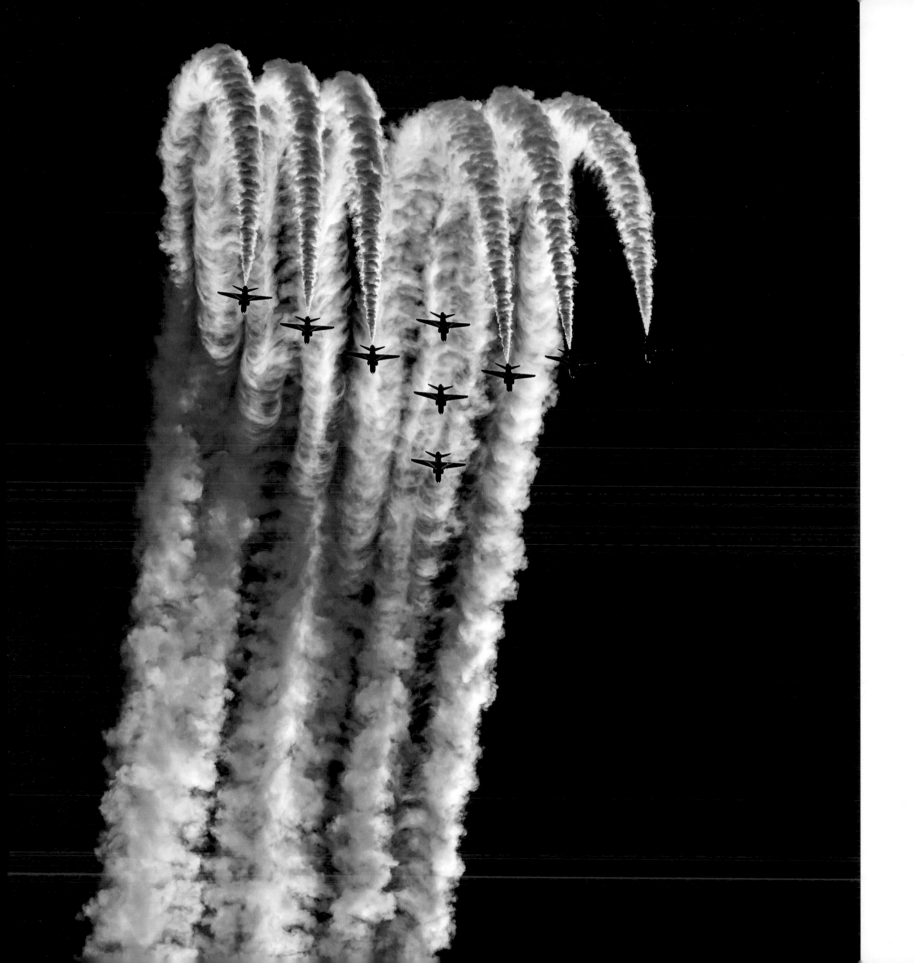

SOURCES AND FURTHER READING

CHAPTER 1

Ben Cosgrove. "Behind the Pictures: The Liberation of Buchenwald, April 1945." Time Life, October 10, 2013. http://time.com/3638432/behind-the-picture-the-liberation-of-buchenwald-april-1945/.

Cutter, Holland. "Photography's Shifting Identity in an Insta-World." *New York Times*, June 23, 2016. https://www.nytimes.com/2016/06/24/arts/design/review-photographys-shifting-identity-in-an-insta-world.html?mcubz=1&_r=0.

Hodgson, Bryan, and Steve Raymer. 1976. "The Pipeline: America's Troubled Colossus." *National Geographic*, November 1976, 684–717.

Kramer, Andrew W. "Russian Images of Malaysia Airlines Flight 17 Were Altered, Report Finds." *New York Times*, July 15, 2016. https://www.nytimes.com/2016/07/16/world/europe/malaysia-airlines-flight-17-russia.html.

Raymer, Steve. "Ethics Matters: A Commentary for NPPA's Ethics Committee Regarding the Photographs of Steve McCurry." NPPA: The Voice of Visual Journalists, May 25, 2016. https://nppa.org/node/73364.

Schjeldahl, Peter. "Picture Perfect: An Henri Cartier-Bresson Retrospective." *New Yorker*, April 19, 2010. https://www.newyorker.com/magazine/2010/04/19/picture-perfect.

Sischy, Ingrid. "Good Intentions." Photography, *New Yorker*, September 9, 1991, 92.

Sontag, Susan. *Regarding the Pain of Others*. New York: Farrar, Straus and Giroux, 2003, 77.

CHAPTER 2

Becker, Elizabeth. *When the War Was Over: Cambodia and the Khmer Rouge Revolution,* revised edition. New York: Public Affairs, 1998.

"Striving for Unity: A Thoughtful History of Vietnam." Review of *Vietnam: A New History,* by Christopher Goscha. *Economist* Books and Arts, July 21, 2016. https://www.economist.com/news/books-and -arts/21702433-thoughtful-history-vietnam -striving-unity.

Isaacs, Arnold R. "After the Ceasefire: War Lingers in Hamlets as Cease-Fire Hour Passes." *Baltimore Sun,* January 29, 1973. In *Reporting Vietnam,* part 2, *American Journalism, 1969–1975,* ed. Milton J. Bates, Lawrence Lichtry, Paul L. Miles, Ronald H. Spector, and Marilyn Young. New York: Literary Classics, 1998, 425–28.

Just, Ward. *To What End: Report from Vietnam.* New York: Public Affairs, 1968, xv.

Kennedy, John F. "Inaugural Address." Washington, DC, January 20, 1961. John F. Kennedy Presidential Library and Museum. https://www.jfklibrary.org /Research/Research-Aids/Ready-Reference/JFK -Quotations/Inaugural-Address.aspx.

Mydans, Seth. "Of Pol Pot." *New York Times,* April 17, 1998. http://www.nytimes.com/1998/04/17 /world/death-pol-pot-pol-pot-brutal-dictator -who-forced-cambodians-killing-fields-dies.html.

Raymer, Steve, and Paul Martin. *Land of the Ascending Dragon: Rediscovering Vietnam.* Winter Park, FL: Hastings House, 1997.

White, Peter T., and Steve Raymer. "The Poppy.'" *National Geographic,* February 1985, 142–189.

Whitney, Craig R. "Gloria Emerson, Chronicler of War's Damage, Dies at 75." *New York Times,* August 5, 2004. http://www.nytimes.com/2004/08/05 /arts/gloria-emerson-chronicler-of-war-s-damage -dies-at-75.html.

CHAPTER 3

Addario, Lynsey. *It's What I Do: A Photographer's Life of Love and War.* New York: Penguin, 2015.

Chapnick, Howard. *Truth Needs No Ally: Inside Photojournalism.* Columbia: University of Missouri Press, 1994.

Fass, Horst, and Tim Page, eds. *Requiem: By the Photographers Who Died in Vietnam and Indochina.* New York: Random House, 1997.

Feinstein, Anthony. "In Harm's Way: Why War Correspondents Take Risks and How They Cope." *Globe and Mail,* August 29, 2014. https://beta .theglobeandmail.com/news/world/in-harms-way -why-war-correspondents-take-the-risk/article 20278510/?ref=http://www.theglobeandmail.com.

Feinstein, Anthony. *Journalists Under Fire: The Psychological Hazards of Covering War.* Baltimore, MD: Johns Hopkins University Press, 2006.

Gellhorn, Martha. "Dachau: Experimental Murder." *Collier's,* June 23, 1945, 16. http://www .oldmagazinearticles.com/war-correspondent -martha-gellhorn-at-DACHAU-death-camp_pdf.

Hedges, Chris. *War Is a Force that Gives Us Meaning.* New York: Public Affairs, 2014, 3.

Keller, Jared. "Photojournalism in the Age of New Media." *Atlantic*, April 4, 2011. https://www.theatlantic.com/technology/archive/2011/04/photojournalism-in-the-age-of-new-media/73083/.

Kotler, Steven. "Einstein at the Beach: The Hidden Relationship between Risk and Creativity." *Forbes*, October 11, 2012. https://www.forbes.com/sites/stevenkotler/2012/10/11/einstein-at-the-beach-the-hidden-relationship-between-risk-and-creativity/#43b411d09f54.

Levathes, Louise E., Steve Raymer, and Herb Kawainui Kane. "Kamehameha: Hawaii's Warrior King." *National Geographic*, November 1983, 558–599.

Newman, Cathy. "Bill Garrett–An Appreciation." Photo Society, August 23, 2016. http://thephotosociety.org/bill-garrett-an-appreciation/.

Raymer, Steve. "Bangladesh: The Nightmare of Famine." *National Geographic*, July 1975, 33–39.

Shawcross, William. "Report from Ethiopia: An Update on the African Nation's Catastrophic Famine." *Rolling Stone*, August 15, 1985. http://www.rollingstone.com/politics/news/report-from-ethiopia-19850815.

White, Peter T., and Steve Raymer. "A Little Humanity amid the Horrors of War." *National Geographic*, November 1986, 647–79.

White, Peter T., and Steve Raymer. "The Poppy." *National Geographic*, February 1985, 142–189.

CHAPTER 4

Anand, Geeta. "Modi Faces 'Disappointed' Voters in India's Most Populous State." *New York Times*, February 14, 2017. https://www.nytimes.com/2017/02/14/world/asia/modi-voters-india-uttar-pradesh.html?_r=0.

Barry, Ellen. "Kolkata Testifies to the Grace of Mother Teresa, Its New Saint." *New York Times*, September 4, 2016. https://www.nytimes.com/2016/09/05/world/asia/mother-teresa-kolkata-canonization-saint.html.

BBC.com. "Yemen Crisis: Who Is Fighting Whom?" March 28, 2017. http://www.bbc.com/news/world-middle-east-29319423.

Bensemra, Zohra. "Life in a Sahrawi Refugee Camp." Reuters: The Wider Image, March 4, 2016. https://widerimage.reuters.com/story/life-in-a-sahrawi-refugee-camp.

Buultjens, Ralph. "Understanding Modern India." The Asia Society: Center for Global Education. http://asiasociety.org/education/understanding-modern-india, accessed November 19, 2017.

Canby, Thomas Y., and Steve Raymer. "Can the World Feed Its People?" *National Geographic*, July 1975, 2–31.

Charlton, Linda. "Assassination in India: A Leader of Will and Force." *New York Times*, November 1, 1984. http://www.nytimes.com/learning/general/onthisday/bday/1119.html.

Cole, Teju. "A Too-Perfect Picture." On Photography, *New York Times*, March 30, 2016. https://www.nytimes.com/2016/04/03/magazine/a-too-perfect-picture.html?mcubz=1&_r=0.

Di Giovanni, Janine. "Drawn into the Middle East: A Novel, a Memoir, and an Account of Life in the Region." *New York Times Book Review*, February 8, 2017. https://www.nytimes.com/2017/02/08/books/review/attack-loic-dauvillier-and-glen-chapron.html.

Grove, Noel, and Steve Raymer. "North Yemen." *National Geographic*, August 1979, 244–69.

Hodgson, Bryan, and Steve Raymer. "New Delhi: Mirror of India." *National Geographic*, April 1985, 506–33.

Hubbard, Ben. "Saudis Turn Birthplace of Ideology into Tourist Spot." *New York Times*, May 31, 2015. https://www.nytimes.com/2015/06/01/world/middlecast/saudis-turn-birthplace-of-ideology-into-tourist-spot.html?_r=0.

Raymer, Steve. *Redeeming Calcutta: A Portrait of India's Imperial Capital.* Oxford, UK: Oxford University Press, 2013.

US Department of Agriculture Foreign Agricultural Service. "India's Agricultural Exports Climb to Record High." August 29, 2014. https://www.fas.usda.gov/data/india-s-agricultural-exports-climb-record-high.

CHAPTER 5

Canby, Thomas Y. "A Generation after Sputnik: Are the Soviets Ahead in Space?" *National Geographic*, October 1986, 420–58.

Edwards, Mike W., Steve Raymer, and Pierre Mion. "Chernobyl—One Year Later." *National Geographic*, May 1987, 632–53.

Edwards, Mike W., and Steve Raymer. "Mother Russia on a New Course," National Geographic, February 1991, 1–37.

Edwards, Mike W., and Steve Raymer. "Ukraine," National Geographic, May 1987, 595–631.

Garrett, Wilbur E., and Steve Raymer. "Air Bridge to Siberia." *National Geographic*, October 1988, 504–9.

Raymer, Steve. "St. Petersburg: Capital of the Tsars." *National Geographic*, December 1993, 96–122.

Raymer, Steve, and Mike Edwards. "Siberia: In from the Cold." *National Geographic*, March 1990, 2–39.

Saxon, Wolfgang. "Jaroslav Pelikan, Wide-Ranging Historian of Christian Traditions, Dies at 82." *New York Times*, May 16, 2006. http://www.nytimes.com/2006/05/16/obituaries/16PELIKAN.html.

EPILOGUE

Ginsburg, Tom. "Stop Revering Magna Carta." *New York Times*, June 14, 2015. https://www.nytimes.com/2015/06/15/opinion/stop-revering-magna-carta.html?_r=0.

Howden, Daniel. "The Big Question: What Is the Commonwealth's Role, and Is It Relevant to Global Politics?" *Independent*, November 26, 2009. http://www.independent.co.uk/news/world/politics/the-big-question-what-is-the-commonwealths-role-and-is-it-relevant-to-global-politics-1827478.html.

Schmemann, Serge. "End of the Soviet Union." *New York Times*, December 25, 1991. http://www.nytimes.com/1991/12/26/world/end-of-the-soviet-union-the-soviet-state-born-of-a-dream-dies.html?pagewanted=print&src=pm.

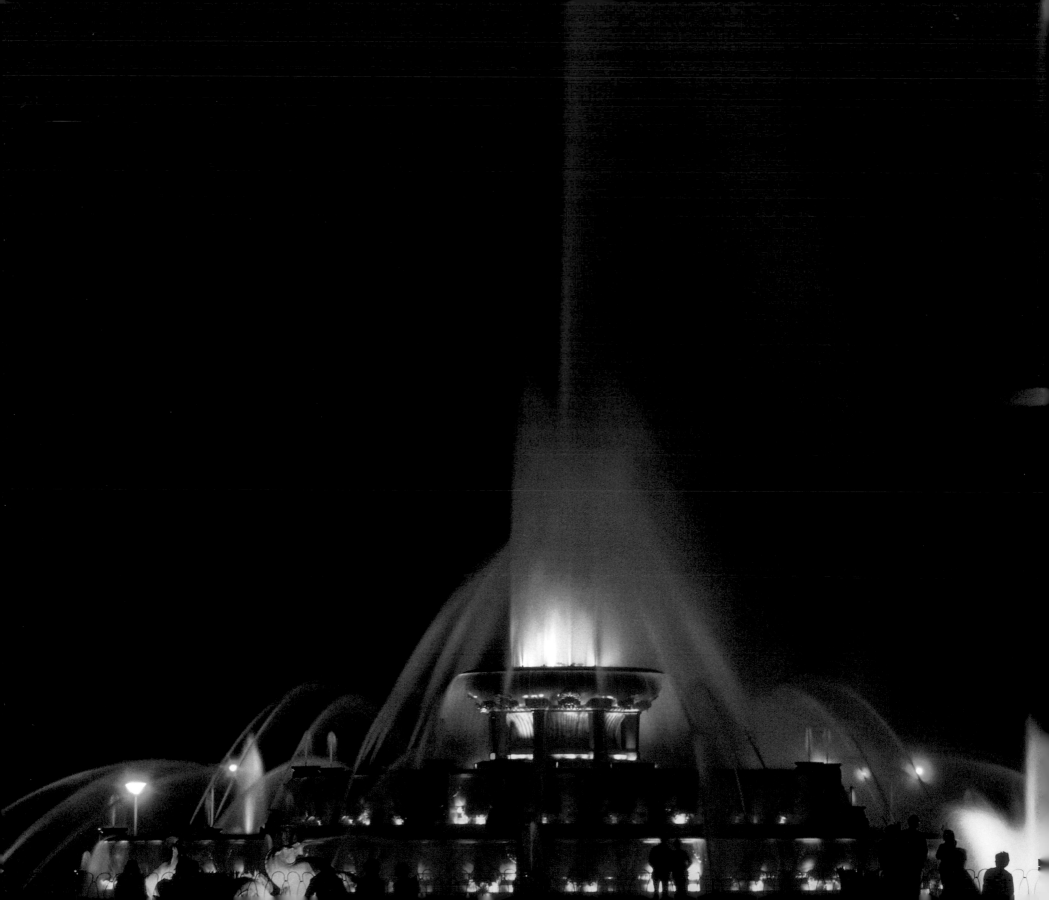

Illuminated by a full moon and floodlights, Buckingham Fountain remains a Chicago landmark that dazzles visitors with an hourly display of water geysers during the summer.

STEVE RAYMER is a former *National Geographic Magazine* staff photographer and professor emeritus at Indiana University Media School. The National Press Photographers Association and the University of Missouri named him "Magazine Photographer of the Year"—one of photojournalism's most coveted awards—for his reporting of the global hunger crisis. He has also been honored by the Overseas Press Club of America for international reporting requiring exceptional courage and is the winner of numerous first-place awards from the National Press Photographers Association and the White House News Photographers' Association. His books include *Redeeming Calcutta: A Portrait of India's Imperial Capital.*

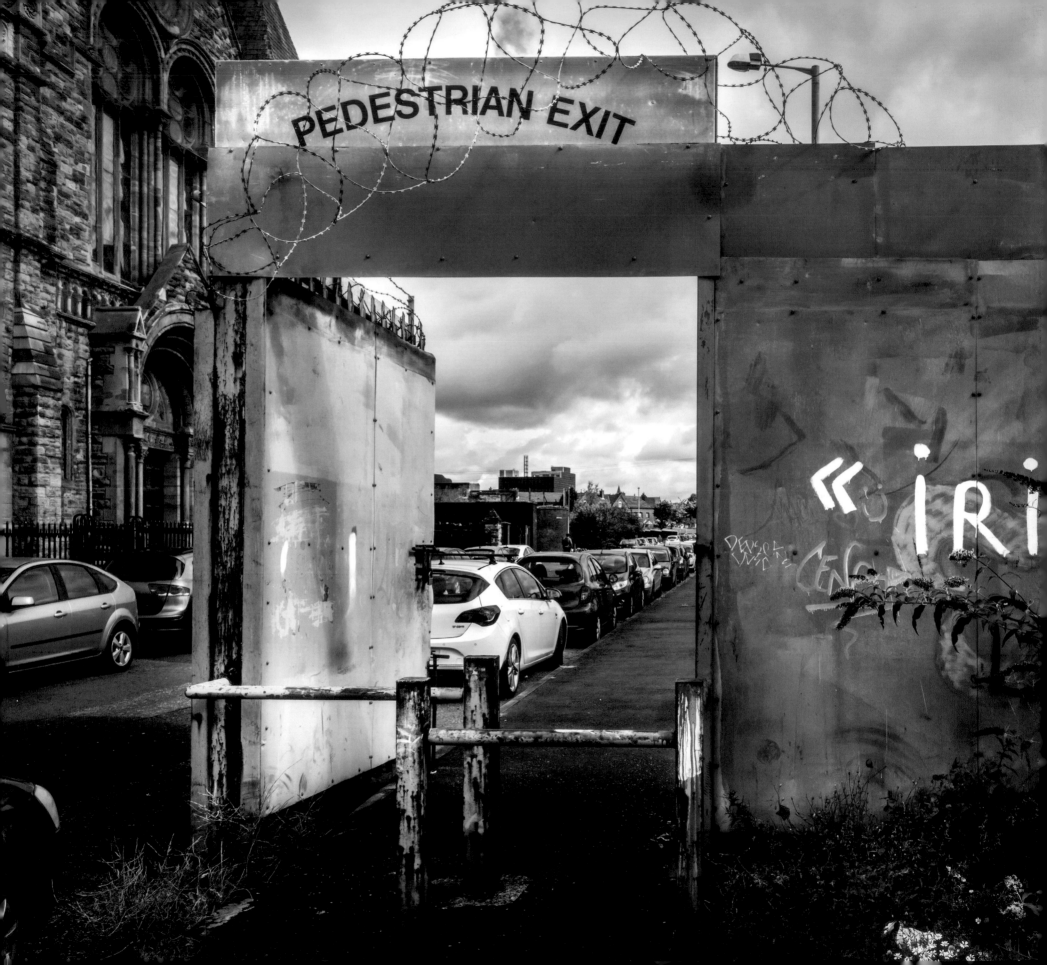

More than forty years ago, I traveled through Belfast, then
a battleground of sectarian grievance, and saw the British
Army lock the gates that separated Catholic and Protestant
neighborhoods. The Berlin Wall has long ago come down,
but Belfast's barriers—some made of concrete and topped
by barbed wire—are still standing, locked for the night
between 3:00 and 10:30 p.m.

Many photojournalists, myself included, believe in the
power of pictures to open minds and unlock hearts. In
that spirit, the team of dedicated Indiana University Press
staff members, whose names appear below, have worked
tirelessly to create *Somewhere West of Lonely*. Moreover,
Ms. Susan (Susie) Riggs and her team at National
Geographic Creative have been generous with their
resources and time in making available many of the images
in this book. And special thanks is due Larry Buchanan, a
graduate of the Indiana University journalism program, now
a designer for the *New York Times*, who created our map.

Steve Raymer
Bloomington, Indiana, 2018

DIRECTOR	Gary Dunham
PROJECT MANAGER	Nancy Lightfoot
BOOK & JACKET DESIGNER	Leyla Salamova
COMPOSITION	Tony Brewer